Fearless Creating

Fearless Creating

A STEP-BY-STEP GUIDE TO STARTING AND COMPLETING YOUR WORK OF ART

ERIC MAISEL, PH.D.

A JEREMY P. TARCHER/PUTNAM BOOK
published by
G. P. PUTNAM'S SONS
New York

A Jeremy P. Tarcher/Putnam Book
Published by G. P. Putnam's Sons
Publishers Since 1838
200 Madison Avenue
New York, NY 10016

The author acknowledges permission from
Sally Goodman to quote from
Homespun of Oatmeal Gray, poems by Paul Goodman.

Library of Congress Cataloging-in-Publication Data

Maisel, Eric, date.
 Fearless creating: a step-by-step guide to starting
and completing your work of art / Eric Maisel.
 p. cm.
 "A Jeremy P. Tarcher / Putnam book."
 Includes bibliographical references and index.
 ISBN 0-87477-805-0 (acid-free paper)
 1. Creation (Literary, artistic, etc.) 2. Artists—Psychology.
I. Title.
N71.M237 1995 95-10427 CIP
701'.15—dc20

Cover and interior design by Mauna Eichner

Cover illustration © by Henrik Drescher

Photograph of the author © Jeanine Reisbig

Printed in the United States of America
10 9 8 7 6 5 4 3 2 1

This book is printed on acid-free paper. ∞

For the women
NATALYA, KIRA, ESTHER, ROSE, & ANN

ACKNOWLEDGMENTS

I would again like to thank my clients in the arts for the privilege of working with them and learning from them. I'd also like to thank the many workshop participants who bravely came forward to role-play situations, like those between an author and an editor or between a painter and a gallery owner, that confront creators who take their work to market.

I'd like to thank and acknowledge the book's editor, Allen Mikaelian, and its publisher, Jeremy Tarcher, for their professionalism, guidance, and vision. Not many writers are so fortunate as to receive such aid and support. I would also like to thank my literary agent, Linda Allen, for her ongoing counsel and advocacy.

Every book has its secret helpers. This one had the help of Metece Riccio, psychotherapist and friend, who brought her enthusiasm and genuine interest to the project; Gary Camp, heroically persevering as a thinker, questioner, and wonderer; readers like Peter London and Sally Warner, who took time with the book in manuscript; and my daughters Natalya and Kira, who generated many titles for the book, including the around-the-house favorite, *It Could Be the Sun but It's Blue: Creativity and You.*

Again I reserve special thanks for my wife, Ann, rock-solid provocateur.

CONTENTS

Art and rebellion will die only with the last person.
ALBERT CAMUS

The work involves commitment, pain, and a giving of oneself,
and yet all of it is essentially a joyous experience.
SIDNEY LUMET

PREFACE

Nancy Schlossberg and Susan Porter Robinson, researchers investigating the subject of nonevents, those things that don't happen that affect people for a lifetime, like not completing college or not advancing at work, began by asking their subjects the following question: "Where do unmet dreams reside?"

That beautiful question is central to this book. Each of you has dreamed of creating and creating well. But in too many of us that dream remains unfulfilled. As a counselor to artists, I know that even they find this dream unfulfilled. They create, but not, in their own estimation, well enough, deeply enough, or often enough. Of course there are reasons for this, but the pain that accompanies unmet dreams is not relieved by reasons.

Both artists and would-be artists feel this lack, this diminishment: that what is finest for a human being to do, to create true and beautiful things, is eluding them. As a deferred dream, it is another source of depression, another eroder of self-esteem, another stumbling block in life.

But because I teach adults who return to college after a long absence, I am in the happy position of seeing enormous changes occur in people in practically no time at all. An adult comes into the program frightened, undisciplined, adrift; three months later he or she is producing long essays of startling sophistication. The transformation is nothing less than remarkable.

How is this possible? Because the students have it in them and because they receive support and guidance. That is all. And that, I hope, is the same equation that will make this book successful. My goal is not that you bring another product or idea into the world, as valuable as that product or idea might be. My goal is that you realize your dreams. You have it in you to create, and this book provides guidance. I hope that the match is a fruitful one.

INTRODUCTION

You Are Creating

*i*n *this book,* I mean to guide you step by step over, around, and through the obstacles inherent in the creative process. Therefore this is a book about work and love, about self-doubt and self-confidence, about nervous tensions and deep (but brief) satisfactions.

It is not a book in which I seek to glorify the creative process. Creativity needs no glorification. It is not a book in which I simplify the creative process. Creativity is not a simple matter, not even for the artist lost in the trance of working. Nor is it a book in which I presume that you are mentally healthy as you create. You may be just as disturbed as the next person.

Nor, lastly, is it a book in which I suppose that each of you will create. Some of you will, but many of you won't. Rather it is a book in which I attempt a handful of things, beginning with the naming of the stages of the creative process.

Sure I have self-doubts. I just spent three days trying to paint a two-inch rock and thought maybe I'd be better off wrapping produce in a supermarket.

MARIA MIJARES

STAGES OF THE CREATIVE PROCESS

I do not evolve, I am.
PABLO PICASSO

The anxiety is unbearable. I only hope it lasts forever.
OSCAR WILDE

These are not the same stages which you've encountered in other works on creativity: the preparation, frustration, incubation, illumination, elaboration, and communication stages described by many authors. I have not found that scheme to accurately capture the rhythms and reality of the creative process. In this book the stages of the creative process are called by the following names: wishing, choosing, starting, working, completing, and showing. People create in these stages whether they are painters, novelists, actors, or physicists.

These are active stages and not passive ones. Where there is no vitality, there is no creativity. Where there is no burning curiosity, there is no creativity. Work is not incubated; the alive, energetic person incubates work. Work is not prepared; the obsessed artist works incessantly, in and out of her own conscious awareness, on problems and melodies, sentences and atmospheric effects, tonalities and passages. If you would like to be creative, you must first come alive.

ANXIETY AND THE CREATIVE PROCESS

The greatest block to aliveness is anxiety. Anxiety is a word with a long history and many meanings, and doubtless conjures up many thoughts and feelings in you. For some, the word is connected to another word, neurosis. For others, it is the thing they experience before and during performances. Others will hear echoes of the phrase "age of anxiety" and will hear in the word what many hear in the word "stress," a pervasive problem, afflicting virtually everyone, with sources both inside and outside the person.

In this book I mean to describe the kinds of anxieties that inevitably attend each stage of the creative process. In large measure these are anxieties that you *should* experience because, while anxiety is the greatest impediment to aliveness, in order to create you must invite anxieties into your life and live anxiously. For every miracle of creation, you will experience a week of anxious brooding. You will only earn fine camera angles, lucky brush strokes,

and brilliant poetic images by risking anxiety and living with anxiety.

If you are to create, you must invite anxiety in. But then you must manage it. If you can't manage this necessary anxiety, you will block; and we can start right now to call creative blockage the inability to manage the anxiety that attends the creative process, for that is what creative blockage most often is.

Each stage of the creative process is characterized by its own kind of anxiety. The hungry-mind anxiety associated with the original wish to create is different from the chaotic-mind anxiety of working, and both are different from the critical-mind anxiety and attached-mind anxiety that make it so difficult to declare a work of art finished. While there is artifice involved in naming these anxieties just this way, there is nothing artificial about pointing out the very great role anxiety plays in the creative process. In its negative aspect it blocks the artist, causes her to limit her scope or create second-rate work, and more. In its so-to-speak positive aspect it is like the itching that accompanies the healing of a wound: horribly uncomfortable, but proof that creativity is happening.

At the same time, I want to present a basic remedy for the anxiety that attends each stage. The logic and look of this remediation is presented in the following table.

Stage	Anxiety	Solution
1. Wishing	hungry mind	appropriate feeding
2. Choosing	confused mind	appropriate clarity
3. Starting	weakened mind	appropriate strength
4. Working	chaotic mind	appropriate order
5. Completing	critical mind	appropriate appraising
6. Showing	shy mind	appropriate performing
	attached mind	appropriate detaching

Writing is so difficult that I often feel that writers, having had their hell on earth, will escape all punishment hereafter.

JESSAMYN WEST

What never vary are the necessities of being in the world, of having to labor and to die there.

JEAN-PAUL SARTRE

The remedy in each case is not only doing something, but doing it appropriately. When you choose an idea to work on, what is appropriate to know is that you largely do not know what is about to happen. Coming with too clear, too simply made, or too safely constructed an idea at the start of the work is an example of inappropriate knowing.

In order to bind the anxiety that naturally arises when one doesn't know, an artist may determine to know anyway. The landscape before her is not held as a fantastic problem or a great mystery; instead, she knows what to do. She knows that if she lays down a wash like this and twists her brush like that, decent bushes will appear in the foreground. One sure way of binding anxiety is reflected in this knowing.

But the artist who is more interested in creating deeply than in ridding herself of anxiety will refuse to know too soon. She will remain with doubts, worries, questions, and the burning desire to realize herself. She will courageously refuse to bind anxiety by knowing too soon, refuse for the sake of her art and for the sake of truth and beauty to reduce her encounter with the landscape to a matter of familiar technique, and experience, beneath any surface calm, an internal war. All that not-knowing, all those doubts, all the sense data flooding her from without and within! This is the chaos of working, the necessary chaos that must not be avoided by too much knowing.

Of course it would be splendid if the above table accurately reflected the relationship between anxiety and the creative process. But the picture isn't at all that simple. Anxieties coexist. You are full of hungry-mind anxiety and feel the pressure to work at something. The blank canvas across the studio is waiting. You stand, you take a step, and out of the blue the specter of one day needing to sell that as-yet-unmade picture fills you with shy-mind anxiety. You stop. You struggle and somehow manage to dismiss that thought. Again you feel the pressure to work. You take a step toward the canvas: but what exactly will you paint? What choices will you make? The unpleasure of confusion courses through you. You stop, turn around. Where will you run, where will you hide? No! You stand your ground. You turn back to the canvas, again committed to the encounter. You take three steps; and the com-

mitment wanes. For no reason that you can name, you feel weak. Is this chronic art fatigue syndrome?

All of this takes place in the space of seven seconds. The chart has in no way alerted you to this possibility, that you may experience all the anxieties in the blink of an eye, one after another, one on top of another, one peeking out from behind another. All the while the artist prepares, the anxieties play like mice in the corner, within earshot. When she works, they run through her arms and scurry around her stomach. If they are very alive, if she is straining a lot, if she is wrestling with real not-knowing, the state she is in is a state of anguish.

Many writers before me have pointed out that creative blocks are actually stoppages caused by fear and anxiety and that creativity is a risky pursuit defined as much by its accompanying anguishes as by its joys and satisfactions. But sometimes a subject must be examined from a new perspective. I mean to encourage you to experience these anxieties, to face them, *even to welcome them.*

What an invitation! No wonder we hold back. No wonder so many artists-at-heart never travel far. No wonder so many artists work on the surface of things, only half thinking and half feeling. As Albert Camus explained in his essay "Create Dangerously":

> On the ridge where the great artist moves forward, every step is an adventure, an extreme risk. In that risk, however, and only there, lies the freedom of art. Like all freedom, it is a perpetual risk, an exhausting adventure, and this is why people avoid the risk today, as they avoid liberty with its exacting demands, in order to accept any kind of bondage and achieve at least comfort of soul. But if art is not an adventure, what is it and where is its justification?

I'll have fallen short of my goals if I help you do anything less than *create* as a result of encountering this book. I want you to write songs that destroy frontiers, not have insights about anxiety. I want you to write the novel of your dreams and not just recognize that you're constrained by fear. I want you to break free of stale imagery and make images that cause our eyes to burn, not just realize that freedom entails risk.

I know that today just as at any time in the past, every true poem or painting, every measure of true music is paid for with life, with suffering and blood.

HERMANN HESSE

STRUGGLE AND THE CREATIVE LIFE

It's very possible that your life in art—your successful *life in art—might be a struggle from start to finish.*

SALLY WARNER

If it adapts itself to what the majority of our society wants, art will be a meaningless recreation.

ALBERT CAMUS

Third, I want to make explicit the fact that every artist who dreams of creating sets himself up for a life of struggle. This follows logically from the last point. It may seem at first glance as if the relationship between anxiety and creativity is of interest only to the young artist, the budding artist, the blocked artist, or the frustrated artist (the so-called artist-manqué). For hasn't the mature artist mastered these matters? Isn't he somehow immune or exempt?

But of course the answer is that he is not. The productive artist with thirty years of creative work behind him still struggles with the anxiety that attends the creative process—especially if he still *is* creative. Furthermore, *every* artist is a young artist, a budding artist, a blocked artist, and a frustrated artist. Every artist is perplexed anew as he begins to work, every artist feels the specter of potential failure as he works, every artist negotiates this rocky terrain as a veritable babe in the woods.

And what if the veteran artist no longer appears anxious or even no longer experiences anxiety as he creates? Is this a blessing or a curse? I must ask you, the veteran artist, to examine that question for yourself. If you've settled into a style which no longer challenges you, if you can "phone in" your art, if years pass by productively but mechanically, I hope you will invite anxiety back into your life. Rejoin the anxious artists working at the edge! Dare to look over the precipice again.

Of course in their public utterances artists do not dare explain how risky the creative process is and how often they fail at what they attempt. They reasonably fear that to talk about such matters will brand them as weaklings, whiners, and failures, and will lessen the chances of selling their work. They rightly refrain from publicly proclaiming, "My new novel doesn't end well," "I was a nervous wreck every moment of making this movie," or "To play it safe, I'm still exploring a musical theme I exhausted several years ago." None of this can be said in public—nor usually in private, either.

So each artist comes to believe that the next artist, who perhaps looks assured and seems to be progressing nicely, is somehow a different creature from himself. But at bottom all good artists

are young artists and all good artists are frustrated artists. If you don't work at your art because you feel like a beginner or because the work frustrates you, I would ask you to stop using those facts as excuses. If you believe that celebrated artists are not beginners for whom each new creative project is a trial, now is the time to reconsider. You will remain a beginner and find the work hard until you die: you need no longer feel sad about that. So will every other artist: you no longer need envy them their supposed maturity or ease.

In this regard this is a book full of secrets and should be handled in private or only passed among artists. Perhaps it ought to come in a brown paper wrapper. Publicly, as a salesperson of your art, you will continue to act as if you had realized your intentions in your work. You will say that everyone who worked with you on the project was wonderful. That is part of the job of being an artist (or any other salesperson) in America. You have no permission to publicly air your doubts and concerns. If your product is not new and improved, why are you hawking it? Since everyone in our culture acts this way, so, too, must you and I.

But in private, including in the privacy of the artists' group I hope you will courageously form, I would like you to reflect on your life of struggle, on the truth behind the publicity, on the truth of your personality, circumstances, and culture. You need nor dream of being happy, except for precious moments: forget it. You need not dream of arriving somewhere you will not soon depart: forget that as well. The struggle is the thing, the struggle in the service of truth and beauty.

Objectivity means being in harmony with one's own subjectivity, not lying to others or to oneself.

EUGENE IONESCO

The greatest of all vices is superficiality.

ALBERT CAMUS

WORKING VERSUS WORKING DEEPLY

Fourth, I would like to make explicit the distinction between working at one's art and working deeply at one's art.

No doubt it appears to be the goal of every blocked poet, painter, or composer—the putative goal, that is—to work *at all,* to work at something, anything, to finally get some words on the page, to fill up some canvases. No doubt this appears also to be the goal of the artist-manqué, the person with the wish to create who never begins. But no artist wishes merely to work.

Tell truth, and shame the devil.

JONATHAN SWIFT

It is a confusion on several counts to argue that the act of writing, painting, or composing is its own reward. No theoretical physicist would argue that doing math is its own ultimate reward. However much he loves math, loves its elegance, logic, and beauty, loves to fiddle with equations, loves to take math puzzles with him on vacation, he would still be forced to admit that mathematics is a tool in the service of a higher goal: understanding the universe or some aspect of the universe.

So, too, with the artist's work. The process can have its own splendid rewards but the goal is to produce work that has meaning and makes meaning in the universe, that touches and transforms others, that speaks to others, that decorates or enriches the lives of others, that bears witness—that, to put it in the most old-fashioned way possible, is both beautiful and true. The concepts "beauty" and "truth," if dissected, vanish, leaving nothing but fodder for coffeehouse debates and seminars on aesthetics. But each of us knows that the special marriage of truth and beauty, where witness is borne and material crafted, is the very definition of deep work and high achievement.

The Russian novelist Aleksandr Solzhenitsyn explained in his 1972 Nobel Prize acceptance speech:

> Dostoevsky once enigmatically let drop the phrase: "Beauty will save the world." What does this mean? For a long time I thought it merely a phrase. Was such a thing possible? When in our bloodthirsty history did beauty ever save anyone from anything? Ennobled, elevated, yes; but whom has it saved?
>
> But I have since learned that works which draw on truth and present it to us in live and concentrated form grip us, compellingly involve us, and no one ever, not even ages hence, will come forth to refute them. And thus the old trinity of Truth, Goodness, and Beauty may not be simply the dressed-up, worn-out formula we thought it to be in our presumptuous, materialistic youth. What Dostoevsky wrote—"Beauty will save the world"—is not a slip of the tongue but a prophecy.

I am not making explicit the distinction between working and working deeply merely as a rhetorical matter. I want to help

you do your deepest work and not just any work. I want to help you move on from making images that bore and tire you or which have only commercial reasons for existence, I want to help you bring artistry even to the details, I want to help you bear witness in ways that are meaningful to you and meaningful to others.

If working is a struggle, working deeply is a greater struggle. What will you see down there? Will your whole afternoon be overturned? Will you run about like a madman chasing an idea just out of reach? Will you dare to face the facts you don't want known? Will you be forced to throw up your hands and cry, "That just can't be captured in paint!" Will you be forced to weep, "I am not equal to this task!" Can you drill as hard as you need to drill, in order to go as deep as you need to go?

Because this is so hard, because artists are so often unequal to this task, they are perpetually apologizing to themselves. They wake up, they can't face the work, anxiety courses through them, and they walk away, saying, "I'm very sorry, I just can't do it." Or they go through the motions, all the while feeling empty, listless, unimaginative, all the while saying to themselves, "I'm sorry, this is pointless." They fear as they work in drudgery that they are untalented and unimaginative.

The composers Gustav Holst and Ralph Vaughan Williams carried on a correspondence over the course of many years. Holst wrote to Williams in 1903:

> I really cannot feel concerned about your fears that all your invention is gone. You got into the same state of mind just before you wrote the Heroic Elegy. But though you have never lost your invention, it has not developed enough. Your best is an indescribable sort of feeling, but when you are not in that strain you either write "second class goods" or you have a devil of a bother to write anything at all. So, however much I like your best style, it must be broadened. And you are right about mental concentration—that is what you want, not more technique.

Mental concentration, an ability to confront oneself and reveal oneself, an ability not only to master one's disinclination to work but to defeat one's inclination to work shallowly, all of this and

We seek the essential, but we seek it in our personality and not in eternity.

JEAN METZINGER

What one makes music out of is the whole—the feeling, thinking, breathing, suffering human being.

GUSTAV MAHLER

xxiii

much more make for deep work. If you would like to do less, be prepared to bore yourself.

Each shade of a flower, a face, a tree, a fruit, a sea, a mountain, is noted eagerly by the intensity of the senses, to which is added, in a way of which I am not conscious, the strength or weakness of my soul.

MAX BECKMANN

PERSON, PROCESS, ACT, PRODUCT, AND WORLD

Consequently there are five puzzle pieces that you will need to hold on to simultaneously as we proceed. First, there is the person of the artist: your personality, your whole being. Second, there is the creative process, that invisible internal operation. Third, there is the creative act, that combination of mind, heart, and muscle that we witness when we see you cross the room, sit down, boot up the computer, fidget, and finally disappear into the trance of working. Fourth, there is the creative product, the growing, living thing that dictates to you even as you dictate to it. Fifth, there is the world you inhabit, this country, this time, this marketplace, this world of people, events, and things.

It would be nice if we could mark these five items as a simple feedback loop:

$$\longrightarrow \text{person} \longrightarrow \text{process} \longrightarrow \text{act} \longrightarrow \text{product} \longrightarrow \text{world} \longrightarrow$$

To put it in the sentence we wish we could construct: the person manifesting her creative powers acts creatively and produces a product that enters the world, which process informs the artist and allows her to grow. In one sense this progression represents something true. It is what allows us to start with wishing as our next chapter and end with showing as our last chapter. But it is also too small a way of holding the subject.

When you work on a given sculpture or poem, all five elements are present simultaneously. The pain of a childhood event which is remembered is present, but so is the pain of a childhood event which is forgotten. The hatred of a neighbor is present and the nuclear weapons stored down the road are present. Unpaid bills, old misanthropies, romantic yearnings are all present. The possibility of having an audience and the possibility of never having an audience are both present. The wish to confound that audi-

ence and the wish to seduce that audience are both present. So much is present that we want to shout "Stop!"

But how can we stop? How can we avoid the complexities of our own being, the complexities of our process, the complexities that the work demands? By not working? By drinking? By shooting up? By working walled off from ourselves, mechanically making lines on paper or telling the oboe what to play?

If we do that, we are on the run. We are on the run like the Japanese novelist Yukio Mishima, who grew up forced to dress as a girl and ran right up to the moment of his insane, exhibitionistic self-disemboweling suicide. We are on the run like van Gogh, who, raised in a frigid environment, ran until he put a revolver to his chest. We are on the run like Virginia Woolf, whose childhood experiences of molestation helped bring her to a final shore where she walked rather than ran into the river to obliterate herself.

We must know who we are and where we have been. What you create and what you fail to create are a result of all five acting at once. Your subject matter, the colors you choose, the scenes you set, the ideas you elaborate, the way you polish a stone, the characters you create result from this harrowing gestalt. Who can make this go away? Who dares do anything less than consider everything at once, a trick beyond the capabilities of even the greatest of future supercomputers?

It was quite amazing to hear my young students' pieces, each so true to its author. Some were very classical and very prim, others very modern and aggressive—absolutely the mirror image of their composers.

YEHUDI MENUHIN

The young artist of today need no longer say "I am a painter," or "a poet," or "a dancer." He is simply an "artist." All of life will be open to him.

ALLAN KAPROW

What's in a Name?

Whom am I addressing in this book? All artists and all would-be artists; and that includes the actor, the jazz pianist, the diva, the modern dancer, and everyone else in the performing arts.

A creative actor or musician is exactly as creative as a creative sculptor or playwright, and proceeds through exactly the same stages in order to manifest that creativity. The writer does his productive concentrating in private, the actor does his in large measure in public, but the quality of concentration is the same. The writer, bringing his whole being to the process, makes choices; so, too, does the actor, who has learned from method acting work or from his own realization that his talent "resides in the choices."

An excellent example of the shared identity among so-called

creative artists and so-called performing artists is in the theatrical process, where the playwright provides something vital—a text—and the actors provide something equally vital—their willingness, as Norman Mailer put it, to take a "deep spiritual gamble" and create characters out of their own being. For the play to live, the actors must possess this wish, they must make choices, they must work, they must sell the piece. In short, they must create.

Many plays—certainly mine—are like blank checks. The actors and directors put their own signatures on them.
THORNTON WILDER

This fact Mailer learned when he associated himself with the Actors Studio while adapting his novel *Deer Park* for the stage. He came to the Actors Studio in the hope, he later confessed, of figuring out some way to "bypass the actor." Actors were necessary, he understood, but perhaps only in the way newscasters were necessary. It was the lines that mattered, not who said them.

But he learned what every playwright learns, that a text not enlivened by actors who are willing to risk and create, who are not good at what they do and strong at what they do, remains a text and not a play. The playwright's private creativity and the actor's public creativity are both necessary if the work is to live. The composer's private creativity and the string quarter's public creativity are both necessary if the work is to live. Both Mozart and Horowitz are necessary.

It follows from this fact that it is vital for every performer who wants to do rich work to understand the stages of the creative process, to understand what it means to be creative. If you are an actor, dancer, or musician, do you suppose, for instance, that your success at auditions is contingent on technique alone? It is much more contingent on your wanting that job, on the *wish* you hold; on the choices you make as you interpret your audition piece, on the basic *choice* you make to risk, to be present, to relate; on your *starting* boldly and not hemming and hawing; on your *working* every second of the audition, from entrance to exit; on your *completing* the work and knowing when it is complete and that it is complete; and on *managing your anxiety throughout.*

The only distinction to be made between a performing artist and a creative artist is one that the performer makes herself in disparaging her creativity. That disparagement aside, there are no differences: they are simply artists in different disciplines in love with different things.

I would also like you to better recognize yourself when you

hear the word "artist." I would like you to *feel* a part of the group, club, fraternity, sorority, or shared universe that in fact you *are* a part of. This is a very great challenge.

Writers think of themselves as writers. Dancers think of themselves as dancers. Sculptors think of themselves as sculptors. Actors think of themselves as actors. A director who acts and writes plays will not simplify his introduction at a party by saying, "I am an artist." He will say, "I'm a director who acts and writes plays." If he simplifies his introduction, it will by choosing among his hats and calling himself a director, actor, or playwright.

Why? Because the word "artist" carries with it so much baggage. For most people it is much too hard a word to say. Built into it in a subtle, disturbing way is the implication that the speaker is special and good. It turns out to be simply too arrogant a thing to say. If you say, "I am an artist," you are just about saying, "I am a good artist," or even, "I am a great artist." Your natural sense of modesty, along with your desire to say things clearly and carefully, prevent you from using a word that carries with it so many associations. You are no doubt happy to be called great, but you refuse to pin that label on yourself as a matter of linguistic course.

For this is primarily a linguistic matter. If we say that a chef is a lawyer or a doctor, we take that to mean that the chef has two professions. If we say that a chef is an artist we do not take that to mean that he is also a painter, dancer, or writer. We take it to mean that he is good at what he does. If you say that a painter is an artist, you are in one sense being redundant and in another sense not being redundant at all.

But this linguistic problem translates into terrible real-world problems. This linguistic problem disempowers millions of American artists. It is incredible but true that part of the reason that artists fare so poorly in our culture is that writers don't break bread with violinists, that sculptors have nothing to do with documentary filmmakers. They do not attend the same conferences, they do not read the same magazines. Indeed, there probably has never been a real "artists' conference" in the history of the world. Nor is there a single magazine embracing all artists toiling in the various disciplines. Isn't that remarkable?

But all of these people *are* artists. "Being an artist" does not mean "having a certain profession." A choreographer has a vision

What is interesting is the artist, and what is interesting about the artist are his own convictions.

DAVID SMITH

of the whole dance, that vision lasting but a fraction of a second. A writer has a vision of the whole novel, that vision lasting but a fraction of a second. A painter has an intuitive grasp of the entirety of her next suite of paintings and goes out to buy twice as much cadmium red as cobalt blue with a feeling verging on certainty. These are the same people, brothers and sisters, but without a family name to embrace them.

Let me make the same point in a different way. If you are a novelist, when do you meet with painters, dancers, musicians, and filmmakers to talk about your mutual concerns? When do you meet to discuss selling art, managing depression, or surviving as a truthful witness in America? My estimate would be, never. This is really too bad. One of the agendas of this book is to provide some momentum for changing how you interact with other artists by providing you with ideas for group activities. Another is to remind you that you will surely suffocate if you live in a vacuum.

PRACTICAL WISDOM

As a practical matter I mean to offer you two things in this book, the first rhetorical, the second technical.

Simply by choosing my language and organizing my material, I hope to influence you. Rhetorical devices are powerful influencers. A writer need do no more than say "inner child" or "codependency" to start a bandwagon rolling. Now that "the cold war" has lost its rhetorical power, no one knows how to think about relationships among nations. "New world order" appears to have little rhetorical power. We don't know what it means unless it is explained to us, and metaphors that have to be explained die.

Marking the stages of the creative process is the central rhetorical device I mean to use. I want you to be able to locate yourself in the creative process, for every time you locate yourself you will be taking an active and not a passive stance toward your creative work. If this device seeps into your bones, you will feel at all times *somewhere* in the process, rather than nowhere.

I also mean to employ other rhetorical devices, ideas like "holding your work," "the most important split second in an artist's day," and so on. Each device is meant to package an idea in

Honest communication among artists is necessary, and it won't happen at openings.

SALLY WARNER

The soloist can emerge only after having participated in the group dance.

ARSHILE GORKY

a useful way. Taken together they amount to a vocabulary and a language.

But these rhetorical devices still need technical backup. Take, for example, the problem faced by the Buddha and by modern cognitive therapists. They, enlightened a little, say to their students or clients, "All suffering is a result of the mind clinging to its unfortunate thoughts." This is a powerful idea, a splendid rhetorical device, and the student or client nods gratefully. But still he or she has the temerity to ask, "And?"

"Well," the tired Buddha replies, "just stop it!"

"Yes," his student agrees. "But how?"

Just *saying* that "all suffering is mind clinging to thought" is part of the solution. But on the technical level, strategies must be offered: dharma talks, koans, disciplines, meditative practices, cognitive techniques like thought blocking or thought substitution, whatever the Buddha or the cognitive therapist can invent.

The primary technique I mean to offer is the following one. After an idea is presented, I'll sometimes ask you to act, think, and feel. Let's start here.

What you have to do now is work. There's no right way to start.

ANNA HELD AUDETTE

ACT

Stop reading. Do half an hour of creative work. We'll call this ability to quickly get up from the television, the sofa, or this book "switching gears." Cultivate this ability in yourself: the ability to move *immediately* from the passive to the active. Do your half hour of creative work *now*.

THINK

Did you actually stop and work? Or are you still reading? If you are still reading, why? Why don't you believe me? Why read this book if you don't believe me?

Did you know what to work on? Are you "holding" a piece of work in such a way that it is nearby, available to be worked on?

If you are a performer, how did you translate the phrase "creative work"? What did you get up and do?

Writing is a craft. You have to take your apprenticeship in it like in anything else.

KATHERINE ANNE PORTER

The idea is: "switching gears." Please add the phrase to your vocabulary. The goal is to be able to switch gears at a moment's notice.

FEEL

What did it feel like in your body to attempt to move? Did it feel as if your feet were screwed into the ground? As if you weighed a million tons? Was it a feeling like hopelessness, sadness, or depression? Did you want to cry out in frustration because you could not just get up and work? Then cry out.

Cry out in frustration. *Cry out.*

Whatever you feel, feel it. *Feel it.*

Sometimes I'll offer these instructions in the following way: that one person should *at all costs* do a thing *right now* and that another person should *under no circumstances* do that same thing right now.

Say that a novelist-to-be with the sort of personality and history that prevents her writing comes to the place of choosing a piece of writing to which she wants to commit. She has a vision, an idea. In her case, she must act: commit, start, write. Even if she has chosen incorrectly, she must act, for in an important sense she has no basis upon which to choose correctly. There is nothing for her to assess, nothing for her to appraise. She doesn't know her own process, potentialities, or capabilities well enough to say, "Should I *really* commit to this piece?"

Her job is to get from the beginning to the end of her work on this project, after which she will have a history of writing she can refer to when next she means to choose and commit. To put it simply, now she must risk writing her first bad novel.

But for the writer who has written several novels already and who is struck by a vision or an idea, the step that best follows may be one of active appraising and not active writing. I will ask that writer *not* to write but to *think*.

Is he again writing this book for himself, or will he this time write it for an audience? Is he again writing this book for an audi-

ence, or will he this time write it for himself? What has he learned from his previous writing experiences that ought to be brought to this book? What has he learned about his own journey, what personal myths has he exploded, what strength has he gained since the completion of his last book? Does he have a gut feeling that this new idea, however seductive, is not as rich as it ought to be? Does he feel dull and dutiful, rather than awake and fascinated?

To make this same point a little differently: the artist disinclined to work should work and should take the action step of the three steps offered. The artist inclined to work should not work and should instead take the appraisal step of the three steps offered. (Both should feel.) If this sounds as if I will always be asking you to do exactly what you do not want to do, I can only reply that there is some method to this madness.

STOP RUNNING

You may be able to do simple things on the run and do them well. You may be able to create on the run and create well, tossing off a drawing or a line of a poem that is richer than anything you labor over. But what you can't do on the run is understand the relationships between person, work, and world that this book explores. For that you must stop. It is imperative that you bring the same productive concentration to this exploration that you bring to your best creative efforts.

Your goals, after all, are nothing less than creating more richly and living better. There is much step-by-step work to be done.

The only solution for an artist is to change, not *his work, but* himself. *Then his artistic conscience will require of him another kind of work.*

JACQUES MARITAIN

I used to work in bursts of intuition. Now I find the very process of working step by step feeds my imagination.

ANNE TRUITT

HUSHING AND HOLDING

Nurturing the Wish to Create

*Y*ou are wishing to create. This wish is an exhortation, a command from deep within you. It cries out to be realized, it demands that you serve your own purposes. Maybe you call it by another name: desire, dream, passion, need, want, urge, itch, obsession. Maybe it exists only in a diluted form, but still you feel it. You may even fear it, but still you feel it. The wish to create.

I am certain that you possess it. But do you nurture and honor it? Not so many people do. It is altogether likely that this wish to craft your thoughts and feelings into art, a wish that is your birthright but that requires stubborn nurturance to survive intact, is dimmer and more distant now than when, as a child, you drew or sang. This dimming and distancing of the wish to create is as sad an experience as any we can name.

What caused the wish to grow dim? The fact that in most of

The artist's sense of freedom demands its rights, the right to develop, as great Nature herself develops.

PAUL KLEE

I

It is not wishing which causes illness but lack of wishing. Every genuine wish is a creative act.

ROLLO MAY

Art is a drive, a very complex desire and need, urgency and pleasure.

MARY FRANK

us more anxiety is generated *by* creating, or by contemplating creating, than is generated by *not* creating. In the working artist the scales are tipped in favor of creating, even though creating makes her anxious; in the blocked or would-be artist the scales are tipped in favor of not creating, even though she experiences that state as nerve-wracking in its own right. In each case the person is making a calculation, out of conscious awareness, about where *less* anxiety resides.

Like a Laurence Olivier who experiences severe stage fright but still acts, like a Maria Callas who experiences severe stage fright but still sings, it is our job to exclaim, "Both creating and not creating make me anxious, *and I choose the anxiety of creating.*" The task is to replace paralyzing anxieties with hungry-mind anxiety, with the anxiety of wanting *so badly to create* that the walls of Jericho will not stand up to our trumpeting. This is perhaps a strange idea, that our goal is not to grow calmer but to substitute one anxiety for another. But in fact every challenge in life is met exactly that way.

You choose to do something challenging not because you expect a worry-free experience, but because you want the experience so badly that you accept *beforehand* the new anxieties you are about to encounter. Typically you make this calculation out of conscious awareness, and indeed if the calculation enters awareness, the likelihood is great that you're leaning toward avoiding the challenge. If you say, "Yes, I'm unhappy not writing my novel, but writing it would be really difficult," you're heavily leaning toward not writing it or any novel.

Calculations in favor of accepting the anxiety of creating are made, in the lucky predisposed creator, out of conscious awareness. If you have to make that calculation consciously, you have a harder job of it than does the artist who knew at eight that she would paint or write. But that is *exactly* the job you have, hard as it is: to nurture the wish to create, to accept that you will be made anxious by creating, to affirm your own hungriness.

How will you do that? How will you become this hungry person, this person who must create at all costs? The answer is by *becoming that person:* that is, by transforming yourself into a person who manifests the qualities of a productive artist.

SUBLIMATION AND SELF-ACTUALIZATION

Thousands of writers have had something to say about this wish to create, about creativity and its sources. As a rule, each has settled on one or the other of two governing metaphors to explain it: creativity as sublimation or creativity as actualization.

As sublimation, art-making is seen as a substitute for living, a way of fulfilling one's secret, illicit wishes, an instinctual process that helps defuse dangerous impulses and helps channel drives in socially acceptable ways. As self-actualization, art-making is seen as the embodiment of one's noblest aspirations, one of the higher things that human beings are capable of doing, a perfectly natural and healthy thing, a spiritual or heroic journey. Hermann Hesse married these two ideas in the following way:

> All our art is merely compensation, a painstaking compensation far too dearly bought, for lost life, lost animality, lost love. And yet again this is not so. To regard spiritual life as a mere substitute for a deficient life of the senses is to overestimate the senses. The life of the senses is not worth a jot more than the life of the spirit, or conversely.

No doubt you too have your reasons, some positive, some negative, for wanting to create. You want glory. You can't help yourself. You have ideas. You love color. You have to pass the time somehow. Books feel like semi-sacred objects. You want fame. You have a destiny. Each story you write heals you. You don't want to be a doctor or a lawyer. There is a vast tradition behind you. You have your reasons.

It is in your blood. But how diluted a thing it is in the bloodstream of so many! How faint a trace, like the faintest trace of some radioactive material, some little glow that serves only as a constant reminder, irritant, or reproach but not as a real nutrient. This wish desperately needs nurturing. It needs nurturing in working artists and in the millions of souls who feel it but are not transformed by it into active creators. The first step in its nurturance is the following one: learning to quiet the mind, learning to "hush."

I have a strong need to paint; if I don't paint I cry and get bad headaches.

JUDY LEVY

HUSHING

The discipline of the writer is to learn to be still and listen to what his subject has to tell him.

RACHEL CARSON

Hushing is what we do when we go into a museum and sit in front of one painting for fifteen minutes. Hushing is what we do when we drink in a book or a movie. Hushing is what we do when we quiet our mind so as to catch the snatch of melody or lyric that is wanting to arrive. Hushing is a quieting and an opening.

There is no creative life without this ability to hush. If you hush only infrequently, if you hush when you encounter someone else's work but not in support of your own work, you must learn to hush more. This dreaminess, this trance state, this place of reverie is the bedrock upon which art is built. If your mind is full of noise, you must quiet it. If your mind is easily distracted, you must discipline it. If you cannot hush, you cannot create.

One client, a songwriter, likened her thought processes to the autoscan function of a radio tuner. Her mind inevitably raced on in an abrupt, jarring, unproductive way. Could she write the songs she wanted to write in so harsh a mental environment? Of course she could not. Our work together necessarily focused on nurturing her ability to hush.

To create you must quiet your mind. You need a quiet mind so that ideas will have the chance of connecting. You are hushing your mind so that you can use your mind. But much too often our mind is on autoscan, darting from one thought, usually a negative one, to another. On autoscan our mind operates something like this:

That letter she wrote to me . . . I thought she was my friend . . . The hell with it . . . I've got to move from this place! . . . If only I had some . . . Maybe I could ask . . . Damn it! . . . Was I supposed to be somewhere? . . . What? . . . I can't remember . . . I'm losing my mind . . . I used to be able to paint, in school . . . What happened? . . . I hated that stuff at the gallery. . . . How *did* he get that show? . . . Maybe . . . Where's the cat? . . . Was that something? . . . An idea . . . God, are my parents coming? . . . God! . . . I can't stand it . . . I'll kill myself before I put them up for a week. . . . Why can't they . . . They can stay at a motel. . . . Why *did* she write me that letter? . . . I'll never make it . . . The weeds . . .

Where in that cacophony is there room for creating? No-

where. That is a hopeless mental environment, one that must be transformed before ideas will come.

EXERCISE
HUSHING

The following exercise is the most important in the whole book. I mean it!

You must stop your mind from operating on autoscan. Maintaining an autoscan mind is no way to live and no way to think.

Find a quiet place. If there is no quiet place in your environment, that's your first task, to make a haven in which silence is available. Enter that quiet place affirmatively by whispering, "I am hushing." Continue saying "hush" or "s-s-s-sh." Gently hush your thoughts, just as if you were comforting a baby.

Work to grow quiet inside. Thoughts will come, but hush them away. Work to hush your thoughts until you have no thoughts, until you are just empty and breathing. This will take some time. Don't despair if you can't do it easily, quickly, or even at all. Just try. Hush and hush again.

When you're as quiet as you feel you can be, murmur to yourself, "Deeper." Hush and wait. Feel your breathing deepen, feel yourself descending. You will want to close your eyes. Go silently into the darkness.

You are entrancing yourself. What do you see? Ideas will come to you, melodies, lyrics, images. The very darkness will acquire a tone, the very silence a music.

Something that passes by in that hushed stillness may seem especially important. That is an idea with vivacity. Hush again and hold it. Give it a chance to grow more distinct. Hold it and nurture it until you can capture it. Then write it down, draw it, play it on the piano.

I have to lose my mind to be able to concentrate.

HANNAH WILKE

Instead of pursuing the idea you may have just received, repeat this exercise. Right now you are practicing hushing for its own sake. Feel secure that your vivacious idea is saved. Repeat this exercise and hush again. See where your mind now takes you. It

may be obsessed with the previous idea, wanting to explore it and create from it. Explore it then, but remain hushed!

Explore it in the quietest of all ways, in the silence of a working trance, with an absolutely hushed mind. If your idea is vivacious and your mind hushed, you will discover that you are not wishing to create, but creating.

Whether you've been creating for decades or are just now starting, this is an exercise to return to again and again. This is the most important single thing you can do to support your wish to create. *Hush your busy mind.* Go quiet. Depth will follow.

HOLDING

Out of this hushing will come ideas. Out of this wild, quiet state will come visions. Out of this trance come all the world's symphonies, songs, paintings. This is the state of productive concentration in which creative work happens.

But then the work must be "held." "Holding" is shorthand for the following idea: once you nurture your wish to create, once you hush and go into these periodic trances in which ideas gestate, you will begin to possess emergent ideas which, in order to grow in vivacity, must themselves be nurtured.

You "hold" precious both the feeling of working and these nascent ideas. Suddenly the world becomes a more interesting place. The outer world feeds your inner world and you're sent in one direction or another, to the library to look something up, to Bora Bora to learn about blue. Work is happening underneath, in this place of inner quiet (which is also a wild place), but work is not happening independently of you. You are *holding it:* giving it space, giving it a container, offering it life.

Please do the following exercise now. I fully expect that, even though you're immersed in reading this book and quite comfortable where you're sitting, and even though, as an independent person, you're leery of following anyone's advice, you'll nevertheless *exercise* as part of your experience of this book.

If you would rather not do the following exercise right this second, then do it when you're done with the chapter. I'll remind you again then. But I'd prefer that you do it now, because if you

Things are not difficult to make. What is difficult is putting ourselves in the state of mind to make them.

CONSTANTIN BRANCUSI

Everything which I have created as a poet has had its origin in a frame of mind and a situation in life. I never wrote because I had, as they say, found a good subject.

HENRIK IBSEN

do, you will not only be learning about holding but also reenforcing your ability to switch gears, a talent vital to the creative life.

ACT

Bake a potato. If you do not have a potato, you will have to buy one. Bake it carefully so that it will turn out delicious. (Prick it several times with a fork, oil it, wrap it in foil, and bake it in a hot oven for forty-five minutes.)

This will be a delicious potato upon which you can put salt, pepper, butter, sour cream, chives, anything you like. This will be a very special and very delicious potato. But there is a problem. Somehow you must deal with this hot potato without putting it down.

Carefully remove the potato from the oven. Put it on a plate. Remove the foil. Let the steam escape. Wait a few seconds. Prepare yourself. Now the exercise begins in earnest.

Hold the potato until it is cool enough to eat. But you can't just hold it in your hands. *Please realize that if you hold it for more than a microsecond, you will burn yourself.* Do not blame me if you burn yourself. I am giving you fair warning. If you grip it, you will burn yourself. Do not burn yourself! But do not put it down either! You can't put it down: if you put it down once, you must throw it away.

What will you do? How can you hold it without grasping it? Your only chance is to throw it up in the air, catch it, throw it up in the air again, give your hot fingers a chance to recover, catch it—don't let it drop!—throw it up again. You'll find yourself running across the room, chasing the hot potato, alert, frightened, alive, a bit of a madman or madwoman. You have no choice, because hot potatoes left to cool on the counter simply vanish.

Now try hushing as you deal with your hot potato. Quiet your mind. Think of your next book. Think about how you would play Othello. Think about the difference between a polished stone and a jagged stone. Hush, but keep on with your sacred task of managing your hot potato!

No one can help you. But the potato *is* cooling! No one can help you. But think of how splendid your potato will taste! Once it is cool enough, once you can handle it easily, eat your delicious potato.

When I sit in Paris in a café, surrounded by people, watching people pass by, I don't sit casually—I go over a certain sonata in my head and discover new things all the time.
ARTHUR RUBINSTEIN

The event of creation did not take place so many aeons ago, astronomically or biologically speaking. Creation is taking place every moment of our lives.

D. T. SUZUKI

THINK

Were you able to hold a hot thing and not drop it?
Could you hold it and also hush?
What helped you hold it? The thrill of the task? The desire to eat it?
Did it burn you? What happened?
Did you arrive at a principle for holding a hot potato?
The idea: *holding a hot thing coolly.*

FEEL

Were you made anxious? Where? In your stomach? In your mind? Where was the anxiety and what did it feel like?
Did the potato actually feel cooler according to what you thought? Did it almost feel pleasurable at times?
What helped you succeed at this exercise? Learn the answer! A creative project is a hot potato that must be handled coolly.

Holding is the equivalent of working. The wish to create, vital in its own right, is transformed into something visceral as you hold. It is replaced by ideas and you find yourself saying, "Yes, I must write this book" or "Where are my paints?"

Or, as you hold, you encounter something in the world—a snatch of conversation, the look of a person, a smell, a sound—which, because you are holding, rushes into the container you've formed. These snapshots have a place to go, a home, and when you begin on the movie or the poem, you have it and a thousand other snapshots ready and waiting to connect.

But only if you are holding. Otherwise that snatch of conversation is nothing, meaningless, a passing datum, a piece of nostalgia, something disturbing or interesting but without longevity. It is gone because it has no place to go. It is only if and when you are holding that ideas can gestate and grow.

But what is an "idea" in the sense that I mean it? Something!—but hard to express. For one of my novels, *The Blackbirds of Mulhouse,* the central idea had to do with the way the sins of a father could be visited on a son. Two "pictures" came to me: a young

man throwing himself from a cathedral tower and blackbirds on a manicured lawn in blinding sunlight.

I began only with sensations, hints, threads, a sense of time and place—but also with a strong unifying idea that, while impossible to articulate, nevertheless guided the process. Did the picture come first, the abstract idea, or something else? Did everything come at once? Who can say? I was simply holding.

Joan Didion described this holding with respect to two of her novels. About one she explained, "The way the Panama airport looked [at six that] morning remained superimposed on everything until the day I finished *A Book of Common Prayer*." About another she wrote, "I began *Play It As It Lays* just as I have begun each of my novels, with no notion of 'character' or 'plot' or even 'incident.' I had only two pictures in my mind: one of white space, and the second of a young woman with long hair and a short white dress walking through the casino at the Riviera in Las Vegas at one in the morning." From hushing and holding come such powerful images which demand to be pursued and whose vivacity will not leave you until you are completely done with them.

Certain images create private little excitements in the mind.
E. L. DOCTOROW

When I was painting the downstairs hall I thought of a novel to write. Really I just thought of a character; he more or less wandered into my mind, wearing a beard and a broad-brimmed leather hat.
ANNE TYLER

ACT

"Holding" is a metaphor which you must flesh out in order for it to have personal meaning. As a first step in fleshing it out, carry your work around with you for the next half hour.

If you're a sculptor, carry a rock. Just carry it, feel it, think about what it represents. Drift with it to the Rockies, to the first time you ever encountered basalt. Feel it, heft it, carry it, hold it.

If you're a composer, carry blank score paper. Or just carry a pen and paper for jotting down musical ideas. Get up and carry the pen and paper around with you, walk from room to room, take notice of the pencil, of its lightness, its heaviness. Honor it and hold it.

If you're a writer, carry your pad but as if it were a gift, not tucked away under your arm but in your outstretched hands. Carry it to the bathroom, to the window. Offer your pad a view out the window. Hold it.

You always have to be working on something because you have to trust your unconscious life, to be ready to deal with a play when it says, "Here I am."

JOHN GUARE

THINK

Is holding very difficult? Why?
How often do you hold? Most of the time? Little of the time?
Create a plan to do a more effective job of "holding."

Step 1 _____

Step 2 _____

Step 3 _____

The idea: *holding.*

FEEL

What do you feel as you carry your work around? Foolish? Uncomfortable? Embarrassed? Anxious? Or something else? Energized? Alive? Everything at once?

Sort out your thoughts and feelings as best you can, affirming those that encourage the process of holding. Please practice holding and practice encouraging yourself to hold.

STALLED AND STALLING

If you can't hold, you'll stall. Stalling is different from incubating or gestating work. Stalling is an anxiety state in which your wish to create has been defeated by your fear of creating. You go through the motions of life, repeating yourself and not progressing, feeling only half-alive or as if someone else were living your life. When you are stalled, you are a shadow of your real self, a pale imitation of your vital, creative self.

It is stalling in both senses of the word. You are stalled the way a car is stalled and you are stalling, tap dancing around the work, putting off any real reckoning. What do we usually call this? Being "blocked." But what is it? A failure to hush and hold caused by an overdose of anxiety.

Artists sincerely intend to dispute their own excuses for stalling, but the severity of the anxiety they are experiencing pre-

vents them from effectively unstalling. Think for a second of a phobia, which is a certain kind of severe anxiety reaction. The phobic person is not *happy* that dogs make him panic or that Paris is out of reach because he fears flying. He would *love* to change his mind and walk freely down the street or visit the Louvre, he would love to unstall and *move on,* but his anxiety, which is as real as a gun to his head or a boulder on his back, prevents him from even beginning.

Naming the reasons why you are presently not creating will not help you change, any more than naming the safety features of an airplane will help a phobic person fly. The solution isn't in naming the excuses but in doing what cognitive therapists call "desensitization through successive approximations." This translates as "growing less fearful by taking baby steps."

That which hinders your task is your task.
SANFORD MEISNER

EXERCISE
BABY STEPS

Get a pen and a piece of paper. Now, do not write your novel. Just write one sentence of it. That's all. The exercise is over.

Get a tube of paint. Do not paint a picture or think about painting a picture. Just squeeze a dab of paint out onto a piece of paper. Look at it, be with it. That's all. End of exercise.

Do not start your screenplay. Just picture one scene. Picture it for a few seconds, then let it go. That's all. End of exercise.

Do that now. Tomorrow, do the same thing. Make a little schedule: each day this week you will write one sentence, study a different color dab, imagine a different scene for a few brief seconds. That is all you will do. To do exactly that will count as real success and real progress toward hushing, holding, and unstalling.

This week hold the image of a stalled car. Let your mind go and picture it. Can you see it? Something is wrong with it. Who knows what! Is it the carburetor, the transmission, is it out of gas? We don't know. But it is heavy, dead, inert, and we are going nowhere.

I have one aim only: to impart a fraction of the meaning of the word now.

FRITZ PERLS

As soon as I get inside my front door I kick off my shoes and get rid of my watch and public clothing as if I'm tearing fire from my skin.

IRENE BORGER

You could put it in neutral and push it, and with real effort you could move it one foot after another. But how far home is! Would you ever get there? No . . . and how silly you'd look! Better just to stand by the side of the road, looking casual and indifferent.

There you are, standing by the side of the road. The car is stalled. You're stalled. We're all waiting.

But now picture the car on a gentle slope. Not thirty degrees or twenty degrees or even ten degrees but just five degrees, four degrees, three degrees. A very gentle incline. Now push the car with one hand. It will move. It's rolling, not very fast, not dangerously, just slowly rolling. Hop in! Steer; and between your steering and the gentle incline, you will roll right on home.

This week, hold these contrasting images: a stalled car and you stalled beside it, and a car slowly rolling down a gentle incline, with you inside carefully steering.

Gain momentum this week. Take baby steps. Feel yourself quietly nurturing your wish to create.

WILDNESS

You are learning to hush, hold, and unstall. You must also learn to be wild, to manifest the wildness of an artist.

This wildness has many faces. It is an amalgam of passion, vitality, rebelliousness, nonconformity, freedom from inhibitions. Think of this wildness as "working naked." Sue Lowe, biographer of Georgia O'Keeffe's husband, the photographer Alfred Stieglitz, recounted the following anecdote, told by Stieglitz's niece:

> A tribe of us four little squaws dared the ultimate hazardous mission into forbidden territory: scouting Georgia's Shanty. Peering through the window, we were dumbfounded to find her naked at her easel. Georgia's momentary shock turned to immediate rage. Shrieking—and still naked—she flew out, brandishing a paintbrush, to chase us away.

When friends came to call on Marc Chagall at his Paris studio, they had to wait for him to pull on a pair of pants. He painted

naked. When Victor Hugo grew distracted, he had his servant come and take away his clothes. Writing naked freed him, focused him, unblocked him.

This wildness is valuable beyond all measure. It is aliveness made manifest. A wild person with a calm mind can make anything. A hushed, wild person is a god, a marvelous actor, a marvelous cellist, a marvelous writer, a marvelous sculptor. Creators are hushed wild people.

A few years ago a painter (I'll call him Bob) came to see me with a certain complaint. Bob wasn't happy with the paintings he was making. He felt them to be well crafted but not expressive of his real vision. What that vision might be, however, remained an unknown.

He explained his method of painting. Usually he would bring a preformed image to the painting moment. The activity of painting was rather more the reproducing of that ready-made image than the encountering of a blank canvas. On a regular basis the finished product looked like what he'd had in mind and possessed technical merit, but struck him as conventional and dead.

Bob's father-in-law liked to joke that Bob was "too normal" to be a painter. Indeed, it was as if the wildness of twentieth-century art had never infected him. Something in his traditional midwestern upbringing had taken so strong a hold on him that his wildness, which could be felt, had not been able to enter the painting moment.

To put it in terms of our metaphor, as a painter he was too tame. This tameness translated into a concern for literalness, a penchant for "interesting ideas," a need for anatomical correctness in his figures. Passionate mistakes were not permitted. Somewhere along the line he'd turned correctness into a synonym for good-ness and defined good painting as painting like an Old Master.

Unleashing wildness became the issue in therapy. For homework I had him paint naked in the studio, look again at twentieth-century art (especially at the Expressionists), and pin up signs around the studio to remind him of the task at hand. These signs, co-created in session and posted in plain view on his studio walls, became his working mantras:

The creation of works of art is the creation of the world.
WASSILY KANDINSKY

Each work has to be done as intensely as possible.
PHILIP PEARLSTEIN

> Paintings, Not Pictures
> Surprise Yourself
> Feel, Don't Think
> Risks, Not Ideas
> Don't Be Afraid to Fail
> Break the Rules
> Ideas Are the Trap
> Don't Know
> Alive, Not Right
> No Fear, No Failure
> Don't Be Afraid to Fuck It Up
> Power & Passion
> Who Am I?
> Encounter
> Don't Give In, Never Give In
> One Surprise Is Worth a Thousand Ideas
> What Is a Mistake?
> Don't Be Right

When I become anxious and tense, a strong power results.
JUDY LEVY

Using these mantras and releasing his wildness, he began to paint a very different sort of painting. These new, wilder, richer paintings did not represent a final resting place for Bob, a final painting style or aesthetic, but rather breakthrough experiments in fearlessness. He had learned how to encounter a blank canvas willing to be wild.

What will help you work naked? What will help you risk embarrassment, risk mistakes, risk failure, risk foolishness, risk absolutely everything? Where will you start? Can you start by doing the dishes naked? Insofar as that feels hard, do it. Insofar as that feels easy, challenge yourself more. Can you talk on the phone naked? Prance around a private place outdoors naked? Get naked and write a letter to a network censor or a southern senator? Let literal nakedness operate in your life not as a metaphor but as a reality?

ACT

Take the following risk. The next time you take a baby step and write a single sentence, study a paint dab, or visualize a scene from your movie, do so naked. You can do it tomorrow, if you like; but better still, do it now.

THINK

Did you manage to get your clothes off? Why not?

If you did, did you think more about your nakedness or your work? More about your body or your work?

Did you feel freer or less free?

Did you encounter your work differently?

Did you arrive at new ideas?

The idea: *working naked*. The idea: *nurturing wildness*.

FEEL

How did working naked feel? Narcissistic? Silly? Illicit? Bad? Strange? Terrifying? Ecstatic? Were there sexual feelings? Did they go into the work? Where did they go? How did it feel to get dressed again? Reassuring? Inhibiting?

Repeat the process. Work naked again. And again.

I had to get over my fear of running through the world naked and learn to say, "Take me or leave me."
STEVEN SPIELBERG

NURTURING WILDNESS

How can you nurture this wildness? Let's look for a second at the research literature on creativity.

In one study that compared children from homes with strict parents versus children from homes with permissive parents, the children of permissive parents demonstrated more initiative and independence and greater spontaneity and originality. In other studies, researchers concluded that authoritarianism and a demand for conformity crucially limited creativity.

In a study of young art students, researchers concluded that their subjects disagreed with society's moral standards and did not

hold as goals monetary success or high social status. In a study of creative high school students, other researchers found that "creative high school students are more likely to be independent, expressive, asocial, consciously original, and have high aspirations for their future achievement, whereas academic achievers tend to be persevering and sociable."

Josephine Arasteh, in an exhaustive interpretive and annotated bibliography of the psychological literature on creativity called *Creativity in Human Development,* wrote:

> In terms of personality traits, creative children are characterized as being highly sensitive to their environment and at the same time independent and nonconforming in thought and behavior. Weisberg and Springer concluded that creative children significantly demonstrated a stronger self-image and a livelier sense of humor than did children of comparable age and IQ. Creative children have also been described as more "open-minded," responsive to stimuli, autonomous, honest in terms of living truthfully, and playful as related to spontaneity, joy, and humor than other children.

If we take all these studies together we arrive at a wish list for nurturing our own wildness.

1. *Be asocial by holding society and its norms at arm's length.* Let all of them gather over there. I don't care. I'm over here.

2. *Think about big questions.* What is the very most that can be done with blue? How can I do it?

3. *Have high aspirations for yourself.* I will tell the truth *and* have a best-seller.

4. *Accept your own idiosyncratic goals.* Today I will compose naked and get two or three songs written.

5. *Feel autonomous.* I am a creator. I am the god of my world.

6. *Do not conform. I* must decide what is ethical and right.

Within us we have a hope which always walks in front of our present narrow experience; it is the undying faith in the infinite in us.

RABINDRANATH TAGORE

Every one of you should consider yourself from this very moment a free man or woman, and even act as if you are free.

MOHANDAS GANDHI

7. *Be sensitive to human affairs.* What would it feel like to be a member of ruled by colonial police? What would it feel like to be a member of another race or religion?

8. *Be inquisitive.* Is the world shaken when you put a hole through a stone? Or is a new passage opened between two universes?

9. *Be honest.* I admit that I frankly hate my enemies. I admit it!

10. *Be intelligent.* Save me from theories! I know better.

11. *Be joyful.* Kids, let's sing! Who'll play the piano?

12. *Demand originality from yourself.* I can use more than a quarter of my brain without my brain exploding. I can find exactly the music for our time, exactly the imagery, exactly the story!

13. *Be spontaneous.* Here I am, taking off my clothes again!

14. *Rebel.* This is a bad war and I must stop it!

15. *Cultivate a strong self-image.* I am the greatest. I am terribly individual. I am very excellent. I can write books. I can sing songs. I am the greatest.

16. *Take risks.* I'll walk into a museum gift shop with my art pottery and get it consigned on the spot. I will!

17. *Be instinctive.* This is a bad silence. I'd better get out of here *right now.*

18. *Be passionate.* Stop it! Don't hurt that child.

19. *Be stubborn.* I'll paint or die!

20. *Be free.* I am my own person. Believe it!

We writers really are fabulous creatures.

JEAN COCTEAU

Memorize this list and then burn it. Never refer to it again. It must be inside you, not locked away in this book. What good is it here? Hold it as you would secret military instructions. Repeat them to yourself in the middle of the night: I am stubborn. I am passionate. I am smart. I am honest. Call these qualities by whatever names you like. They will make you wild.

THE FACES OF WILDNESS

Paint like a fiend when the idea possesses you.

ROBERT HENRI

Wildness is a virtue, a wonderful thing, an expanded capacity, an extra helping of passion. But any outsized capacity carries with it real dangers and terrors. A little anger made wild is rage. Prejudice made wild leads to book burnings and lynchings. A little idea wildly held is an obsession. A roaring flame can illuminate or incinerate: in a given person, wildness can look like any of the following.

Sheer Energy

You suddenly bolt up in the middle of the night to paint, write, compose. You jam all night. You tour three hundred days a year. You have the bravado to boast as Gioacchino Rossini boasted: "Give me a laundry list and I'll set it to music!"

When this energy is unleashed, it looks like van Gogh painting day and night for three hundred days straight or John Coltrane playing the saxophone. As the jazz writer Ira Gitler described it, "Coltrane's continuous flow of ideas without stopping was almost superhuman, and the amount of energy he was using could have powered a space ship."

Enough wild energy to power a space ship!

Tricksterly Qualities

The painter Paul Klee confessed in his autobiography:

> Two little boys, four or five years old (I myself was seven), were supposed to obey me in everything, because I was the strongest. One of them, Richard, was a gentle soul and easy to influence—it excited me to play on this weakness. I reproached him for his sinful way of life, told him that God (in whom I didn't believe) would punish him, and kept on until he burst into tears. Whereupon I relented and comforted him, telling him it wasn't true. Several times I allowed myself to be tempted by this experiment.

Look up the trickster figure in a book like Stith Thompson's *The Folktale* or Joseph Campbell's *The Masks of God.* Just see what this wild character is up to!

Drama and a Craving for Drama

Disputes and disturbances gone wild have the look of Norman Mailer stabbing his wife, Richard Pryor bursting into flames, Beethoven throwing plates at the head of his maid, or Madonna masturbating with her crucifix. Dramas! Dramas of love, dramas of passion, dramas of addiction, dramas of intrigue, dramas of rebellion.

George Sand wrote of her feelings toward her lover Alfred de Musset:

> You do not love me. You do not love me any more. I cannot blind myself to the truth. I hoped for you, waited for you, minute by minute, from eleven in the morning until midnight. What a day! Every ring of the bell made me leap to my feet. Thank God I have heart disease. If only I could die!

Dramas!

Rage

For me the emblem of this rage is the twisted trumpet brought into session by a client who had crushed it against a wall in a drunken rage two decades before. On that night he hit bottom and began twenty years of sobriety.

Enough rage to crush your instrument!

Might not such an artist need to get away from people for their own safety, because, like Stavrogin in Dostoyevsky's *The Possessed,* he feels himself "too wild" to associate with them? Won't he be pulled to island, desert, or mountain life and be the first one in line to buy his own island as soon as he can afford one? Won't he sometimes look like a mad, aggravated monk or like Diogenes?

Rebellion and the Need to Rebel

This wildness must sometimes manifest itself as no-saying, and even as wild, belligerent, excessive no-saying. An artist caught up in this excessive rebellion will refuse to listen to sound advice, refuse to act in her own best interests, refuse to paint on commission or act in commercials. Like Melville's Bartleby the

A painting is a thing which requires as much cunning, rascality and viciousness as the perpetration of a crime.

EDGAR DEGAS

If I still scream, it is to prevent the others from changing me.

ELIE WIESEL

Scrivener, she will simply "prefer not to." How honorable! How grandiose! In every rebellion is a grain of truth, but also the sting of consequences.

Obsessions and Compulsions

And won't a wild artist be wild *about* something? Won't he suddenly decide to cross the world in order to hear a certain song or see a certain color? Won't he obsess about the roles he really must play before he dies, about the weakness of the ending of his novel, about someday dancing with the only choreographer he respects? Might it not be in the obsessive-compulsive relationship with his art and his art career that he'll have to weather the wildest obsessive waves?

EXERCISE
YOUR WILD FACES

What are your wild faces? How does wildness manifest itself in your life? Draw your wild faces below and give each a name. (If you have more than four, use another sheet of paper.)

_____ _____ _____ _____

Consider the meaning of the faces you've drawn. Is the wildness alive in you? Is it constructively harnessed? Or does it more often manifest itself destructively? Hold your answer as we examine tameness, the partner of wildness.

TAMENESS

Tameness in its healthy aspect is a positive adaptation to the world such that the individual can function effectively. In its unhealthy aspect, tameness is an over-adaptation of the sort the psychologist Otto Rank considered characterized all nonartists. In his estimation, the nonartist, excessively fearful and closed-minded and so incapable of experiencing a "second birth" of self-willed aliveness, elevated tameness to the level of principle and policy.

Limits yield intensity.
STEPHEN NACHMANOVITCH

Floyd Matson explained in *The Broken Image:*

> Not many men are prepared to face the challenge of themselves, to assume the full responsibility for their own existence. Rank concluded that there were three levels or styles of response to this self-challenge: the first, and most common, was simply to evade it; the second was to make the effort of self-encounter, only to fall back in confusion and defeat [the person arrested in his creative development this way Rank called the "artist-manqué"]; the third, and much the least common, was that of carrying the confrontation through to self-acceptance and "new birth." These three attitudes or approaches correspond to Rank's three types of human character: the "average" or adapted man, content to swim adjustively and irresponsibly with the tide; the "neurotic" type, discontented alike with civilization and himself; and the "creative," the twice-born (as represented in the ideal types of Artist and Hero)—at peace with himself and at one with others.

We can think of tameness in its healthy aspect as any one of the following metaphors: as inner governance, inner husbandry, balance, moderation, or reality-testing. It is not tameness for its own sake or for conformity's sake but for the sake of the wildness: tameness is smart caring for the wildness.

To put it another way, tameness is *moderation for the sake of rebellion.* This is both a difficult idea and a difficult ideal. Camus explained in *The Rebel* that "moderation is not the opposite of rebellion" and that "moderation, born of rebellion, can only live by rebellion." For a person to live authentically, her wildness must be harnessed and managed by her tameness but her tameness must

also be confronted and disputed by her wildness. There is no rest here and no resting place; she is never "really tame." Nor is she ever only her passions, appetites, wishes, and desires made manifest, for in that direction lie self-indulgence, nihilism, and the world's ruin.

Healthy tameness is the equivalent of careful husbandry of the wildness. The psychotherapist Ian Brown argued that "the Husband has little honor in our culture. We all get excited about the Wild Man, and the Husband is unexciting and undramatic. But, for example, without the traditional husbandry of the farmer, I would starve." Unless an artist husbands his wildness, he, too, will starve. He will find himself at a blazing extremity, a half-step from madness and cruelly self-imposed isolation.

Wildness is the heat, tameness the thermostat. Wildness is the energy, tameness the valves that regulate. In the artist's real life, this translates into dynamic tension and dramas as he attempts to value both qualities. It is played out internally when a novelist debates whether to write wildly—to craft a novel that is all one sentence or to pillory church and community—or instead to carefully consider publishing industry requirements. Can he do both at once? *That is the question.* It is played out externally when he debates whether to accept or reject an editorial change that smacks of censorship. Can he do both at once and meet his editor's need for safety while not agreeing to censorship? *That is the question.* To say that healthy tameness and healthy wildness are both valuable means that, in real-life situations, the artist attempts to operate as effectively as is humanly possible, neither playing dead nor combusting.

The straight mind is ultimately the best because it's the long-distance runner of them all. With the others, the road is too dangerous. It can burn you out and kill your talent.

JONI MITCHELL

There is only one difference between a madman and me. I am not mad.

SALVADOR DALÍ

EXERCISE
HEALTHY TAMENESS

Select the word from the following list that best captures your idea of healthy tameness.

balance	care
husbandry	reality-testing

responsibility coolness
discipline governance
centering moderation

How do you affirm and support this quality in your life? What *actions* support it? Can you list a few such actions? What will help you be a more effective manager of the wildness?

Some people feel guilty about their anxieties and regard them as a defeat of faith; but they are afflictions, not sins.

C. S. LEWIS

APPETITE SUPPRESSION

We could call tameness in its unhealthy aspect conformity, over-adaptation, deadness, or even victorious anxiety. But let's think of it instead as "appetite suppression." If you have wildness in you but the tameness is too great, then the hunger to create (and the hungry-mind anxiety that naturally accompanies that hunger) is suppressed.

But the hunger doesn't disappear: it's rather that your appetite is ruined. You suspect that you're starving but still you can't eat. Why? Because eating feels more difficult than starving; which is just another way of saying that the anxiety associated with creating is greater than the anxiety associated with not-creating. Doesn't anorexia make sense in this light? The anxiety around eating is greater than the anxiety around starvation. Don't we stubbornly starve ourselves when we could eat by simply picking up a pen or a brush?

To love ourselves we must grow avid. We need both to feel hungry *and* to eat. If we experience hunger but find eating too dangerous, we can't create. Instead we find ways of further ruining our appetite. We read the newspaper from cover to cover. We watch hour after hour of television. We send out a poem and make of the rejection letter that arrives by return mail a powerful appetite suppressor.

Depression, boredom, fatigue, headaches: aren't these some of the consequences of unhealthy tameness? Sadness, sourness, stomachaches: aren't these some of the consequences of unhealthy

tameness? Isn't it time to regain your appetite and feel really hungry?

EXERCISE
AFFIRMING YOUR APPETITE

Be hungry. Take your hungry mind out for a feast. Go everywhere! Ravage the bookstore. Look at everything. Pace up and down the aisles of an art supply store. Devour the museum. Look at people. Be hungry! Look at a flower. Feed on it! Feel free to be hungry. Walk, stride, be hungry!

Affirm that you have great appetites and that that is splendid. Put down this book, *go out,* and feast while affirming your real hunger.

HUNGRY-MIND ANXIETY
AND APPROPRIATE FEEDING

When your appetite is not suppressed, when you hold a fervent wish to create and a readiness to create, then hungry-mind anxiety is activated. A lot suddenly interests you! There are ideas to grapple with in every book on every shelf. Every vista has something arresting about it. Every musical fragment starts worlds spinning. So much is activated!

Creators are hungry in body and hungry in mind. Look inside them and you see them obsessing. You see the insides of an addict. Sex addict, food addict, work addict, drug addict: always hungry. To be alive is to be hungry. "Alive," "hungry," and "anxious" are the same words.

Hungry for what exactly? Just hungry! Famished. Hungry to understand. Egoistic. Grandiose. "Curious" hardly captures this hunger. Ravenous—to understand the universe. Anxious to make worlds out of words, pictures, sounds, *ideas.*

Think about what this hungry-mind anxiety really means.

You're out walking and you see a shadow in a doorway. Something occurs to you: not in so many words, but as a vibration, a vision, a something. Because you're hushed, because you're holding, because you're wild, because you have this anxiety to see the world and to solve its riddles, something happens. It is nothing but a shadow in a doorway, but you have a violent experience. At the same time, nothing is there. Just a shadow in the doorway.

I want to seize fate by the throat!

LUDWIG VAN BEETHOVEN

Now, from that experience, from that shadow seen for a split second, you have a book to write. A mystery: the plot comes to you. Or a nonfiction book about the realities of homelessness: you see that doorway as the cover photo. Or a poem about night spaces. Or a movie about black and white, about shadows. Or a virtually all-black charcoal drawing. Or a painting of sullen eyes. Or a song like a Gregorian chant, filled with bass voices, cavernous halls, ecstasies, horrors.

It has all come to you just like that. But it remains a vibration only, a fleeting vision, a who-knows-what. What exactly is the idea? Something, something, but what?

What just happened? Where should you go with it? *Should* you go with it? This is hungry-mind anxiety. This is the painter Willem de Kooning explaining, "If I'm confronted with a small Mesopotamian figure, I get into a state of anxiety. I know there is a terrific idea there somewhere, but whenever I want to get into it, I get a feeling of apathy and want to lie down and go to sleep."

This is the wish confronted by the work, the wish uncertain if it has been confronted by the right work. Should this shadow in the doorway consume you? Yes? No? Why? Why not?

You have the desire, the wish, the wildness, the will. But still you end up on the sofa, depressed and inert. What were you supposed to do with that shadow? And how dare you let it get away! In pain on the sofa, confused, failing yourself, you feel the vision evaporate, the moment pass. Gone! What *was* it about that shadow, that doorway? Who knows? Who cares? Where is the bottle?

Too many people end their art careers here, before they've begun them, because they mistake this moment for a tragic one. This is no tragedy, this is hungry-mind anxiety! This is what must be tolerated if you are to be alive: data taken in, deep connections

made out of conscious awareness, projects begun in a split second and abandoned in the next split second. This is pain, but not tragedy. This is hungry-mind anxiety.

The productive artist lives with this. She knows that something wonderful and terrible is going on, something *difficult,* something important and uncontrollable. She also knows that this will happen again and again, and that she is *lucky* if this happens again and again, for it means that she is oriented correctly toward her own wish to create, that she is a creator at the ready.

Just being in a room with myself is almost more stimulation than I can bear.

KATE BRAVERMAN

An active, creative, hungry mind needs feeding. It insists on it. If it shuts itself down, if it suppresses its own fascinations and curiosities, if the wildness is stifled, if it says to itself, "Be tame, damn it!" it is killing itself and knows it.

I hardly mean that if a hungry mind is appropriately fed, hungry-mind anxiety will dissipate. This point needs repeating. If you are alive and creative, you must live with hungry-mind anxiety forever. On the other hand, if you feed your hungry mind appropriately, you will acquire resources with which to better tolerate it each time it arises.

Here are the ways to appropriately feed a hungry mind.

Follow your Work

When you are working, the work will make its demands. The painting won't allow itself to be completed until you spend a day by the sea, looking anew at foam. The song won't allow itself to be completed until you spend an afternoon in a church, listening for echoes. The novel won't allow itself to be completed until you spend a morning in the library, studying Gothic arches. The best feeding of a hungry mind is to feed the living, growing work in whatever way it requires.

Look at Snapshots

Research by reading a single paragraph, not whole books on a subject. Discover Ireland by looking at a single picture, not by spending three weeks there. Encounter a single Egon Schiele drawing to learn about erotic lines. Take a snapshot of anything alive—a glance, a sound, a texture—and devour that snapshot. Discover the blanks and fill them in yourself.

Plant Seeds

Drop yourself little tidbits. White whale. Running fence. Angels in America. Feed yourself juicy morsels of ideas that can't be realized yet but that have a right to life: the idea of joy around which you'll compose a symphony one day, the idea of pain around which you'll construct a novel one day, the tiny pearl of an idea, born of irritation, that will grow into something large and lustrous.

Act for yourself. Face the truth.

KATHERINE MANSFIELD

Think By Feeling

Antonio Damasio, in *Descartes' Error,* puts forward the argument that an absence of feeling breaks down rationality. To feel, he asserts, is to possess a vital link to body states and consciousness. Isn't what we do as creators as much about feeling as thinking, and isn't what enlivens dead thought the pulsating feelings behind them? Feed your hungry mind by feeling, by crying out in pain, by rocking with laughter.

Eat With Two Hands

Do you mean to learn daintily what red can do? No! Spread red around with two hands, live with it night and day, paint your ceiling red, paint your body red, see red everywhere, learn its every association, its every meaning. Dream red. Be red. Feed your hungry mind a lava flow of red, a torrential sunset of red, a bloodbath of red. Learn deeply.

Find a Few Masters

Not everyone has something to teach you. But some few do. Who has impressed you? Return there for an afternoon. Who plays an instrument beautifully? Listen. Who has sculpted like a god? Learn. Whose mind sends chills down your spine? Read. Whose films enthrall you? Rent a video. Return to an old haunt. Dance with a master.

Hold Prior Works

What can feed your hungry mind? Your own poems, sculptures, songs, stories. Each one remains an offering. Reread one of your

published stories. What a feast! Hold a slide show of your paintings. Isn't that interesting? Look at the imagery: the caves, the ghosts, the upside-down women, the almost-all-yellow painting, the sea-green-chaotic painting. Isn't that interesting? What was going on then? What is going on now? How interesting! Prior works are offerings with plenty left in them upon which to feed.

Serve sometimes

How can you feed your hungry mind? By feeding others. Learn by giving, learn by teaching. Cook up a choice banquet of ideas and take it on the lecture circuit. They will feast and you will feast. Show a child how to pot. Lend your mind in support of a cause.

Hush

Surrender. Be quiet. Feed your hungry mind only silence. Hush. Quieting your mind is the same as feeding it. Hush. When you grow quiet, when you drift into the trance of working, your hungry mind's hunger vanishes: it is being fed from who-knows-where exactly what it had hoped to feast on.

There is a last way to feed a hungry mind appropriately, one vital enough that it demands its own discussion. That last way is thinking.

THOUGHT FOR FOOD

If you happen to enjoy thinking, if anxiety hasn't curtailed your ability to think (and remember that anxiety can make a smart person stupid), then you're more likely to create and create well. Few people, including intelligent people, spend much time or energy thinking, but strong, productive artists are among the few who do.

An interview with a fine filmmaker will likely reveal that he has seen a thousand movies and has *thought* about how camera angles, pacing, and cutting create effects. He will have analyzed scenes from his favorite movies from childhood to see why exactly they had such an impact on him, and he will be able to talk articulately about his discoveries. He won't know everything about film,

I remember my first ecstatic experience, working all day on a sculpture.

LENORE TAWNEY

Keep quiet. Do your work in the world, but inwardly keep quiet. Then all will come to you.

NISARAGADA HA MAHARAJ

but he will know a lot more than you do, unless you also have done that thinking.

An interview with a fine painter will likely reveal that she has studied some other fine painters intensely, that even if she eschews certain painterly effects she knows them inside out (she can do sunsets and stormy skies, only she cares not to), and that she has thought deeply about color and especially about the colors that move her. She is not guaranteed a fine painting the next time she paints, but because she thinks about art she will paint passionately and smartly.

I hope that you, too, will think more. In the language of this book, I hope that you will hush and hold more. I hope you'll think not just about the piece of work you're creating or mean to create, but also about what language, sound, or color can do, what an image is, what a song is, what the chemistry, biology, and physics of your art are.

How do you do this? How do you "imaginatively analyze" your art discipline? An intriguing question is always a good starting point. If you're a novelist, wouldn't it be interesting to know, say, how many ways a writer can make use of a mute character? You think about this question and at first you draw a complete blank. Your mind reels. But as the anxiety subsides and you enter a thinking trance, you begin to get glimmers of an answer.

You stick with your dreamy thinking and remember scenes from novels. You remember Billy Budd lashing out at Claggart because he can't find the words to defend himself. You remember the character in Camus's short story "The Renegade," who rebels although his tongue has been cut out. You remember mute characters and silenced characters from a hundred stories, novels, and movies. Suddenly you realize that you have a fascinating subject on your hands, one that could seriously enrich your understanding of fiction.

You begin to calculate—that is, you begin to count, categorize, compare and contrast, using all of the devices of rhetoric and logical thinking. You discover that you can imperfectly but quite interestingly come up with six or eight categories. You spend time with this, you do a little bit of research, you craft your ideas a little. And in your next novel, you present us with an astounding mute character.

Imagination is more important than knowledge.

ALBERT EINSTEIN

The evil life is really the thoughtless *life.*

<div style="text-align: right">DHAMMAPADA</div>

Beauty is not "out there" in things to be perceived by the appreciative viewer; it is a creation of thought.

GARY WITHERSPOON

If it is true that artists will find the best answers to their artistic questions *as they work,* why then should they bother to analyze imaginatively beforehand? Why bother to think so systematically? Why not just wait to arrive at an answer in the trance of working? The answer is that imaginative analysis doesn't serve the purpose of answering a specific question, which answer is indeed found in the trance of working. Rather it helps you deepen your understanding of your discipline, start better, make richer initial choices, and nurture your wish to create.

Think of a painter. He selects a certain blue from his palette while in the trance of working. But why is that blue on his palette in the first place? Why is there perhaps nothing but blue on his palette? How do we explain the passionate involvement of a Chaim Soutine with cadmium red, an Yves Klein with blue and gold, or a Robert Motherwell with black? The answer is that the painter has been thinking, not systematically, not analytically, not in a so-to-speak left-brain way, but in the dreamy reverie that I am suggesting you engage in more often.

In that reverie he has been valuing his colors, raising some, lowering others. He engages in this thinking reverie out of a love for his medium, and by engaging in it he nurtures the creative process. He may not possess an idea yet of what he will paint, indeed he may never possess that idea until it emerges directly in front of him as he paints, but he already knows that cadmium red or cobalt blue will support that idea. Isn't what we call "intuition" the fruit of such reveries?

EXERCISE
IMAGINATIVELY ANALYZING

What question related to your art discipline would you like to analyze? Have you a burning question available, a question like one of the following?

- How many kinds of sculpture are there?

- Does the sound of a single instrument touch the soul differently than the sound of two instruments? What about three instruments?

- What is dialogue in a novel? How many kinds of dialogue are there?

Problems to an artist are life.
AL HELD

Dream up a provocative question that you can profitably analyze. Spend the next few minutes hushing and holding the following affirmation: "I am really curious." Go right to the heart of what you love.

How many ways can a landscape be rendered? How many existential themes are there in literature? What *is* a film? What *is* a documentary? What *would* a novel for the new millennium look like?

Write the large, provocative question that emerges from your hushing and holding here:

Today or tomorrow, think about this question. Dream about it. Write down your thoughts. If you're provoked to do a little research, do the research. Remember that you're not looking for complete answers, a dissertation topic, or an experience in dissection. You're simply nurturing your wish to create and increasing your understanding of your art discipline *by thinking*.

Think. Feed your hungry mind from your own stored-up wisdom. Haven't you seen a lot already? Haven't you much raw material? Don't you remember that grass can cut, that the sun can burn, that certain men and certain women always end up together? Look to your own stored memories. Look to the faraway ones, look to the recent ones. Look to the ones that feel as if they go back a thousand years. Look to the ones that pass in an instant and seem ungraspable. There is no such thing as a perpetual motion machine, but the brain comes closest: your own mind will richly feed itself forever, if you'll let it.

Plan for the appropriate feeding of your hungry mind by cre-

ating metaphoric dishes to serve yourself. What would make for a mind-enriching meal? Work to make sense of this metaphor. Strong black coffee, for instance, might equal a bracing, eye-opening idea, a hot, strong idea. An herb tea might remind you that your materials possess smells you love. A cellared red wine might remind you of well-made ideas from long ago worth considering anew, ideas like the Platonic dialogue, vegetable and mineral dyes, music for a single reed flute, haiku.

One of the highest delights of the human mind is to perceive the order of nature and to measure its own participation in the scheme of things.

LE CORBUSIER

EXERCISE
MEAL PLANNING

Create a menu of mind-satisfying dishes to serve yourself. Feed your hungry mind and keep feeding it. Feel the work grow within you.

Menu

Choice of appetizers

Appetizer _____

Appetizer _____

Appetizer _____

Choice of entrées

Entrée _____

Entrée _____

Entrée _____

Choice of desserts

Dessert _____

Dessert _____

Dessert _____

Choice of beverages

Beverage _____

Beverage _____

Beverage _____

INAPPROPRIATE FEEDING OF A HUNGRY MIND

It is your choice whether you will feed your hungry mind in appropriate or inappropriate ways. Appropriate feeding supports your wish to create. Inappropriate feeding satiates but does not nourish; it seduces the mind into thinking it has eaten but leaves it hungry. The choice is yours.

Here are ways of inappropriately feeding a hungry mind.

Give me a fruitful error any-time, full of seeds, bursting with its own corrections.

VILFREDO PARETO

Gorge On Facts

Know the best stereo equipment to buy, the speed of your computer and the speed of all other computers, the number of references to homosexuals in the Bible, the number of Sufis it takes to fully describe an elephant.

Feed On Sweets Only

Only watch shows with laugh tracks, only read comfortable articles in comfortable magazines, only read light fiction, only read decorator catalogues, only attend musical comedies.

Have Intellectual Conversations

Argue about whether realistic painting is less or more vital than abstract painting, argue about atonality, argue about form versus function, hear without listening and talk without caring.

Do Not Hold

Let all your ideas go by, however vivid they are, however important. Do not hold them, do not build on them, let everything go by with great insouciant indifference. What's an idea, anyway? Tennis, anyone?

Think and Chew Gum

Always do two things at once. Never allow yourself to enter into the trance of working. Always distract yourself. If you feel creative, quickly think of something else important and exciting to do, like a little more research.

Join a Movement

Swallow dogma whole. Call yourself a Jungian or a Freudian. Call yourself a psychic or a realist. Do not doubt and deconstruct. Have illusion be your mind-set of choice.

Lie to Yourself

Finished persons are very common—people who are closed up, quite satisfied that there is little or nothing more to learn.
ROBERT HENRI

Tell yourself a book is interesting when you know it isn't. Make sure you read all such books to the end. Tell yourself that a leader is honest, even when you see that glint in his eyes. Follow all such leaders. Tell yourself that you're about to get to work, even though you know you're lying.

Attend a Workshop

Presume that what you need to eat is prepackaged and about to be served for $295 for the weekend. Eat dry things like dull classes. Eat enough of them and earn an advanced degree.

Feed On Drama and Sense Data

Go to bars. Women! Men! Electricity! Alcohol! Noise! Yes! Go to bars every day and every night. Be Don Juan. Be Don Juanette. Party. Use. Call that "gathering life experiences." Call that "intellectual stimulation." Vomit, sleep it off, do it again!

Never Use the Resources of Your Own Mind

Never feed yourself from your own limitless supply of nourishing inner stores.

TAMENESS AND WILDNESS IN CONFLICT AND IN BALANCE

Wildness is vital but it must be tempered by tameness. Nonconformity is vital, but so is adaptation. Rebelliousness is vital, but who wants to be in opposition all the time? Self-centeredness is vital, but modesty and empathy are also called for. Indeed, isn't mental health a delicate balance between tameness and wildness?

Isn't personality integration the ability to monitor and control these polar states?

Consider the following example. A seventeen-year-old high school girl entered therapy with me, as many young clients do, at her parents' insistence. In her case it was her mother who expressed concern about her daughter's drug and alcohol use and her slide onto academic probation.

She was undeniably creative and had been singled out by her art teacher as his finest student, but in her other high school classes she experienced great restlessness and found it next to impossible to concentrate on the lectures. At home she experienced great restlessness and found it next to impossible to concentrate on her homework. She loved to read and loved to do her artwork, but everything else about school felt enormously burdensome.

Outside of school she engaged in wild, exhibitionistic escapades that became the talk of the school. She flaunted conventions, dressed provocatively, and remained aloof and separate from the school cliques.

Asked in session to draw herself, she divided the page into four parts and drew "the lesbian," "the mother," "the having-affairs-all-over-the-world me," and "the real me?"—the last consisting of two images, one a modest girl with books under her arm, the other a steamy seductress.

Her father, a well-known artist and heroin addict, offered her a lifetime of the following advice: "Be wild." Her mother, separated from her father, insisted: "Don't be wild." Tameness bored her but wildness worried her. She understood the rightness of both her mother's and father's injunctions, and also the wrongness of each.

She understood that her wildness was channeling itself into disturbing byways. She had undeniable drug and alcohol cravings. She entered into obsessional relationships: with an older bisexual alcoholic, several alcoholic schoolmates, a bisexual cellist. She binged on junk food and purged. She had a "thing" for motorcycles and the men who went with them.

At the same time there was a forthrightness, soundness, and sensibleness about her that suggested that she might still find ways of remaining true to her wildness while avoiding its most self-destructive transformations. But how to do that? How to deal with her own personality, all the inner injunctions, all the energy,

I got caught in a terrifying trap that to be creative I had to be on some substance. In the end there was no creativity at all coming from me, because I was too busy taking the shit.

RINGO STARR

her busy mind on autoscan and rarely quiet, her self-doubts and brazenness? How, as a complicated, formed person, was she to be both wild and tame?

School was too inhibiting and too difficult to manage and eventually she dropped out, but not without committing to getting her general equivalency diploma. As a wild person, she had to run. As a tame person, she made a deal, and indeed got her GED shortly after dropping out.

She began to work hard at not losing herself in relationships and practiced abstinence for months at a time. As a wild person, she still stopped to listen to the roar of a motorcycle. As a tame person, she thought twice about what value, if any, that roar had for her.

She stopped smoking marijuana with her father and put new limits on the contact between them. The wild person in her was sexually connected to him. The tame person said, "No! This is not right!"

When therapy ended she was applying to college, where she hoped to major in psychology and art. Even her choice of majors represented her ongoing effort to balance her passion and her need to self-regulate, an effort that is incumbent on each of us to make.

Sanity is madness put to good uses.
GEORGE SANTAYANA

EXERCISE
TAMENESS AND WILDNESS TOGETHER

In order to hold wildness and tameness in balance, in order to support constructive wildness and constructive tameness and eliminate destructive wildness and destructive tameness, you need to be able to recognize them in your life.

Which of your wild faces are constructive and which destructive? Which of your tame faces are constructive and which destructive?

Define for yourself the following terms and add them to the vocabulary we are building:

1. Constructive wildness

2. Destructive wildness

3. Constructive tameness

4. Destructive tameness

5. Wildness and tameness in dynamic balance

What are you? What am I? Those are the questions that constantly persecute and torment me and perhaps also play some part in my art.

MAX BECKMANN

GROUP WORK

Throughout this chapter you've been offered work to do. The goal of these exercises has been to prime you to pursue your own major creative project. As I said earlier, I want you to write your first book or your next book, sculpt your first monumental sculpture or your next monumental sculpture, compose your first concerto or

your next concerto *in the course of engaging this workbook,* not at some point in the future. I want you to do that creative work while you read this book: that is, right now. But there is also a secondary goal: that you live a healthier life. To balance wildness and tameness and to nurture your wish to create are the sorts of things that support your ability to create but that also heal your heart.

So far, the exercises have involved solitary tasks. But to live a healthier life, you may find it very valuable to reach out and exercise with other artists. To do this you will have to make a significant effort: the effort of finding other artists and interacting with them. Think for a minute about whether the effort seems worth it. I hope that as you hush and hold this idea of mutual support you conclude that a group effort would indeed be worthwhile.

If so, you will have to gather together a group of artists. No one will do this work for you. To do this, you will have to make phone calls, put an ad in your alternative newspaper, leave messages on answering machines, respond to messages on your answering machine, work to find a mutually acceptable meeting time, and all the rest. But finally a group *will* form.

Make it as diverse a group as you can. Have various disciplines represented, artists of various ages, women and men, assertive artists and shy artists, Buddhists and Presbyterians. Give the group the following instruction: "Write for half an hour on the question, 'How can I best nurture my wish to create?'"

Each person writes. There is silence. Each person then reads his or her piece aloud. There is no cross talk and no discussion. This exercise is about speaking and listening, not about commenting, converting, helping, or commiserating. Each artist speaks and then listens. When everyone has spoken, thank the group for its effort. Do any other work the group would like to do. Then repair to a potluck dinner.

AFFIRMING THE WISH TO CREATE

We would have more fine artists if it were easier to be a fine artist. But creating beautiful and true work isn't easy. It requires that you embrace the anxiety of creating, grow quieter than a person normally finds tolerable, hold your creative work through all the

Gauguin says that when sailors have to move a heavy load or raise an anchor, they all sing together to keep them up and give them vim. That is just what artists lack.

VINCENT VAN GOGH

rigors of the day, manifest real wildness while taming that wildness enough so that you can function in the world, and think harder than a person is wont to think.

This is a lot but it is exactly what is required of you. Affirm the wish to create by saying, "I will do important, hard work." Affirm this wish to create by speaking it out loud. Can you say it?

"I'm going to do very good work."

"I'm going to work my rear off."

"I will create, no matter what!"

Affirming *out loud* the wish to create is part of the movement from muteness to speaking that is another name for creating. You have a voice and this is your time on earth, your chance to speak. Will you speak? If you mean to, then the next thing you need to do is choose the very best project to work on.

P.S. I said I'd remind you at the end of this chapter to handle that hot potato. Remember? If you haven't done it yet, then do it now, and enjoy your dinner!

The first duty of love is to listen.

PAUL TILLICH

Man's vitality is as great as his intentionality: they are interdependent.

PAUL TILLICH

MAKING
MEANING

Choosing Your Next Subject

2

b y the end of this chapter you'll have chosen the next creative project you mean to work on, if you haven't chosen that project already. If you've selected that next project already, I invite you to revisit that choice in the context of this chapter's discussion in order to confirm that the project will be a deep, worthy, and beautiful one. Once you reconfirm the rightness of your choice, you'll be that much better able to commit to it, start it, work on it, and complete it.

But please do not imagine for a minute that this is the only way to create, by choosing a project or idea beforehand. You can encounter a blank canvas with no idea and proceed to make something wonderful. You can face the blank computer screen and work artlessly and dully, just waiting for the trance of working to envelope you, presuming that in that trance the choosing will take

> *I would say that the most important duty of a writer is to find what is really his story, his particular story, his unique story.*
>
> **ISAAC BASHEVIS SINGER**

care of itself. You can, in short, work without choosing. But you cannot work without *choosing to work.* And once you begin to work, you cannot continue working without *making choices.*

Choosing is integral to the process of creating. There are three sorts of choices an artist makes, the first of which she may skip, if that is her style, but the second and third of which she can't skip. These are:

1. Choosing what to work on

2. Choosing to work

3. Choosing while working

For the sake of our work together, let's agree that the next project you work on will be one that you consciously choose beforehand. It will be one based on an idea, as we defined idea in the last chapter: something like a feeling, something like an image, something like an abstract idea, something lively, insistent, and fascinating.

This idea is to come from a process of deep and not superficial choosing. Superficial choosing, because it averts inner conflict, produces less anxiety than does deep choosing. To choose deeply means letting in the possibility of tackling large themes, difficult concepts, noncommercial projects. To choose deeply means letting in the possibility of revealing oneself in the work or disturbing oneself because of the subject matter of the work. To choose deeply means to consider embarking on work at which one can quite possibly fail. To choose deeply means to entertain risky ideas and unpopular positions. Because even thinking about these possibilities breeds anxiety, the threat to a creator is that he will opt for a superficial choice so as to reduce his experience of anxiety.

ARRIVING AT IDEAS

How are you to arrive at the vivacious idea at the center of your next project? Where are you to find this book idea worth spending a year on, this sculpture idea worth engaging a foundry?

You can arrive at a strong, fascinating idea in any one of the following seven ways:

For years I persuaded myself that it was hard to use my imagination. Not so. The only hard part in using it is the anxiety, the fear of being mediocre.

BRENDA UELAND

1. By working underneath

2. By knowing already

3. By honoring snapshots

4. By imaginatively analyzing

5. By living a tradition

6. By visiting your collected works

7. By just thinking

I believe the best part of your
work has to be unconscious.
LOUIS MALLE

Working Underneath

The central technique for arriving at ideas is the one described in the previous chapter, the process of hushing, holding, and being wild all at once, the wild, quiet descent into unconscious territory that *inevitably* produces ideas.

This "working underneath" produces ideas right as you awaken, it produces them in the middle of the night and jolts you out of bed, it produces them as you ride the train into the city, it produces them as you paint or write something else. It produces them around the clock, tossing them up one after another into conscious awareness.

Can you take a minute, switch gears, and again practice hushing and holding? Can you put this book down, quiet your noisy mind, and allow a vivacious idea in?

Knowing Already

Don't you possess an idea that you've wanted to work on for the longest time already, an idea that resurfaces unbidden, that you keep putting off, that you love but also doubt? The one that you can't get your whole mind around, and so reject? The one that you don't see as commercially viable, and so reject? The one that you fear will require too much research, and so reject? The one that you believe you just aren't equal to, and so reject? The one that you're sure someone else could do a better job with, and so reject? The one that you're sure someone else has already done a better job with, and so reject?

None of these are good reasons to reject the idea you've long been harboring. Bring it back now. Dust it off. Remember that

choosing is anxiety-provoking and that the anxiety of this stage is "confused-mind" anxiety. Accept your confused mind: accept that you don't know whether this old idea is worth dredging up again or not. For now, just dust it off, honor it, think about it, cherish it. It is an idea that has been with you a long time and at the very least deserves attention.

With a fresh (albeit confused) mind, look again at the idea that you've long wanted to pursue. Name it again and write about it for two or three minutes.

Honoring Snapshots

There is a way to be that, in the creativity literature, is called "openness to experience" but that is rather a special brand of openness. It isn't that heat waves of experience constantly crash over the creator, keeping her in a state of perpetual upheaval and causing her to live at an insane fever pitch. It is rather that she goes about her business, fascinated by life, a subject in her own life and also an observer, enmeshed but also detached, and every so often she comes upon a snapshot moment, a moment pregnant with meaning. To this moment she is open: *this* is the openness to experience that she possesses.

The snapshot moment can be anything, literally anything: the texture of her baguette, the sound of a voice on her answering machine, the look of her room as she awakes from a nap. These snapshot moments produce vivacious ideas and produce them instantly. You are walking in a foreign country, take a wrong turn, and come upon something: a wall beautiful with peeling paint, a limping dog, a young girl dressed for church, a priest. Snap! The image out there flies right inside you, attracted by something already in your heart and mind.

Your lover tells you a lie and instantly you know that this is an archetypal lie, a lie so lie-like that it captures the very essence of lying, a lie like a stab through the heart not just of you but of all before you and after you, so perfect and Platonic a lie that a whole drama really must be built around it. Snap! You know it, you have no doubt.

You see bleached bones in the desert, you hear the chime of a bell in a walled city, you see a father strike a child in an amusement park. Snap! There is a painting to be made. There is a song to write.

The first concept is always the best and most natural.

ROBERT SCHUMANN

I know with certainty that a man's work is nothing but the long journey to recover, through the detours of art, the two or three simple and great images which first gained access to his heart.

ALBERT CAMUS

But it isn't that you know the subject of that painting or song with perfect clarity or even with any clarity. Remember what "idea" means. It is rather that you have been shocked awake, fascinated, alerted in a visionary way. You both see the painting and do not see it. You may more see it or more not see it. Maybe you see nothing at all! Still, it was a snapshot moment. Your whole body knows it.

Everything is taken from one's life. You can call them emotions or thoughts. These are all names for experience.

ISAAC BASHEVIS SINGER

EXERCISE
REMEMBERING SNAPSHOTS

Do you remember some snapshot moments? List a few of them now. Next to each, give its feeling tone and its translation as an abstract idea. Here are a few.

Snapshot	Feeling tone	Abstract idea
1. At a party you glance across the room and see your lover looking into the eyes of another person.	Despair, envy, hatred, an overwhelming sense of betrayal	The inevitability of betrayal, given the personality of your lover
2. You're switching channels and suddenly you see frenzied mourners chasing the coffin of a famous religious figure.	Fear, anger, disgust, and confusion all commingled	The insanity of believing in a personal god, the basic insanity of religious belief
3. You sit in your graduate seminar and again realize that your teacher and your fellow students are colluding in doing nothing.	Rage, despair, and severe doubts about the value of academic learning	That banal evil wears this benign face; that one face of evil is this boring class in which ideas are suppressed.

45

Make such a list for yourself. Collect a small album's worth of snapshot moments from your memory. Think of the feelings and ideas that accompanied each. Each snapshot on your list is an idea worth considering.

Ideas are "merely" points of departure, the kernels from which greater units grow, the observations that trigger larger developments.

ANNA HELD AUDETTE

I posed a difficult task for myself: I tried to write without a single male character. I wanted to have a play with only women. I wanted to find out whether this kind of play could also possess interesting dramatic episodes.

BAI FENGXI

Imaginatively Analyzing

I suggested in the last chapter that artists ask themselves interesting questions much too infrequently. That is because interesting questions are difficult by their very nature. If I ask, "What is America about?" or "Why are the orthodox of every persuasion always so punitive?" or "What goes on in a person that she can be both feminist and masochistic?" even smart people start to run, feeling such questions beyond them. These most interesting questions are difficult, slippery, and unanalyzable in any thoroughgoing way. What can red do? What a question! What is the very essence of a German, a Jew, a Moslem, a Baptist? What a question!

But in science, to tackle such questions is to start on the road to winning the Nobel Prize. How do molecules bond? How is the genetic code stored? How is it that a duck virus can be passed to humans, but only by way of pigs? Is evolution gentle or do species make magnificent leaps? These are questions that bold scientists adore. But equivalent ideas in the realm of human affairs are badly ignored even by intelligent, creative people.

What are some big questions you've thought too big to tackle? What are some slippery questions you've thought too slippery to grasp? What are some painful, personal questions whose answers would provide all of us with a measure of truth and beauty? Please think about this. Jot down a few remarkable questions that you would love to see answered.

Living a Tradition

What tradition are you in? The existential? The figurative? The atonal? A regional tradition? A craft tradition? A tradition with roots in antiquity? A world tradition? Women speaking? African-

American women speaking? Melodic jazz? A tradition so new that only you and twelve other people know about it?

Even if you prefer to think of yourself as individual and apart from any and all traditions, even if you feel no important connections to any other artists, living or dead, even if the very idea of a tradition seems an idea worth deconstructing, you may as an exercise find it valuable to wonder what you might have in common with other artists.

What ideas have concerned them? Abstracting from nature? Portraying the flawed individual as heroic? Capturing a sequential thing all at once: not four horse's hooves pounding, but twenty? Arriving at a national music? Debating the essence of maleness and femaleness? What?

If their art has interested you, so may their ideas. Try to name those ideas, checking for resonances.

A painted or drawn hand, a grinning or weeping face, that is my confession of faith. If I have felt anything at all about life it can be found there.

MAX BECKMANN

Visiting Your Collected Works

Ideas you had a decade ago may still be the richest ones, the ones still worth pursuing. Where do those ideas reside? In your finished works, in your unfinished works, in your notes, diaries, and journals, in your sketchbooks, in the recesses of your mind.

Read a paragraph or two of the first story you wrote. What were you thinking? Set up your slide projector and show yourself scores of paintings that span your whole career. What have you been thinking? Play yourself your whole songbook, take an afternoon, take a three-day weekend. What have you been thinking?

Ideas from the past may still be worth pursuing or they may point to the revolutionary or evolutionary step you are next to take. Is it time to stop investigating loneliness in your work and to begin investigating relationship? Is it time to invite figures into your paintings? Is it time to write songs about the old neighborhood? Your past work will provide you with important guidance, if you will let it.

Just Thinking

If you are intellectually alive, you think. You think much of the time. You wonder. You ponder. You look at events in the world and go, "Wow! What was *that* about?" You think about the possi-

bilities of your materials. You think about human nature. You think about the future of your genre. You think about your self, your being.

Forgive me for repeating that thinking is generally under-rated and underutilized. You know that we live in a culture that neither supports nor values thinking, and that pervasive lack of support and value influences each of us. We are moment by moment and inch by inch deadened and dumbed down by smiling-face lapel pins, sitcoms, and the philosophy of the bottom line, a deadening and dumbing down that only exacerbates our natural tendency not to trouble ourselves by thinking too hard.

Can you buck the cultural trend and spend more time with your own thoughts? Can you set aside an hour a day to analyze, synthesize, evaluate, and by so doing give birth to some new, excellent ideas?

CHOOSING DIFFICULT IDEAS

You have a vivacious idea. But you also have a large doubt about the idea. You notice yourself saying, "No, this idea is just *too difficult.*"

This "too difficult" can mean many things. It can mean that the idea feels too slippery, too dark, too ambitious, too dangerous, too self-revealing. It can also mean that the idea, even if splendidly realized, will have little or no chance in the marketplace, that it is "too difficult" for the average reader, collector, movie-goer, listener.

What has been your habit with respect to "difficult" ideas? Do you actually stop to analyze which "too difficult" it might be or whether it really is too difficult to tackle? Do you relegate the idea to the scrap heap and breathe a sigh of relief?

Or rather than reject the idea outright, do you alter it to make it easier, tacking on a happy ending, reducing its scope, trading plot for weight, turning it on its head, all in the course of a split second? Do you make this alteration right at the edge of conscious awareness, knowing that you are doing it but keeping the decision distant enough to spare yourself the sting of guilt?

Do stop this. We both know that a "difficult idea" in its origi-

The only alternatives to thinking with reason are thinking unreasonably or not thinking.

RICHARD ROBINSON

Art work is ordinary work, but it takes courage to embrace that work, and wisdom to mediate the interplay of art and fear.

DAVID BAYLES AND
TED ORLAND

nal, unadulterated form is likely to be *the idea* worth pursuing. Isn't it your richest, truest idea? So what if it's dark? So what if it's slippery? So what if it's ambitious? So what if it's dangerous on many levels: politically incorrect, not commercially viable, alienating, painful, easily attacked by critics? Any one of those reasons *may* be a reason not to pursue this idea, but how can you know until you think about it? To dismiss an idea out of hand or to change an idea into its lightweight counterpart *before* you've consciously considered the matter is the commission of a little murder.

It is in the area of self-revelation especially that we often decide to reject an idea without really considering it. Blockage here is common. The creator receives the idea, dismisses it without daring to look at it, adamantly refuses to work on it, but also can't work on anything else, because that *was* the idea to pursue. The problem is not that he rejects it but that he rejects it blindly, fearfully, and out of hand, without giving it a fair chance.

Once he airs it, he may indeed want to reject it. It may be that the subject has been done to death recently, that he owes it to his family not to do work bereft of commercial possibilities, that he isn't up to feeling the pain that would be invited if he pursued the idea, or because it turns out to be only part of the truth and he would rather work on the fuller truth. If he rejects a difficult idea after honorably considering it, the artist will have rejected it righteously.

Deep creativity often means dangerous creativity. The idea that presents itself as you hush and hold arises from a place that knows nothing of safety. The top of your mind knows safety. There you know perfectly well that animal paintings sell, that adolescent boys and men are the market for action movies, that millions of women are insatiably hungry for romance novels. The top of your mind knows many such things.

But when you hold the desire to create deeply, you bypass the top of your mind, you bypass the safety net of formula, you bypass marketing considerations, and you travel to a region where truth resides. And what is the truth if not dangerous?

Will you choose to work on the idea that arises from that place? Will you choose to do the dangerous thing? For what the work based on a truthful idea reveals may not be pretty. It may

I'm revealed in my paintings. But I'm not always satisfied with my self-revealment. I would want to be something else from what I am.

RAPHAEL SOYER

not please your parents. It may not please the people you expose. It may not please you, when you stop and see that you had *that* inside you.

Why, then, do it? For the sake of truth and beauty and for the sake of authentic living. Period. But the decision to make such a choice remains a very hard one. On the debit side are a great many reasons not to proceed. On the credit side are only a few, although they're profound ones. So the creator vacillates.

It's better not to compose lies, if only because it takes so many notes.
ERMANNO WOLF-FERRARI

EXERCISE
RECONSIDERING DIFFICULT IDEAS

Which ideas have you rejected in the past as too difficult to deal with? Can you name a few?

Pick one. Grab it. Write about it a little, discuss it with yourself, think about it. What exactly is too difficult about it? Is it too ambitious? Too disturbing? Too self-revealing? Too technically difficult?

What, as you think about it now, are the good reasons for entertaining it? What are the good reasons for rejecting it? Make a list of the pros and cons.

Pros	Cons
_____	_____
_____	_____
_____	_____
_____	_____
_____	_____
_____	_____
_____	_____

And on balance? _____

Give this difficult idea a fair airing. Try to decide if it is or isn't
an idea worth choosing to work on.

YOUR TRUE CIRCUMSTANCES

It is certainly possible for an artist to remain blind or nearly blind
to his own real circumstances—the reality of his childhood experi-
ences, the truth of his personality structure, the real shape of his
cultural environment, the exact nature of his belief system—and,
lacking that self-awareness, to still choose difficult material to
work on.

Rich art has been produced by people who never realized what
terrors they were subjected to in childhood, who never remem-
bered clearly the icy coldness or viciousness of their childhood
environment. Rich art has been produced by people who were
made wretchedly unhappy in childhood, who were beaten, dis-
counted, and molested. History is full of such artists, artists who
never really understood what had happened to them and who
never really appreciated the full consequences of what had hap-
pened to them, but who still stubbornly chose difficult ideas to
work on.

Rich art has been produced by people full of hate for other
races—I am thinking of Emil Nolde, who, although almost com-
pletely silenced by Hitler and kept under guard so that he would
not paint, nevertheless never stopped hating Jews or admiring the
Nazi agenda. Rich art has been produced by people unconcerned
about their happy state of privilege, unconcerned about the fate of
their neighbors, unaware of their own exaggerated sense of self-
importance, their own mental disequilibrium, their own despica-
ble idiosyncracies.

In short, wounded and damaged people can and do make such
difficult choices. You, too, even if you are hurt and damaged, can
choose to write *Crime and Punishment* or *To the Lighthouse,* if only
you will hush, hold, be wild, and all the rest. But I would ask you
to go a step further. I would ask you to become better acquainted

*Courage is not the absence of
despair. Rather it is the ca-
pacity to move ahead in spite
of despair.*

ROLLO MAY

*Writing a book is a horrible,
exhausting struggle, like a
long bout of some painful ill-
ness. One would never under-
take such a thing if one were
not driven on by some demon
whom one can neither resist
nor understand.*

GEORGE ORWELL

with your true circumstances. I would ask you to become, not the hurt child who as a hurt adult writes exquisite novels of pain and rage, but the hurt child who as a hurt adult *heals himself* and then writes a novel of pain and rage, from a different perspective and not because he must but because he will.

An example close to home is from my clinical practice of this morning. At 9 a.m. I saw a couple. I'll call the partners in this couple John the filmmaker and Jane the sculptor. Among the many disturbances between these two artists is the fact that John almost always equivocates. Jane did not realize this until I pointed it out, and John did not realize it for a couple of sessions longer.

Why did John equivocate? In order to feel safe around his father, he always had to say what his father wanted to hear. When his own truth contradicted what his father wanted to hear, he would say both things in complicated sentences filled with buts, ands, and evasions, sentences that would finally trail off in confusion. A listener could not be sure at all what John meant to say. Was he for a thing or was he against it? Was he angry with you or was he angry with himself? Did he want to do something or did he not want to do it?

When John finally saw how horrible it was not to speak his own truth, he wept. He had been able to make films without knowing this about himself: he was and had been creative all along. But he had not been enlightened and he had not begun to heal himself. Such a lack of self-knowledge is a hallmark of human existence; and artists, no matter how creative, are not immune to such self-ignorance.

Of course, some artists love to say that if they were to lose their "neurosis" they would lose their creative powers. *They have the fear wrong, but they are not wrong to have a fear.* It can certainly happen that if an artist manages to see through to the ways in which her childhood formed her, the subject matter she has previously worked on may no longer interest her. The themes she has spent years elaborating and articulating may now seem false to her. If what Alice Miller in her eloquent books on child abuse calls "banished knowledge" returns, everything must change. It is not that the truth will make an artist uncreative and sterile. It is that the truth will unleash new demons and may well change the subject matter of her art.

Can you still do a charming mystery or romance, a pop song about love, a cowboy painting or dog painting, or an opera based on a romantic myth if you understand your true circumstances? Can you still poke callous fun at women when you realize that you are only mimicking the hatreds of your father, whose hatred extended to you? Can you still tell any of the stories you meant to tell or salvage any of your old imagery once the truth is revealed to you? Who can predict what the new works of the abused children of the world will be like—children like Buster Keaton, Chaim Soutine, and Friedrich Nietzsche, to name a few examined in Alice Miller's *The Untouched Key*—when once as adults they become enlightened?

What is important to me is not the truth outside myself, but the truth within myself.

KONSTANTIN STANISLAVSKY

Who knows what losses or gains might be realized, once an artist becomes really aware of her own situation? Is she likely to be less rageful or more rageful? Will she find peace or want to extract revenge? No one can tell. But the gamble is still worth it. The person who possesses the qualities of an artist—that is, the essentially truthful person who can think and feel—and who is also wounded or damaged, *is already guaranteed the experience of pain.* With that as a certainty, how bad a gamble can it be that she demand clarity from herself about her own true circumstances?

EXERCISE
TRUE CIRCUMSTANCES
AND DIFFICULT IDEAS

Let's say that difficult ideas come in the following four categories:

1. They feel different because they disturb us when we work on them.

2. They feel difficult because they tax our abilities.

3. They feel difficult because they feel too revealing.

4. They feel difficult because they appear to have no commercial viability.

Please do the following. Clear your mind and think about your life. If you have the stamina and interest, write a ten-page autobi-

*If you start with something
that's false, you're always
covering your tracks.*
PAUL SIMON

ography as a spur to thinking. (This is a profound exercise for an adult to undertake.) Or just clear your mind and think about yourself "as if for the first time."

Now think about the following questions.

1. What about your true circumstances makes it hard for you to encounter disturbing material?

2. What about your true circumstances makes it hard for you to stick with tasks that tax your abilities?

3. What about your true circumstances makes it hard for you to reveal or expose yourself?

4. What about your true circumstances makes it hard for you to contemplate doing unpopular work or work that might be very hard to market?

Try to reconstruct and fathom your true circumstances. Can you help yourself heal and grow stronger? In your hands to unravel is the relationship between your true circumstances and your abil-

ity to choose difficult ideas. A great part of the value of the work of art you bequeath to us depends on your understanding of that relationship.

No tears in the writer, no tears in the reader. No surprise for the writer, no surprise for the reader.
ROBERT FROST

CHOOSING EASY IDEAS

Just as an artist may too quickly reject a difficult idea, she may too quickly accept an easy idea.

The reasons for this are obvious enough. An artist who grows increasingly edgy as she fails to work, who is dying to possess an idea but for whom no idea has materialized, who feels barren and foolish as she waits, is likely enough—and unlucky enough—to suddenly receive and settle on a second-best idea, an easy idea, an idea which she then latches onto simply because she must work on something.

Some "little story" which she might otherwise not have tackled seems suddenly worthy, important enough, a reasonable choice. As the French writer Louis-Ferdinand Céline put it, "Most authors are looking for tragedy without finding it. They remember personal little stories which aren't tragedy." Unable or unwilling to dream up a great theme, no wonderful inspiration upon her, but feeling internally pressured to work, she attempts to make a mountain out of a story the size of a rolling hill.

Or she chooses to work but sits in front of the blank screen or stands in front of the blank canvas without much energy, care, or attention. Rather than enter the trance of working, she works from the top of her head, and what pops out is something small and half dead. It is an "idea," but one without vivacity, one bred in the half-light of anxiety.

Because the idea is too dim or dull, problems soon arise. The center will not hold. So she tries technical solutions, she pens in more characters, she adds colors, she adds plot, she adds forms, she provides counterpoint, but all the while a warning bell is ringing. "Stop!" it chimes. "You haven't really started. You had an idea but it wasn't the right one. Stop!"

Or, consciously or unconsciously, she invites in a commercially viable idea because she would really rather be on vacation, because she is too distracted to really hush and hold. She invites in an easy idea because of a deadline on the horizon, which she can't meet if she works deeply. She invites in an easy idea because easy ideas make for neat packages and she's not in the mood for a mess. She invites in an easy idea because it will be well liked and she is in the mood for a compliment, because her last work on a difficult idea failed miserably, or because she feels it shrewd to reveal little about herself.

Just as "difficult" in the phrase "difficult idea" meant many different things, from ambitious to ambiguous to self-revealing, so "easy" means many different things. It can mean small, sterile, formulaic, commercial, superficial, unfelt, second-rate. But it can also mean something seductively close to "whole" or "complete."

An idea suddenly comes to you such that the premise can be explained in a single neat sentence and the plot in another sentence. Everything is known to you, every wrinkle, right down to the marketing handle. Isn't that splendid? Isn't that an idea to kill for? Isn't that Mozartian? Isn't that a moment of sheer inspiration?

Or is it dreadful? How *did* you get the idea completed inside, done from beginning to end, unless you took a shortcut, used a formula, or tamed the material? How did you manage that trick unless you reduced a big wonder to a bite-sized query, skimmed the surface, or killed the writhing, living thing and now plan to present us with the carcass?

How is the artist to distinguish one from the other, between unfortunate "complete knowing" and that other, rare "complete knowing" when a work derived from a vivacious idea comes to a creator whole? For sometimes a song will just come. Sometimes a poem will just come. Sometimes a play will just come. In those rare times the creator need do little but transcribe. "Ease" in such cases is not a problem but a great blessing. But how to distinguish one from the other?

How do *you* distinguish between a work that is easy because it has been beautifully and fully formed out of conscious awareness and one that is easy because a shortcut has been taken? Do you know the difference? Can you feel the difference?

The difference is palpable and clear if you will surrender to your own knowing. There is no checklist, no test to take to help

you know when "easy" is a blessing and when it is a mistake. All you can do is surrender to your own knowing.

But remember that even if the idea that comes to you is easy "for the wrong reasons," you may still want to choose it. Just as there are good reasons to reject a difficult idea, even though it is a rich one, there are good reasons to accept an easy idea, even if it is a superficial one. All I would ask is that you not accept it without thinking. Be honest and forthright in your own heart. If you hunger for a popular success, fine. If you would like, for a change, not to make a mess, fine. If you would like to test out a formula, fine. But make such a choice openly and brazenly, not as if it were a dirty little secret.

A man will enjoy today what exasperated him yesterday.

JEAN METZINGER

E X E R C I S E
EXAMINING EASY IDEAS

Which easy ideas have you accepted in the past without considering if they were *too* easy? Can you name a few?

1. _____

2. _____

3. _____

Which easy ideas have you rejected, on the grounds that they were just too easy? Do some come to mind? Pick one now, grab it, and write about it a little. Discuss it with yourself. Think about it. What exactly is too easy about it? Is it too small? Too superficial? Too formulaic? Too crass an attempt at popular success? Too what?

What, as you think about it now, are the good reasons for entertaining it? What are the good reasons for rejecting it? Make a list of the pros and cons.

Pros	Cons
_____	_____
_____	_____
_____	_____
_____	_____

_____ _____
_____ _____
_____ _____
_____ _____
_____ _____

And on balance? _____

Give your easy idea a fair airing. Try to decide if it is or isn't an idea worth choosing.

WHOSE ART IS IT?

Am I making the implicit or explicit demand that you choose difficult ideas to work on? Am I asking that your songs be complex, your acting style "method," your literature experimental, your paintings disturbing?

The answer is a simple "no." I would like you to know your own true circumstances. At the same time I would like you to work hard. That is all. The judgments about the art you then produce are your own business. To put it simply, it is your art. As a person, I will question it. You, too, must question it. But when all is said and done, it is your art.

A feminist critic, for instance, will correctly point out that in André Malraux's *The Royal Way,* a novel based in large part on his trip to then Indochina, the author made his adventurers male and employed women in the story only as prostitutes. On the actual trip, Malraux not only traveled with his wife, Clara, and not a male buddy, but survived solely because of her help in extricating him from an Indochinese jail.

Was Malraux dense, ungrateful, unconsciously resentful, consciously resentful, or guilty of some other flaw or sin in excising

Clara from his novel? If he resented her and determined not to give her her due in the novel, is that all right? Is that his right? Or is the matter a different one entirely, one of necessary literary license? Was it important for the story that the adventurers both be men? Was it a creative and not a psychological decision? Do we judge Malraux innocent or guilty, or innocent *and* guilty?

These are important questions but they are not the focus of this book. Here, instead of offering an opinion, I would rather say to Malraux: Think about it. I will say to you: Think about it.

If an artist says, "I could paint the same vista my whole life," should we feel a certain sympathy rise up in us or a certain irritation? We do not offhand know if she is finding perpetual richness in that imagery, such that each new attempt is full of her life meanings, or whether she has blinded herself to other important meanings within her. Even if we knew that answer and concluded that she was working deeply, we still might wonder if we shouldn't demand more of her. Even if every canvas burst with life, couldn't we still charge her with treason? Who has permission to paint beautiful vistas in this world at this moment?

But again, those are our opinions. To the artist herself I would only say: think about it. Whose art is it? It is the artist's. Here I am only asking that you think about what you're doing, that you justify yourself to yourself, that you understand yourself. The art that flows out of that self-knowing is your art and your responsibility.

Can you do that? Can anyone do that? Do we really expect a van Gogh or a Mishima, a Woolf or a Dickinson, a Camus or a Beethoven to be able, for all their brilliance, to see themselves? That they will generate their next ideas, their next images, their next songs goes without saying. They will create. But will they reflect? Can they or anyone else say, "Stop! I will do nothing until I understand myself better and make the necessary changes!" It doesn't seem that people very often can.

A tormented person who manages to create masterpieces is not for me the ideal. Nor is a tormented person who fails to create at all. It is your art, but it is also your life. Won't you stop and consider that? Now, as you choose the subject matter for your next work, is a splendid time to do that considering. When you enter your working trance, you don't want to be pestered by doubts.

To tell the truth, I could work with one flower forever.

NELL BLAINE

Between each fruitful phase are long periods of exploration, faltering, learning, and working things out.

KENNETH NOLAND

You don't then want a voice saying, "Why paint flowers, dear? Why not gritty urban landscapes? How bourgeois, dear. Pretty flowers!" That pestering voice will only hurt the artist; if she is really working, she is committed to that painting, and that is how it should be.

Now is the right amount. No canvas is stretched. Your latest novel is finished. Your latest album is finished. Your latest symphony has been performed. Your movie has made its film festival debut. You have worked hard on one thing and have not yet chosen the next thing; now you have the opportunity to think. You have the chance to understand your true circumstances and the direction you want to take your art. It is your art and your life; it is also all our lives together. What will you do next?

Who can tell what goes on in his own brain? My brain makes my whole body work so wildly; it can be explained only by guessing and astonishment.

LEOŠ JANÁCEK

CONFUSED-MIND ANXIETY, APPROPRIATE AND INAPPROPRIATE CLARITY

What *will* you choose to do next? Don't you naturally reel back in confusion, anxious about not having a really vivacious idea to work on, anxious about having too many, anxious about choosing among these bright or dim ideas, anxious about choosing for the wrong reasons or rejecting for the wrong reasons, anxious about the quality of the one idea that seems to be separating itself from the pack, anxious about the confusion and confused about the anxiety?

In the face of such anxiety and confusion, isn't there a great pull to just skip being creative? Choosing is such a terribly uproarious, stressful, and confusing business: it demands resolution, even if that resolution is to flee. The anxiety of this choosing stage is confused-mind anxiety, and what one desperately wants is *clarity* to replace the pain and anxiety of confusion, but that is a wish that *can't be appropriately realized at this moment.*

You can be clear that you will proceed: that is courage. You cannot, however, be clear about the idea or that you have chosen correctly. That sort of clarity is not available to a creator at this stage of the process. But how wonderful clarity feels! It feels so wonderful to know which menu item to select or which movie to watch, wonderful to know that an idea is worth choosing and that

one is competent to tackle it. How much pressure there is to attain clarity! What then happens when we strive for clarity when clarity is an impossibility or frankly undesirable? We reach inappropriate clarity only.

You can gain this spurious clarity by:

- Knowing everything about the work because internally you killed it, stuffed it, embalmed it, and mounted it beforehand. Yes, the idea is clear now, mounted above the mantel. And dead!

- Knowing everything about the work because you engaged in some inner manipulation that provided the clarity: exchanging clean, clear plot for real-life ambiguity and complexity, returning to an old comfortable chord scheme rather than encountering a presently unfathomable chord scheme, deciding, in the space of an instant, to be tricky with the image rather than self-challenging. These inner manipulations, available to a beginner and a veteran alike, provide clarity at the expense of the idea's sanctity.

- Knowing clearly that the work will turn out well, that the product will prove an unblemished masterpiece. This clarity, which seems like nothing but necessary optimism, endangers the process. It is one thing to have high hopes for the work and a good feeling about the work. That is splendid. It is quite another to presume to know how the work will turn out beforehand; clarity of this sort is a close cousin of wishful or magical thinking.

- Knowing clearly that the work will not turn out well. This defeatist attitude, which depresses the artist and depresses the idea, seems reasonable enough if one turns a statistical calculation into a state of mind. You say to yourself, "There have only been a handful of great, original novels ever written. So the odds must be ten thousand to one or a hundred thousand to one against my novel being great. Therefore it is clear that mine will fail." To work with optimism and passion,

To act is to be committed, and to be committed is to be in danger.

JAMES BALDWIN

You must become aware of the richness in you and come to believe in it and know it is there, so that you can write opulently and with self-trust. If you once become aware of it and have faith in it, you will be all right.

BRENDA UELAND

I'm totally on my own with no one to blame or congratulate but myself.

BARBARA SIEGEL

you must operate under the illusion that the odds are very different from these and much more in your favor. This adaptive illusion, which should amount to a kind of certainty in the body, is the equivalent of saying, "The hell with the odds. How does it help me to think such depressing things?" Do not be clear that the work will fail. That sort of clarity is a death threat to the creative process.

Clarity like this is not worth possessing. On the other hand, all of the following are things to be clear about:

- You know clearly that you are alive. You are clear about what being alive feels like. You are clear that you aren-ever more alive than when in the trance of working.

- When a vivid idea comes to you, you know it, just as clearly as you know that the doorbell is ringing. You are clear about how it feels to receive and hold such a gift.

- You are clear that you can't know the outcome of the work you have chosen to undertake. You can't know anything important about it beforehand, whether it will be a bug or a fish, whether it will be alive or dead. You are clear about that.

- You are clear that creative work is hard work. You understand that it can't be done at the level of attention of watching television or shopping at the mall.

- You are clear that you have wildness in you, the wildness to battle any god, to wrestle with any writhing, flapping book. You are clear that you're a wild man or a wild woman, a terror, an animal. You are clear that you can be as wild as needed.

- You are clear that you can choose, that you are equal to making choices. Would you rather write this book or that one? You are clear that you are equal to making such choices.

▾ You are clear that you are competent. If you're not clear that you are competent, if you have troublesome doubts about that, you will have to work on affirming your own competence. One way to affirm your competence is to courageously struggle through your doubts and complete the work. A second way is to let go of any investment you have in the idea that you are incompetent. A third way is to tease apart the following two ideas: "It is clear what to do" and *"I can be clear in my own being."*

Disorder is always in a hurry.

NAPOLEON

Remember this important distinction. You can't expect an unclear situation to be clear. But you can expect *you* to be clear. Take the following example. If you shake a bottle of rich Italian dressing, a bottle filled with oil, vinegar, whole spices, chopped garlic, and dried herbs, does it become clearer? No. The oil and vinegar emulsify, the particles swirl, less light comes through, more chaos is created, the whole is opaque, the particles hang suspended.

There is no longer any moment when the dressing is clear, when you can see through to the other side. If you are tracking one parsley flake, sometimes you can follow it, sometimes you can't. Never can you feel certain that a given garlic slice can be spotted. Never is the liquid anything like distilled water.

It is a cloudy, busy, chaotic, opaque mixture. But are you disturbed? *Why need you be?* You are perfectly capable of clarity, even though the salad dressing is not. You can comment on it, analyze it, conclude that you can't tell a parsley flake from a bit of oregano. You can calmly and clearly resist the temptation to identify with the dressing, to call its opacity your opacity, its murkiness your murkiness. You can be clear even as you witness chaos. You can wait as the oil and vinegar separate, you can be patient, *you can be sure that the confusion in the dressing has nothing to do with you.*

Can you feel the difference? You may say, "But the dressing *is* me, I am both observer and salad dressing." But the distinction still holds. Take a minute and describe the difference in your own words. *Find the difference.* Do you see how important it is to apply this principle to the murky ideas that come to you?

What helps quell confused-mind anxiety? The certainty, which must ever grow in you, that you can survive the process of choosing, even if your choice turns out to be a wrong one; and that you can be clear, even if clarity about the work is not available to you.

ARRIVING AT IDEAS THROUGH VISUALIZATION

It's time now to arrive at an idea or ideas. If you possess your working idea already, proceed with this exercise anyway. Do so as a check to make certain that your idea, which may have been with you for a long time, is still vivid and viable.

Shut your eyes and imagine a shelf full of your future books, a museum courtyard full of your future sculptures, a gallery full of your future paintings, a CD rack full of your future albums. Don't strain to make out the titles of the books or CDs, don't expect the sculptures to come into focus or to retain their shapes, don't expect the gallery to remain the same as you watch it. Feel instead the warm sun in the museum courtyard, the warm lamplight on the books. Feel good. There are your works, your accomplishments. Feel proud. Smile. Relax.

You do not need clarity *about* these works. But feel clear that *you created them.*

Look a little closer. See the titles of the books without really seeing them. You are looking for the one that next wants to be written. Glance at each sculpture in the garden without really seeing it. You are looking for the one that next wants to be fabricated. Look at the CD spines without making out the titles. You are looking for the theme, the unifying idea, the sound around which your next collection of songs will be constructed.

If you're a performer, imagine yourself a creator. See not your oboe but you at your desk, writing for the oboe. See yourself among a thousand drums, not just in front of your own drum set. See yourself learning from all those drums and all those drummers, see yourself fronting the drummers, conducting the drummers, leading, creating. See yourself not in some famous role but among roles you've created for yourself, in among your own plays, your own performance pieces.

The seed of the idea is developed by both labor and the unconscious, and the struggle that goes on between them.

CARSON MCCULLERS

For a true writer each book should be a new beginning where he tries again for something that is beyond attainment.

ERNEST HEMINGWAY

Take your time. These are your babies, your babies to be. You know nothing about them and you know all about them. Let them come in and out of focus. Notice your puzzlement but also your wonderment, your uncertainties but also your certainties. Aren't a few of these future products quite clear? Don't they only require making?

Stay in the warm sunlight or warm lamplight of your future products until some of them come into focus. Which of them wants to be made first? The book about your Swedish grandmother or the book about your younger sister? The earth-colored mural and not the one in blues and blacks? The song about your escape from Cuba and not the song about life in the ghetto? The painting after Matisse, all in red, that you mean to stand for an entire century of color exploration, and not the gray one, which must come second?

Which one wants to be made first? Work to find it. Hush, hold, think, be wild, be tame, feel everything, all the work you've ever done, everything about the world, everything about your true circumstances. Hold and contain everything. Is the idea coming? Have you got it? You don't need to write it down or rush anywhere to save it. Just hold it.

Can you hold it? Are there some details you want to make notes on? Make those notes. But don't worry about losing the idea. Determine to remember it. This is the idea you *may* have chosen to next work on. We'll call it the primary idea.

But what about the gray painting or the book about your sister? Hold those secondary ideas, too, but hold them differently. Write them down neatly and start a file, an "all projects" file to which you can return. Spell out each idea clearly enough so that six months from now it will make some vivacious sense to you. Be patient and unafraid, but work quickly, because ideas can and do evaporate. Describe these secondary ideas as carefully as you can, then put away the folder.

Bring the primary idea back. Is it there? Is it the same? Has it changed slightly?

If it has changed, you're either doubting it or already working on it. Which is it? Try to find out. If you kill good ideas out of fear and doubt, this is the moment to discover that. Why has the idea changed?

Depending on its persistence, depending on its importance, depending on what role it is playing, an idea will keep intruding in little bursts and either crash through or be wiped out.

SIDNEY LUMET

Taking a new step, uttering a new word is what people fear most.

FYODOR DOSTOYEVSKY

No man can describe how an idea comes to him.

ISAAC BASHEVIS SINGER

If you suspect it has faded or altered because you're afraid of it or afraid of creating, bring it back in its original form *right now.* Demand that it return. Get it back and hold it.

If, however, it's altered its shape because you're already working on it, bravo! You are creating.

If you don't yet have a primary idea, please start this exercise over again. Stop everything until you arrive at a worthy idea that you can love and build on. Life is a half-dead affair without primary ideas to nurture. Please stop everything until you have one.

When you have it, hold it. Just hold it. Just say, "The book about my Swedish grandmother." Just say, "The red painting."

How does it feel to possess this idea? Splendid? Frightening?

To have anxiety accompany a vivacious idea is natural. If anxiety is present, just accept it. Do not leap up and say, "This is making me anxious, it must be the wrong idea." If anxiety is present, just accept it. Be anxious but not worried!

If you don't possess a vivacious idea yet, try not to feel discouraged. Try not to feel like an idiot or a failure. Just start again. Do this exercise again, go back to the beginning of the chapter, go back to the beginning of the book, or, best yet, go inside yourself. But don't carelessly go forward, as if ideas didn't matter.

Work on this. Hush. Hold. Do whatever it takes to arrive at an idea worth pursuing, an idea that, if you judge it worthy, will be one you can commit to.

JUDGING THE RIGHTNESS OF YOUR IDEA

You have a primary idea. Write it down here. Don't worry about capturing it exactly or eloquently. Your headline for the idea can be something as vague (and complete) as "that white painting" or "that book about Venice." Or it can be much more detailed. Write it down here:

Congratulations!

Now you need to know, is this the right idea to pursue?

What a question!

When a really insistent idea comes to a creator, it feels like the right or only idea she can consider. To imagine working on anything else seems virtually impossible. This idea—to examine the nature of conscience in a book called *Crime and Punishment*, to abstract from nature until a tree has given up its essence to a Mondrian—fills the mind, fills the heart, sends the artist right off to work. What can there be to question?

But, as insistent and vivacious as such ideas feel, *are* they the right ones? And what if the idea is much less insistent than that? What if it feels mild, dim, a little theoretical, a little too familiar, a little off target? Might it still be the right one? If so, how are you to know?

Remember that ultimately you must proceed to work even if you don't know whether your idea is right or not. *You can't have the clarity or certainty you want.* Remember that. Do not use as an excuse for not working the suspicion that your idea might not be vivacious enough. Even if you can't choose it with certainty, you can and must choose *to work wholeheartedly.* A Rembrandt does not find reasons not to draw. A Bach does not find reasons not to compose. Do not use this notion—that the rightness of an idea may valuably be examined beforehand—as an excuse for not working.

But do examine ideas beforehand. To know if an idea is the right idea to work on, apply the following three tests. No artist since the beginning of time has quite managed to do such a thing, and possibly you won't either. It nevertheless remains a powerful and meaningful thing to do, to test your idea to determine if it's the best one to pursue right now.

If you're able to test the rightness of your own ideas you may grow in ways Picasso himself confessed he had failed to grow. If a Picasso can manage to delude himself into believing that his ideas were the right ones, only to realize later that he had opted far too often for easy ideas that merely entertained his public, isn't any creator in danger? Couldn't any creator benefit from taking a moment, even in the face of a really insistent idea, to attempt to gauge its rightness?

Test your primary idea in each of the following three ways.

If there is a soul, it is mistake to believe that it is given to us fully created. It is created here, throughout a whole life. And living is nothing else but that long and painful bringing forth.

ALBERT CAMUS

67

1. The "Gestalt" Test

You will remember that creating can profitably be thought of as the following feedback loop:

$$\rightarrow \text{person} \rightarrow \text{process} \rightarrow \text{act} \rightarrow \text{product} \rightarrow \text{world} \rightarrow$$

This schema represents *the whole picture,* so to speak, everything that the creator brings to the moment, everything about the creator's world, all the ideas floating about, all the family history, everything about her personality, work, and universe. This is the gestalt, the everything, the indivisible picture which a creator *can still manage to survey, even though she is embedded it it.*

It is a miracle that she can do this, that she can see herself clearly even with her own distorting eyes. It is a miracle, but it is a miracle available to each of us. Survey *everything* now. Be your own fly on the wall. Position yourself so that you can see everything about you and your universe. Squirm in your chair, squirm in your mind, move, shift, contort yourself, and get yourself in position to see your childhood, adulthood, and old age, your neighborhood and all the neighborhoods of the world, your idea and all the ideas in the world, *all at once.*

I hope you are smiling but not laughing. This is an absurd, preposterous exercise and yet *you can do it.* You can be Chinese, Black Muslim, Jewish, and a John Updike character all at once, you can hold every painting style and every painting idea, you can go back ten thousand years and travel ten thousand miles, you can do all of that, because human beings simply can. Take advantage of this miraculousness.

Get into that position. Now . . .

From that vantage point, is your primary idea worthy? Does it possess the richness, the completeness, the rightness it needs to possess? Is it true, but true for another time and place? Is it fresh, but very thin: does it evaporate in the gestalt?

The everything is deep and wide: is the idea? The everything contains past, present, and future: does the idea? The everything contains that which is meaningless but also that which is meaningful: is the idea rich with meanings? The everything contains

the amoral and the natural, the rocks and lightning bolts of the universe, but also the moral and the human: does the idea partake of the moral?

Hold your primary idea in the context of the everything. Does it sink? Does it evaporate? Does it continue to shine?

Meaning is an intention of the mind.

EDMUND HUSSERL

EXERCISE
SUNDAYS AND IDEAS

The idea you choose to work on, which may or may not be this primary idea, will become part of the meaning-making process that an artist continually engages in. To make meaning is to consider everything and then do the right thing. Sometimes this process takes a microsecond and sometimes it takes three decades. But insofar as an artist lives authentically, this is what he does: he considers the everything and does the right thing.

If this task is left undone, his life is rendered meaningless. Thus he must continually reinvent his mornings and evenings, his weekdays and weekends. But since a host of conventional tasks take up so much of his week, it is often only on Sunday that he is confronted by the need to invent his day and make some meaning. While people around him busy themselves in ways that he finds unconvincing, he is left to make sense of all the hours between rising and bedtime.

A Sunday, then, is an excellent day to take your primary idea on a visit to the everything. Next Sunday forgo the paper, brunch, the football game, the shopping, the chores, the laundry, the yard work, the oil change, the hours of boredom, the nap, the foreign movie matinée. Retrieve your primary idea and take it out into the sunshine. Walk with it down by the beach, around the town square, up in the hills. On that timeless and placeless Sunday, feel the complex expansiveness of the everything and measure in hushed wonder the rightness of your idea.

2. The "Burned-Down Barn" Test

The dancer Twyla Tharp explained:

In the mind of the beginner, all things are possible. But in the mind of the expert, only a few.

D. T. SUZUKI

> There is a tradition in the Orient in which masters are allowed at one point in their lives to change their names. They're allowed to keep their knowledge but they get a fresh start. I like that idea.
>
> I used to think that the luckiest painters were the ones whose barns burned down, with all their old paintings inside. That way, they had no past to be responsible for. They could get a clean start.

The "burned-down barn" test is a bit of this same self-gifted freedom. You say to yourself, "Yes, I have a past, yes, I have a formed personality, but all of that is gone. Puff! Now, how does the idea look?"

If the gestalt test asks you to look at everything, the burned-down barn test asks you to forget everything, to forget all the constraints placed upon you, to dream without worry, to think without inhibitions. How does your idea look from that perspective?

EXERCISE
BURNING THE IDEA

Write down your primary idea twelve times, once on each of a dozen small slips of paper. All you need put down is something like the following:

Red painting of sunrise

Play about infidelity

Terra-cotta army, excessive revenge

Face in a stone

Song like my father's voice, smoker's voice

Movie about a burning lake of fire and an abortion

Piece for bluegrass violin and Irish bagpipes

Find something in which you can burn these slips of paper, one at a time. A bowl-shaped candle holder or incense burner will work well.

Settle in with the following ritual. Clear your mind: burn your bridges behind you. You have no past, no personality, no race, no gender, no material being. In that state of mind, burn the first slip of paper.

Now you are free of that idea, too, just as you are free of everything. Feel free, unencumbered. As wonderful as that idea was, you are not a slave to it! Farewell, red painting of sunrise. Farewell, play about infidelity. Feel the freedom of nothing.

Now invite the idea back. Hold it again. Is it less vivacious now? Less worth obsessing about? Or is it just as interesting? Even more interesting?

Measure the brightness of the idea in this void, this empty, unencumbered place. Hold your answer.

Repeat the process. Empty yourself of everything and burn the next slip of paper. Feel it completely gone. Feel yourself completely free of it. Then invite it back. Judge its brightness, its importance each time it returns. Do this twelve times.

Will you burn it? Will you keep it? Value the results of this exercise.

My projects are the high joy of freedom.

CHRISTO

3. The "Turn the Idea Around" Test

"Turning the idea around" is a metaphoric way of saying "analyze." It is a metaphor that may be replaced by any similar metaphor you prefer. The following three are like-minded metaphors:

1. Hold the idea in your hand. As you shift it in your palm, the idea appears in a different light or can be looked at from a different angle.

2. Picture the idea in a kaleidoscope. Each time you turn the lens, a fantastic distortion occurs, but the original idea is not lost.

3. *Put the idea under a microscope.* Not only is the image enlarged, but it can be so enlarged that the whole disappears, allowing you to observe individual details. Reduce the magnification and the whole returns, increase it for an atomic understanding of the idea.

Whatever metaphor you prefer, the central notion remains the same. Scrutinize the idea. Examine it. How vivid is it really? Is it richer from one angle than another? Is it more like what you had in mind from another angle?

EXERCISE
TURNING AN IDEA AROUND

Imagine that you're a nonfiction writer and the following idea comes to you: "A husband strikes his wife." It is an idea that percolates up and begins to fascinate you. Something in that idea—in the image that has conjured itself up of a violent split second, the husband's look, the wife's look, the blow—starts to obsess you. Without any real clarity as to what this book might be about, you have the feeling that you would like to choose this idea to work on.

If you apply the "turn the idea around" test to this new idea of yours, what would you learn? With each turn a new idea would present itself, related to the original idea but different from it. The following are ten such twists:

1. You see that he was beaten by his father, that he identifies with aggressors, and that he feels aggressive toward her. He manifests that aggression through hitting. The book title that comes to you is *Fathers and Sons: The Violence Cycle and Its Effects on Women.*

2. You see that she is the daughter of an alcoholic father whom she could not change, that she determined to change some other weak man, and that she attempts to change this man by criticizing him, which provokes him into hitting her. The book title that comes to you is *I Only Called Him a Stupid Coward: What Women Say and How Men React.*

3. You see that he really enjoys seeing someone scared of him. The book title that comes to you is *Everyday Sadism: When Hurting Others Feels Good.*

4. You see that they both have poor impulse control. She speaks impulsively, he hits impulsively. The book title that comes to you is *Hair Triggers: Impulse Control Disorders in Men and Women.*

 (For the next six, you supply the book title.)

5. You see that he neither likes nor respects women, and that hitting her is no more significant an action for him than kicking a can down the street. The book title that comes to you is _____

6. You see that she is depressed and craves drama, and that she values being hit because it wakes her up and brings her out of her depression. The book title that comes to you is _____

7. You see that she hates him but that she needs her hatred of him to be periodically reenforced by concrete actions. The book title that comes to you is _____

8. You see that hitting her arouses him. The book title that comes to you is _____

9. You see that she considers being hit by him the appropriate punishment for the mismanagement of her life. The book title that comes to you is _____

The direction of the mind is more important than its progress.

JOSEPH JOUBERT

10. You see that both of them are anxious and depressed but that neither of them has any self-knowledge. The book title that comes to you is _____

This is one example of turning an idea around. How will you turn your idea around in order to test it?

You have Hamlet or Juliet to inhabit in an upcoming play. Can you imagine holding the role in your hand and turning it around, seeing and feeling the different interpretations?

You have a song to sing that you've sung a hundred times already. Hold the song, hear it, turn it, feel how it is a hundred different songs if only you will turn it.

You know that snow must be in your poem. But which of the fifty whites of snow will it be? Hold the field of snow, turn it bluer, yellower, creamier, grayer. Manipulate the hues and feel the poem alter.

Let your mind make of your primary idea a hologram on a pedestal. Now your idea has no dark side. You can see all sides of it: see it turning to reveal everything. Let it rotate. Write down the results.

CHOOSING AMONG IDEAS

The last exercise not only provided an example of how to turn an idea around but also *generated* different ideas. Any of the ten book ideas created from twisting around "a husband strikes his wife" might actually be worth writing. And isn't it often the case that creators will have more than one idea to consider at a time?

Every so often a novel may come to you that you *must* write: you have no choice in the matter. You're certain, singularly motivated, singularly focused. The work simply starts to flow through you. You have images you must photograph, a movie you must make, a song you must write. Obsessed, driven, you simply begin. It might be nice to test the rightness of the idea, but you barrel through any such testing, certain that you must proceed. Any

doubts you have about the potential rightness or goodness of your choice are submerged under waves of desire.

But this is a rare occurrence, even for the highly imaginative and productive artist. It is just as often the case that such an artist is either bereft of ideas or else brimming over with them, full of half-ideas, half-images, old projects, new projects. Which precise thing will she decide to work on today? Should it be this play, that play, or the half-finished movie script? Should it be the small blank canvas, the large blank canvas, the half-finished blue painting, or the very-much-worked-on green painting? Should she collaborate with several excellent people on film X or proceed all alone with film Y, which Foundation Z will partially fund? How are these choices to be made?

Some books are written in anguish, others just write themselves and those are jolly to write.

SOMERSET MAUGHAM

Artists make exactly these kinds of choices, and until they choose, they can't proceed. If the choice is predetermined, so to speak, if the artist is a Mozart channeling symphonies—hearing them and transcribing them—that is one thing. But even then the artist must choose, for he must look at the results of his "predetermined" choices to see if the products really are good ones. If they are not equally good, if they seem too easy, if they begin to slip in quality, if the process becomes less trustworthy, mustn't an artist then choose whether he will accept that channeled material or reject it? Mustn't the material, still flowing through him, be examined and tested even as it flows?

For an artist wants there to be important reasons behind the choices he makes. To choose arbitrarily, for no particular reason, is a painful condition about which artists despair. The painter Jennifer Bartlett, for example, explained:

> Picking colors revolted me. There never seemed to be any reason to make any special choice. It always ended up with my solving the problem in the same way. The problem I was facing was that I couldn't judge between alternatives. I'd do forty drawings for one painting. But then you have to pick. And I had the feeling my choices were structurally arbitrary.

On what grounds will an artist choose one idea over another? Think for a second about the sorts of reasons that inform your decision to choose one menu item over another when you dine out.

75

For every poem that I begin to write, I think of at least ten which I do not write down at all.

STEPHEN SPENDER

You love duck but not chicken. But you don't like duck in a sweet sauce, only in a savory sauce. And although you don't love chicken, you've never had it cooked with artichokes before. Does that make a difference? The duck is two dollars more than the chicken. The duck comes with rice but the chicken comes with potatoes. The potatoes are fried: calories. But also: no doubt delicious! Both come with sautéed vegetables. That's a draw—except the chicken already comes with artichokes. What a lot of vegetables! And what about the beef tenderloin in puff pastry? Well, a little red meat once in a while . . .

What actually happens when a group dines? Something like the following: One person looks at the menu, scans it, and says, "That sounds good! I'll have the beef tenderloin!"

A second person scans the menu but doesn't really concern herself with it, because she has already decided to order a lobster salad. If the lobster salad is there, fine. If it isn't, she asks the kitchen to make it up to order or else she orders the most similar salad, say the crabmeat salad.

The third person weighs and balances, judges and evaluates the entrées along the lines described above, licking her lips all the while, and eventually arrives at something she can comfortably or even enthusiastically order.

The fourth person weighs and balances, judges and evaluates the entrées along the same lines, but without much gusto, enjoyment, or interest. Eventually she places her order, because she must, but doubtfully, already sure that the chicken with artichokes won't be what she really wanted.

Stop! If you choose in this fourth fashion, if you are a "number four" diner, it is a sign that *at this moment* you haven't a significant wish or appetite to create. How can it be that not a single dish on the menu sounds delicious? How can it be that not a single one of your own ideas fascinates you?

Please consider this matter as *vital* to your creative life. At the very least, return to the regimen of hushing, holding, and being wild so that a hot wish to create will arise in you.

We can characterize these four ways of choosing as follows:

1. Rapid-scanning choosing
2. Rigidly predetermined choosing
3. Analytic choosing with appetite
4. Analytic choosing without appetite

One is encouraged to repeat, discouraged to explore and radically shift the nature of his terrain and viewpoint.

MARK DI SUVERO

It might seem at first glance as if the first way must be the best. Confronted by several choices, you find yourself lucky enough or clear enough to have one leap right out at you. It has vivacity, appeal, an immediate sense of rightness. It has everything you want of an idea. Certainly this must be the most efficient and satisfactory method of all!

And it *is* the best way, so long as it isn't a disguised version of method number two. If this kind of instantaneous choosing is merely a flamboyant way of arriving at a choice rigidly made beforehand, it loses a great deal of its value. If you choose the roast beef because it leaps off the menu at you but also because you can't even *fathom* having a salad or a stir-fry, you are less open to the process of choosing than you might suspect. You may snap your fingers and go, "This choosing thing is easy!" But aren't you potentially missing out on your most important ideas?

If, however, the first method is the third method done very rapidly—real analysis done at computer speed, followed by surrender to the choice and commitment to the choice—then the result is indeed of inestimable value. It is the nugget of an idea that comes in the night, the snapshot moment that yields a work of art, the song idea with rightness, the sculptural idea with strength. It is the result of intricate analysis, done out of sight and presented to the conscious mind whole.

For it is the third method that is essentially the best: intricate analysis, an alert checking of the merits of the various ideas, testing of the sort described in the previous section, a selection based on an informed understanding of the possibilities. This play, that play, or the script? Well, let me see now, play A has this to recommend it but these drawbacks, play B has this to recommend it but these drawbacks, script C has this to recommend it but these

drawbacks. Let me see now. On balance, all things considered, I think play B is the one. All right. I am choosing. I have chosen.

The artist must yield himself to his own inspiration.

GIUSEPPE VERDI

EXERCISE
EVALUATING THREE IDEAS

Have you several ideas that you might want to work on? Choose three of them to consider. If you haven't several ideas, please take a few minutes to invite some new ideas forward.

You are to judge the merits of each one. How? A good question! Give it a try.

Idea 1

Pros *Cons*

_____ _____
_____ _____
_____ _____
_____ _____
_____ _____
_____ _____
_____ _____

Idea 2

Pros *Cons*

_____ _____
_____ _____
_____ _____
_____ _____
_____ _____
_____ _____

Idea 3

Pros *Cons*

_____ _____

_____ _____

_____ _____

_____ _____

_____ _____

_____ _____

_____ _____

Calculation

On balance _____

Decision

Therefore, I am choosing _____

There is not *a way* to make this calculation. But that isn't to say that such calculations can't be made. It is possible to order exactly what you really want to order (no matter that the dish that arrives is saltier than you expected) and to select an idea to work on that is exactly the idea you really want to work on (no matter that in the working out it sours or takes a detour). This calculating is possible. But you must figure out how.

> *The aim of art, the aim of life can only be to increase the sum of freedom and responsibility to be found in every person and in the world.*
>
> ALBERT CAMUS

Consider the following metaphoric idea. Usually we conceptualize "choosing" as the process by which a unitary self selects

among alternatives. The implication is that there is a coherent "I" that chooses. While we know perfectly well that we experience different pulls when we attempt to choose—conflicting thoughts, conflicting feelings, conflicting values—we still rather hold to the idea that a single integrated "self" is making the decision.

But think for a second of the possibility that we are an amalgam of coexisting and interacting selves. What does that imply about choosing? Will the selves bring forward different ideas which will be judged by an internal steering committee or by some boss self? Who will make the choice and how will the choice be made? Mightn't it be the case that if the decision is arrived at by anything less than consensus, then blockage is likely to occur?

Making a decision is a commitment. It always involves the risk of failure, and it is an act that my whole Being is involved in.

ERNEST KEEN

The brush stroke at the moment of contact carries inevitably the exact state of being of the artist into the work, and there it is, to be seen and read by those who can read such signs.

ROBERT HENRI

EXERCISE
SELVES AT WORK

Imagine that you are made up of many selves or subpersonalities. If any of the following selves "exists" in you, discover its role in your decision-making process.

- The self who knows how much things cost. It knows how much it will cost in time to commit to a novel versus a short story, how much it will cost in terms of pain and anxiety to commit to a difficult idea.

What role does this self play in your decision-making process?

What choices does it typically opt for? _____

- The self who knows what work has a good chance of selling, what work has some chance of selling, and what work has little chance of selling. This self not only knows what things cost but also knows how to sell, who buys what, what's going on in the marketplace, and other real-world things.

What role does this self play in your decision-making process?

What choices does it typically opt for? _____

▾ The self who knows the quality of the work you do. This self knows that you are not masterful at perspective or counterpoint, that you often let your best ideas slip by, that when you surrender and work hard you really are quite capable. This self knows a lot about your abilities and disabilities and about the work you have done and are capable of doing.

What role does this self play in your decision-making process?

What choices does it typically opt for? _____

▾ The self who wants to take risks. This self hates to be bored, never wants to make the same thing twice or do the same thing twice. This alter-ego would happily rush off to Japan to see a sunset and happily drop a prized bowl on the pavement to see what pattern the shards make.

What role does this self play in your decision-making process?

What choices does it typically opt for? _____

I am very much aware of my own double self.
INGMAR BERGMAN

What is really important is the nature of the artist, not the nature of the material.
JACQUES LIPCHITZ

Scratch an artist and you surprise a child.

JAMES GIBBONS HUNEKER

▾ The self who needs to work on one thing over and over again. This self desires tried-and-true images, could listen to the same song a hundred times in a row, likes things in their place, never tires of the paintings on the walls, happily follows a character from story to story in a genre series.

What role does this self play in your decision-making process?

What choices does it typically opt for? _____

▾ The self who knows about finiteness, smallness, mortality, despair, and other such things. This self does not believe that pigment on a canvas amounts to all that much, that a novel can possibly capture the roundness of life, that writing a poem has any chance of saving one's soul. This self particularly loathes bad art, its own and everyone else's, for bad art is disappointing as mortality is disappointing.

What role does this self play in your decision-making process?

What choices does it typically opt for? _____

▾ The self who is in love. This self loves the smell of paint, the sound of a violin, the beauty of a page of crafty prose. This self grins happily in a bookstore, blissfully watches movies, goes to heaven and back at the hearing of beautiful music. This self knows that eternity resides in every instant.

What role does this self play in your decison-making process?

What choices does it typically opt for? _____

Are there other selves you recognize in yourself? Name and describe them.

Another self: _____

What role does this self play in your decision-making process?

What choices does it typically opt for? _____

Another self: _____

What role does this self play in your decision-making process?

What choices does it typically opt for? _____

Another self: _____

What role does this self play in your decision-making process?

What choices does it typically opt for? _____

I don't believe a committee can write a book.

ARNOLD TOYNBEE

> How do these selves coexist and interact? Who's the boss, and in which situations? What are the various influences of these selves when it comes time to choose among ideas and select one to work on?

What you think, you become.
MOHANDAS GANDHI

Can you make your selves collaborate and not quarrel? Can you help them reach consensus? Take some time to fathom the implications that arise from the possibility that you are not a unified self but a rowdy team in need of some self-coaching.

A Choosing Flow Chart

The flow chart that follows summarizes the activity of choosing as described in this chapter.

Remember that a time must come when you choose *to work,* even if you haven't arrived at a vivacious idea to work on. Use this flow chart but do not circulate endlessly, inviting up ideas and then rejecting them one after another. Once you've circulated half a dozen times, say, choose to work without an idea. Commit at that point to encountering the blank page or the blank canvas.

YOUR CHOICE

Millions of artists and would-be artists do not work at their art because they cannot make choices. They are defeated not by the process of art-making but by the process of choosing. They spend years on the horns of a dilemma—whether to start this historical novel or that mystery—remaining all the while agitated, depressed, and unfulfilled.

Sometimes they do work at their art, but absently and half-heartedly. They "choose" figurative work and make a small effort to get a model, but the model cancels and the artist never calls her back. Months pass. A decade passes. Like the diner who really doesn't care if her entrée ever arrives, the artist waits, not exactly hungry but at the same time starving.

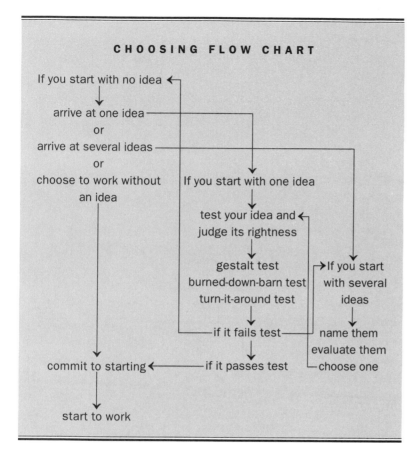

CHOOSING FLOW CHART

If you start with no idea
↓
arrive at one idea
or
arrive at several ideas
or
choose to work without an idea

If you start with one idea
↓
test your idea and judge its rightness
↓
gestalt test
burned-down-barn test
turn-it-around test
↓
if it fails test

If you start with several ideas
↓
name them
evaluate them
choose one

commit to starting ← if it passes test
↓
start to work

That an artist robustly chooses does not mean that she knows in advance that her choice is right. Choosing does not guarantee a successful outcome. It is simply something the artist must do. Since the outcome may prove unsuccessful, the artist naturally feels anxious during this choosing process. But she begins. She chooses at the very least to stand in front of the blank canvas, to boot up the computer, to sit at the piano. If she is lucky, a moment of conviction will arrive, a moment of certainty or reduced uncertainty, when she commits to the choice she's so far held as a provisional one. But for that moment to arrive, she must choose to be there.

I hope that you now possess an idea to which you can provisionally devote yourself. If not, I hope that you can commit to starting without benefit of a vivacious idea. One way or the other, starting is the next step on the agenda.

BELLIGERENT COMMITMENT

Starting Your Work

You've now chosen an idea to work on or chosen to work without an idea. You've chosen to write that play about mothers and daughters or that novel about the Midwest and skeletons in the closet. You've chosen to paint a large self-portrait, larger than anything you've attempted before. You've decided to work on that opera set in the suburbs. Or you've chosen to work without an idea, to encounter a blank canvas or the computer screen with "no mind" and fierce energy.

Now you must start. Starting entails a commitment that choosing does not. It is one thing to choose not to smoke. It is another thing to actually not smoke. It is one thing to choose to travel to Tahiti. It is another thing to check on airline prices, get vaccinated, and renew your passport. It is one thing to choose to cold-call a literary agent about a book idea. It is another thing to pick up the receiver and dial the number.

I have 21 pages, unusable, unprintable, destructive of the book as my mind still partly sees it, contradictory of character and inconsistent in tone. But I am undoubtedly started.

JANET BURROWAY

Starting separates the artist from the would-be artist. Starting separates alive people from the multitudes in limbo. Starting is a manifestation of strength, and the anxiety of this stage of the creative process is weakened-mind anxiety.

WEAKENED-MIND ANXIETY, APPROPRIATE AND INAPPROPRIATE STRENGTH

There's always that frustrating chasm to bridge between the concept and the writing of it.

FANNIE HURST

This weakened-mind anxiety, which prevents countless people from creating, is experienced as fatigue, heaviness, a fog in the brain, depression, apathy, boredom, emptiness, dullness, stupidity, and a host of other knee-buckling feelings. It is an anxiety that makes you want to cry, sleep, watch TV, slit your wrists. Its attack is doubly disabling because it saps not only strength but self-esteem: the weakened would-be creator feels weak but also humiliated by his weakness.

Indeed the fog may feel so dense, the emptiness so great, the fatigue so overwhelming that the would-be creator does not even hear that he is saying "No!" to the work. He simply turns away without a clear sense of having failed himself and so maintains his illusions: that, on the positive side, he is really about to work or that his work is being unconsciously incubated, or, on the negative side, that he is empty and hence uncreative, that he is someone around whom the muse has taken a detour.

All these—the fog, the emptiness, the weak knees, the negative self-talk—are nothing more and nothing less than the physical and mental consequences of anxiety. You are *anxious,* plain and simple, as you confront the matter of starting. Your mind has weakened in the face of the difficulties you believe will engulf you if and when you begin. If only creating didn't require all that active aloneness, incessant choosing, confrontation with the idea, thinking, confrontation with self, mistakes, parts failing, the whole failing, and all the rest, you would certainly start! But faced with the serious reality of starting and not the mere wish to create, your body alerts you with a whole-body "Warning!" and your mind loses its muscle tone.

This is the severe anxiety reaction that the would-be artist and the blocked artist experience all the time. This *is* the blockage.

But the seasoned artist and the working artist experience it also. Indeed they do! They may experience it more mildly, or just as severely but not every day. They may be less phobic, less panicked than the blocked or would-be artist, but still they find themselves unpleasantly distressed, unhappily weakened. Instead of starting powerfully, they limp to the computer screen, white-knuckle the encounter, and groan as they knead their new clay, wild artists tamed by anxiety!

This is a horrible affliction, a calamity, but entirely natural. This *is* the anxiety of this stage. What is a person to do? What will you do? The "why" of the calamity is real and important, but also irrelevant. You must find the strength to start, no matter what the reasons are for the severity of your anxiety reaction.

How do people weakened by these attacks of anxiety find the strength to start to work? In both inappropriate and appropriate ways; and those who find strength inappropriately far outnumber those who start out healthily. These inappropriate ways include all of the following.

Weakened artists begin:

- By beating themselves up, calling themselves names, and, bloodied by shoulds and a heavy sense of duty, taking their swollen eyes and bruised hearts to the studio.

- By finding fortitude (that is, relaxation) in drugs that chemically quell their anxiety.

- By engaging in magical thinking and convincing themselves that the work won't be so hard—"Hey, any jerk can write *The Brothers Karamazov*!"—and then, unable to tolerate the frustration of real work, lasting barely five minutes at their work before they have to make a phone call or hit the café.

- By squeezing their minds shut and narrowly focusing on something do-able, something pre-formed and known that requires only care and not creativity.

- By starting with a dilettante's mind-set—"So what if the work turns out poorly, I'm an amateur and *not really*

I felt tired ahead of time for the work to be done to build The Book word by word.
MAXINE HONG KINGSTON

Not writing is probably the most exhausting profession I've ever encountered. It takes it out of you. It's very psychically wearing not to write—I mean if you're supposed to be writing.

FRAN LEBOWITZ

My second day of work is a bust as far as getting into writing. I suffer as always from the fear of putting down the first line. It is amazing the terrors, the magic, the prayers, the straitening shyness that assails one.

JOHN STEINBECK

trying"—and, bored and unengaged, working precisely as superficially as they intended.

▾ By marshaling their anger at themselves and the world and attacking the work while crying "Fuck it!"; which exclamation translates as "I know I shouldn't do what I'm about to do in the bad mood I'm in, but I'm going to do it anyway!" They then slash at the work, murder it, hone their ironies, dump their vitriols.

▾ By standing on craft, as if craft could save them. (Interviewer to Martin Scorsese: "Mr. Scorsese, you know *everything* about film!" Scorsese, testily: "What would I know if I only knew about film? I know about *life*.")

▾ By rationalizing an interest in shallow work, arguing that a foolish culture deserves what it gets, that a sucker is born every minute, that since sex sells they will sell it, that since kids consume they will sell to kids, that since more patrons can be found for flamboyant, ridiculous work than for sincere work, they will be scrupulously flamboyant and ridiculous.

▾ By finding as their only motivation "career paranoia" and provoking themselves to work by the specter that other artists are "getting ahead of them" or "catching up with them."

▾ By returning to a successful style that is "well-liked," acceptable, and profitable, one that was initially heartfelt but that is now stale and formulaic.

These inappropriate strengthening maneuvers do help quell anxiety and do help an artist start. But they are inappropriate because they do not support an artist's desire to do work that is true and beautiful. An artist strengthened this way is a shadow artist and not the moral witness he or she might have become.

The appropriate ways to quell weakened-mind anxiety are precious and few. They are the following eight, and our discussion of them is the subject of this chapter.

You must:

1. Learn to really say no to the work when you mean not to work. You must become accustomed to saying no clearly and consciously, so that you can also become accustomed to saying yes.

2. Grow friendlier with active aloneness.

3. Belligerently commit to starting.

4. Transform yourself by beginning to manifest the qualities of an artist.

5. Learn to recognize the most important split second of your life, the moment when, on a given day, you either say "no" or "yes" to the work.

6. Learn how to better negotiate the most important short walk of your life, the walk to your work space.

7. Learn how to better encounter the first hundred seconds in your work space, so that you invariably enter the trance of working.

8. Learn how to do all of this again and again, each new day.

I have found that the key to not being blocked is to not worry about it. Ever.

CAROLE KING

I think that when I get blocked, it's that I have something to say but I don't want to say it. So my mind says, "I have nothing to say." Closer to the truth is that I have a thought I really would prefer not to have.

PAUL SIMON

SAYING "NO" TO THE WORK

Just as surrender is the road to self-control, so is saying "no" to the work the road to starting.

Would-be artists, blocked artists, and all artists some of the time live in a state of perpetual "maybe," neither affirming their work nor baldly denying it, neither gearing up to work nor frankly living the rest of their life. This "maybe" is of course tipped strongly in the direction of "no" and may in fact be a "no" masquerading as a "maybe," but because it is held as a "maybe" the person avoids the anxiety that would come from saying "yes" and the guilt that would come from saying "no." It is a "maybe" for safety's sake, a three-quarters "no" without the sting of a full "no," a hushed "no" without the power to jar (and awaken) that a full "no" would bring.

This "maybe" is a state of dynamic tension, not calmness. It is

I wasted a lot of time just by dreaming of what I was going to do, rather than working. But that is natural with young people.

RAPHAEL SOYER

not a conclusion but rather a question that continually demands an answer. "Am I about to work? Yes? No? Which is it?" It is a state in which the person waits for the other shoe to drop: a vital question has been asked and all that is forthcoming is a hesitation, a doubt, a confusion, an interim answer, a stall, an evasion.

In terms of concrete actions, this "maybe" is virtually always a "no." The artist does not wake up and go right to the computer screen. The "maybe" is a "no": it is a cup of coffee, a little pacing, a little desk-cleaning. The "maybe" is a "no": he reads the paper, walks by the ocean, calls a few friends. It is not a complete "no," for if it were he would feel too guilty and agitated. It is that damned "maybe," that damned seven-eighths "no"! Saturday evaporates, Sunday evaporates, the "maybe" has verged on "yes" at times, but in terms of concrete actions the "no" consumes the weekend.

For the would-be artist, for the artist who works very infrequently, for the artist in a protracted stagnant period, the "no" is likely so quiet an injunction that it can't even be heard. There is no "yes," "no," or "maybe," no real dispute, no real question demanding an answer, just a state of constant self-reproach, sadness, and deadness. The "no" is there, but quiet as a virus. *It is vital that you clearly hear this deadly, silent "no."* Silent injunctions breed guilt and frustration and steal decades from an artist's life.

If you want eventually to say "yes" to the work, you must say "no" more forthrightly. To keep the "no" a secret from yourself is to make the "yes" all but inaccessible. Better to be frankly disappointed in yourself that the "no" is so loud than to be *bitterly* disappointed in yourself after decades of secret "no"-saying.

EXERCISE
SAYING "NO" LOUDLY AND CLEARLY

Unplug your phone and dial a number. Visualize the person you're pretending to call. It can be anyone able to do the not-so-simple task of agreeing with what you're saying. You don't want him or her to hold the "no" you are about to articulate as a "problem" to solve or to dispute. The other person is simply to agree with you in a host of inventive ways.

Dial the number. Have a brief conversation about the weather. Then let the other person know in no uncertain terms that you don't mean to create, that you don't mean to work, that you don't mean to start.

"No, I'm not going to work now!"

"I hear you."

"No, I'm *not* going to work."

"I hear you."

"No, damn it, I'm not going to work now!"

"All right."

"Damn it, I mean it! I'm not going to work. I won't write that book!"

"Fine."

"Nothing will make me. I won't write that book."

"I hear you."

"No, no, no, no, no!"

"I hear you."

"I won't!"

"All right."

"Never!"

"I hear you."

"No, no, no, no, no, no!"

Wear yourself out saying "no." The goal is not to "get to yes" but to honorably acknowledge the "no." Learn to hear it. Learn to say it. Hate it, but hear it.

All the time I'm not writing I feel like a criminal. It's horrible to feel felonious every second of the day. It's much more relaxing actually to write.

FRAN LEBOWITZ

I long for solitude and yet I cannot stand it.

EUGENE IONESCO

Is it honorable to say "no" to the work? Yes! Is it vital to say "no" to the work? Yes! Is it permitted to sit in the sun and sip a soda and not feel guilty about not working? Yes! Is it right to say "no" to the work when you hear your child crying, when your loved one wants a hug, when your day job demands it, when there's a wrong to right or a principle to defend? Yes!

There are a thousand times when you can righteously say "no" to the work. But there are as many times when you must righteously say "yes." Between the two there is no time left ever to say "maybe."

ACTIVE ALONENESS

When you do say "yes," where will you be? Completely alone.

In order to start, an artist must invite in and be able to tolerate *active* aloneness. We can all tolerate passive aloneness reasonably well: in that dull state we can nap, watch TV, read a book, garden, do a puzzle, play solitaire. But active aloneness is a cat of another stripe. To be actively alone means to be belligerent, alive, ecstatic, afraid, on your feet, wired, doubtful, upset, fired up, and all the rest. It means that mistakes are about to happen. It means that contradictory ideas are about to engulf you. It means that conflicts and confrontations are about to occur. It means that investments are about to be made and capital spent. As the painter Agnes Martin explained:

Some people who might otherwise be artists turn their creative talents elsewhere because they cannot tolerate being alone for extended periods.

ANNA HELD AUDETTE

> The solitary life is full of terrors. If you went walking with someone that would be one thing but if you went walking alone in an empty place that would be an entirely different thing. If you were not completely distracted you would surely feel "the fear" part of the time, the pervasive fear that is always with us. In solitude this fear is lived and finally understood.

Stop!

You must come to grips with the question of whether you can tolerate active aloneness. If your demons are such that they fill the room the instant you contemplate creating, your studio will be too dangerous a place to enter. *Do* demons fill the room when you try to think deeply? If so, engage in the following exorcism.

Light a candle, darken the room, and sit quietly. Say out loud, "I know I have reasons to be afraid." Say out loud, "I know I'm my own worst enemy." Breathe calmly. Sit quietly. Build a sturdy cage in your mind as large and strong as a lion's cage. Invite the demons to enter, one by one. Your mad mother. Your critical father. The alcoholics on your mother's side, one by one. The arrogant, small-minded doctors and lawyers on your father's side, one by one. The nun who embarrassed you. The men who've pointed

fingers and laughed. The women who've snickered behind their hands. The pastor who preached about hell. The aunt whose slip always showed. Everyone who should have cared but didn't.

Fill up the cage. Get rid of them all. Get all your own nasty parts into the cage. The part that hates you, that hates you for all your failures, all your incompetencies. The part that thinks you're ugly, stupid, a fraud. The part that doesn't care whether you live or die. The part that can only think about what others have and what you don't have. The part that wants you deaf, dumb, and blind. Leave only the best parts of yourself. Drive everyone else into the cage. Slam the door shut.

No one can open it! No one can get out!

Now lift the cage with everyone in it and drop it into the deepest part of the ocean. Watch it sink deeper and deeper. Cry out, "Damn you all!" Watch them drown. Do not feel guilty: this is an exorcism, not murder. Do not feel loss: the hell with them! Exorcise your demons. Do you really want them back inside you? Then let them drown!

Take a rest. Nap. When you awake, work a bit on your idea. Start. Enjoy the silence. Relish your solitude.

Solitude is a choice.
OLIVER MORGAN

If you're frightened of being alone, frightened of your insides, frightened of what you'll discover or what you'll hear when you hush and hold, you must work both on loving yourself more and making solitude a safer place.

STARTING STRONGLY = BELLIGERENT COMMITMENT

The sculptor Beverly Pepper explained, "I learned that making art is work. It was the beginning of a belligerent commitment. For instance, now I go to my studio every day. Some days the work comes easily. Other days nothing happens. Yet on the good days the inspiration is only an accumulation of all the other days, the nonproductive days."

With whom is the artist belligerent? With herself. She knows

all about her own disinclination to work, all about the possibilities of failure that confront her, all about the doubts that assail her. She is belligerent in her refusal to allow those real obstacles to prevent her from working.

A less-than-belligerent commitment is the artist's curse. If you want to hex an artist, hex her that way. Make her commitment to her own wish, to her own ideas, to her own choices less than belligerent. Reduce its potency by just enough that each morning she wakes up almost ready to work, but not quite. Give her a doubt to trip over each morning, right next to her slippers. Give her a competing desire, a lack of confidence, a little something to sap the life out of her commitment.

Or give her just enough commitment that she manages to boot up the computer, but with her mind in retreat. Give her just enough commitment that she starts out striding to her studio in a burst of fiery energy but loses energy every inch of the way, so that by the time she's put her palette together her eyes are glazed over. Give her just enough commitment that she manages to make the first four funding calls to strangers in behalf of her documentary film but not the fifth call, the hardest one of all, to her wealthy uncle. If you really mean to hex her, give her enough commitment so that she manages to work, but not so much that she is able to work deeply.

The belligerent commitment the artist wants is at once a commitment to start, a commitment to start with energy, and a commitment to continue with energy. To start already defeated does not make for a belligerent commitment. To start with your first long break already in mind does not make for a belligerent commitment. If you want to work without such a commitment, do less important work than creative work.

ACT

Make a belligerent commitment to your idea or to your choice to work without an idea by right now shouting out loud, "Yes!"
 "Yes!"
 Scare the neighbors. Hope that someone will call the police. Shout at the top of your lungs, "Yes!"

Get rid of all the "No's!" that are stopping you. Write down a hundred no's on a hundred slips of paper and burn each one. Stencil "No!" on an orange and jump up and down on it until it's flattened.

"Yes!" Not "No!"

THINK

Every day you will need to restart. After every break you take, you will need to restart. Between thoughts, between paragraphs, between brush strokes, you will need to restart. How can you restart undramatically and untraumatically the next million times? For in your working life it will literally be a million times.

How can you restart yourself a million times over?

The idea: *a healthy ignition system.*

You want a healthy ignition system. You may be emotionally disabled, constipated, paralyzed, stuck, sad, but you must consider those other ailments as existing elsewhere in the vehicle. Even if you have a cracked windshield and an exhaust pipe that drags the ground, still you must *at least* have a decent ignition system. If you have that, the car will start and you can limp to a gas station. If you can start, you can begin to repair the vehicle.

The idea: *a healthy ignition system.*

FEEL

Can you sense in your body what a healthy ignition system would feel like, what it would feel like to start on a creative project undramatically and untraumatically?

Can you feel what ease feels like? Can you remember what it feels like to turn the key in the ignition of a new car with a well-built engine? The effortlessness. The quiet. No need to think about anything. Nothing to fear. You just turn the key . . .

Try to locate that feeling of ease. Feel it. Feel the purring of a quiet, well-maintained engine. Feel it. Purr inside.

Even the tiniest act of the will towards a thing is better than not doing it at all.

CHRISTOPHER ISHERWOOD

The person who calls himself an artist and who works at his art may nevertheless not have committed to all that being an artist entails. He may still require inspiration to work, still find more

reasons not to work than to work, still turn over more psychic space to comparing himself to others or doubting his abilities than he does to the artwork inside him dying to live and breathe.

It is thus only *possible* and not *certain* that an artist will really commit to the work he starts to do. He begins his play or sculpture but only with half a mind and half a heart, never quite caring about it or investing in it. This, after all, is not so rare a way of working. People work this way all the time, both in and out of the arts.

Artists who do their signature work without any longer caring, simply because readers are waiting for their next novel or buyers are lined up for their next paintings, are easily snared in this trap. Once they were committed; now they're professionals.

Artists who tinker on projects and find things finished around them—finished, as it were, by someone else who held the brush or made musical notes on the page—are likewise caught in this trap. Such works are not "justified," in the sense that the novelist Joseph Conrad meant when he said, "A work that aspires, however humbly, to the condition of art should carry its justification in every line."

The artist who is uncommitted to the project at hand will leave traces of that lack of comitment in the work. A novel that is too short may be one to which the writer never committed; but so too may be a novel that is too long. As the mathematician and philosopher Blaise Pascal put it, explaining to a friend the length of a letter, "I have made this letter longer than usual, because I lack the time to make it short." Commitment means a commitment to take the extra time needed to make the work right, insofar as it can be made right, even if one has invested much time in it already.

Committing a lot of time to art is thus not the same as committing. The uncommitted artist may work very hard and produce very much, but blindly, like a zealot. The philosopher George Santayana remarked that "fanaticism consists in redoubling your efforts when you have forgotten your aim," and many artists are good at obsessively covering canvases or writing songs by the hundred, without, however, stopping to put their hearts into their work. The commitment an artist requires is a commit-

For my very first play I made a complete outline. Then I started to write it and found the characters heading off in another direction, completely in opposition. Now I don't make an outline at all. I begin—I just put the paper in and go.

NEIL SIMON

Until the day of his death, no man can be sure of his courage.

JEAN ANOUILH

ment to make the time but also a commitment to deliver over her soul, to put her being on the line, to belligerently commit.

Is this a risk-free commitment to make? Of course not. The belligerent commitment Pepper described carries with it costs and dangers. In her own case, what accompanied the commitment was the loss of her marriage. She explained, "At that point I knew that painting was the passion of my life, and I was ready to give up everything for it. My husband knew that. He found he couldn't tolerate living with a woman whose attention was divided, and so the marriage was terminated in spite of my fear that I was leading my children into the very life I'd experienced myself."

No wonder that the specter of committing and the act of committing produce anxiety! Such a commitment is an announcement that the artist makes to herself that her life is now in the hands of the work—a surrender, a readying for battle, a gearing up, a pledge of time and psychic energy. But despite the dangers, despite the attendant anxieties, the artist really does want to commit. She knows that commitment is an optimistic, self-affirming act and that noncommitment is a pessimistic, self-murdering act.

The sculptor Auguste Rodin explained, "All master artists reach the private enclosure of the Unknowable. Some of them lamentably bruise their foreheads there. Others, who have a more optimistic imagination, think they hear from behind the wall the songs of melodious birds, who populate the secret orchard." The uncommitted artist bruises her own heart by not committing, while the committed artist, afraid like anyone else of not succeeding, afraid of not knowing enough, afraid of not doing well enough, still determines to listen to the songbirds and to record their songs.

To write this book I must come fully alive, care about life, and heal my own soul, for creativity is life-giving and demands that of me.
MELODY BEATTIE

Everyone must carry out a concrete assignment that demands fulfillment.
VIKTOR FRANKL

The Moment of Commitment

When exactly should this belligerent commitment be attached to a given new work? The moment the idea comes to an artist? Or the moment he chooses it? Or only after he has worked on it for a week to see if something is really there? Or only after he has completed a significant portion of it—a first chapter, say, or a first draft?

We cannot see our unborn creation, we cannot know it, but we know it is there and we love it; and that love drives us to realize it.

STEPHEN NACHMANOVITCH

Should it come very early on: but might not that be premature? Should it come quite late: but then hasn't the development of the idea lacked his best attention?

Artists are pestered and perplexed by such feelings but rarely understand that *commitment* is the issue. The artist is not likely to say, "Should I commit to this book this soon? That feels dangerous." He is much more likely to say, "I don't feel ready." Later on, having worked on the book halfheartedly for a month, he is unlikely to say, "Shouldn't I be committed to the book by now? It's been a month already!" Instead he says, "What's wrong with me?" The feeling is strong but the underlying reasons remain hidden from view. He knows that he has a problem but he can't name it or put a finger on it.

So, when exactly should an artist commit? The answer is a simple one. *The artist should commit every single second.*

What the artist commits to may change. First you're committed to nurturing your own wish to create, to arriving at ideas, to testing them, to choosing among them. When you've chosen an idea, you entirely commit to it while holding that the choice is a provisional one. Is that a paradox, to commit completely but provisionally? Perhaps, but that is still what you must do: *absolutely, completely, but provisionally* commit to the idea you have chosen to work on.

This complete, provisional commitment is not the same as incomplete or halfhearted commitment. This is not the same as wishy-washy wanting, limp desire, hopeful daydreaming. This is not the same as working because you've invested in years of lessons, because you're talented, because a deadline looms on the horizon, because a buyer exists for your wares. This is not a dutiful commitment but a belligerent, absolute, provisional commitment.

EXERCISE
COMPLETE, PROVISIONAL COMMITMENT

Make an omelette very carefully. Completely commit to making it. Beat the three eggs one hunded strokes or more. Use just the

right pan and melt the butter and oil to just the right temperature. Have all the ingredients ready: the grated cheese, the diced ham, the chopped green onion. Negotiate every step carefully, tenderly, with heart, with attention. Pour the beaten eggs in.

Feel your commitment to this omelette.

Now make a big mistake. Pour dishwashing detergent or kitty litter into the pan.

That is the end of this omelette. Throw it out. Clean the pan. Start over.

Begin your second omelette. Commit to it completely. Give it your very soul. This one will have chopped chives, mushrooms, red peppers . . .

I haven't the heart to ask you to ruin this omelette also. But as a creator, reaching up into the unknown for ingredients, you might. You might pull down cayenne pepper, roofing tar, India ink. Who knows? You might; many times you will. Then you will have to throw the omelette out and start over.

Complete commitment. But provisional commitment. One's soul in the omelette, but not after the omelette is ruined.

It's all a struggle. I don't know what should be there until it gets there.

SUSAN ROTHENBERG

This is what an artist must do every day of her life. She commits, but provisionally, because the facts may change. This may not be the book to write. She has the courage to see that. This painting may have failed. She has the courage to see that. The symphony may yield her up only one good movement. She has the courage to see that. Until she sees that, she is committed to the novel, the painting, the symphony. After she sees that, after she has used her whole being to save it, she says, "All right. I was committed to that and now I can't be. I'll have a good cry and go on."

Provisional but belligerent commitment. Amazing! You'll need three sets of eyes, two hearts, big muscles, an engaged brain, kilowatts of energy. You must surrender to this idea: *complete, provisional commitment.* Bring it with you when you start. It *is* the equivalent of starting.

As the painter Pierre Tal-Coat put it, "To yield to one's wonderment requires a necessary precariousness." To accept her birthright, an artist must take the plunge and completely, provi-

sionally commit. Then the work of creating moves from her heart and her mind into her hands.

BEING THE PERSON WHO IS AN ARTIST

An artist must be able to belligerently commit, tolerate solitude, and all the rest. Being an artist is not the same as choosing a career or learning certain skills but is instead *becoming and being a person who is an artist.*

Starting is primarily about being the kind of person who *can* start. Circumstances can slow any of us down, but the person with the qualities and worldview of an artist is less likely to be defeated by circumstances. He will write even though he still has to shop and pay the bills, even though the yard needs attention, even though not twenty minutes ago he had a sad, discouraging fight with his mate. He will write in these circumstances because he possesses certain qualities.

An artist's life is constructed out of the following active qualities. These are the building blocks that make one a fearless creator. I invite you to consider each of these in connection with starting. If you possess them, you will rarely experience difficulty starting.

> *Doubt is not a pleasant state of mind, but certainty is absurd.*
>
> **VOLTAIRE**

> *Man's greatness lies in his decision to be stronger than his condition. And if his condition is unjust, he has only one way of overcoming it, which is to be just himself.*
>
> **ALBERT CAMUS**

FIFTEEN ACTIVE QUALITIES OF THE ARTIST

1. Existing	6. Meaning	11. Affirming
2. Loving	7. Doubting	12. Rebelling
3. Dreaming	8. Committing	13. Looking
4. Thinking	9. Encountering	14. Learning
5. Choosing	10. Acting	15. Stopping

Existing

The fact that we exist, that we are alive, is a wonder and a mystery. But although it is a mystery, there is nothing doubtful about it.

The artist knows that she is alive: she experiences it, she learns from her own existence, she learns from her own aliveness.

We are each of us alive right from the start, we are something, but we can either work at the project of living or proceed passively. We are alive but we must also choose to live.

For the artist, not starting is equivalent to suicide. *Once you commit to existing, you will also commit to starting.*

Loving

A working artist's aloneness is guaranteed. But his relationships are not. To love a book, he must read one or write one. To love people, he must reach out his hand, not hold people at a distance. The artist understands that relationships are only *possible.* A relationship, whether with his work or with another person, does not exist until it exists, until its possibility is translated into reality.

For the artist, not starting is a condition of hatred. To be with his work is *to love.*

Dreaming

An artist can dream. She has this destiny: to entrance herself. We might call this state imagination, a hospitable mental environment, intelligent intelligence, or some immensely valuable hushing mechanism that allows her to go quiet inside, to bring what the sculptor Barbara Hepworth called "the stillness of a hill in Cornwall to Piccadilly Circus."

But let us call it dreaming and assert that, insofar as you refuse to dream, in that measure are you refusing to start.

Thinking

Thinking means: thinking for yourself. Education will suffice if you want to solve a crossword puzzle. Sheer brain power will suffice if you want to argue well. Experience and the right formulas will suffice if you want to build a bridge. But thinking for yourself and *even against yourself—that* is difficult. To think a new thing, you must kill an old thing.

An artist must put on his real thinking cap, not the one he wears to

Love is a high inducement to the individual to ripen, to become world, to become world for himself and for another's sake, it is a great exacting claim upon him, something that chooses him out and calls him to vast things.

RAINER MARIA RILKE

Whenever I face a blank canvas, I feel some panic. But I think the panic and its energy are a very good thing; they mean that I have no mechanical way of beginning and finishing a painting.

RAPHAEL SOYER

score debating points or to pay the bills. And when he puts it on he must be ready to think both for himself *and* against himself.

Choosing

If the universe does not belong to me, to whom does it belong? If I am not master of it, why am I not?

EUGENE IONESCO

Choosing is a difficult, absurd, and continuous activity in the lives of human beings and especially in the lives of artists. Choosing is the essence of freedom. And every choice is a loss of freedom! Choosing is the essence of judgment. And every judgment is doubtful!

Choosing is the way we take life seriously. Choosing is conflict, by definition! What is a choice but the end point of a small or large argument? And what does an argument do but precipitate anxiety? No wonder we flee from choosing and, hence, flee from freedom!

An artist must perpetually choose, but she is not perpetually at war with her own choices. If she were, she would never start.

Meaning

Artists must make their own meanings. But what does "making meaning" mean? It means something very simple—for example, the following. When a person, experiencing the world, uncertain, agitated, busy making decisions (because he can't help making decisions), and led one way or another by those decisions, discovers that he is disappointed by the direction he's taken, he thinks, "What am I to do next?" Insofar as he answers that question consciously, honestly, and in good faith, he is making meaning.

He is saying, "I will do this thing next and it is a good thing to do." If he merely flips on the TV, yells at the cat, or drinks to distraction, he remains embedded in a world of meanings but is not making meaning—nor would he say that he was. We all know the difference.

Starting is a meaning-making effort that demands that you prepare for change and even transformation.

Doubting

An artist is naturally doubtful about human nature. She knows that people lie, fool themselves, delude themselves, say one thing

and do another, prefer ease, act fearfully, hold grudges, exact revenge, close their minds, and more. She is aware of this in the world and she is aware of this in her own nature.

Doubts arise in her because she can see. She is the empiricist par excellence. But she doesn't fear *doubt itself*. She knows that doubting is an honorable state and that she must act even as she doubts. That may be both absurd and difficult, but so be it.

Doubting is not a problem. *But a fear of doubting is an absolute impediment to starting.*

Men are all alike in their promises. It is only in their deeds that they differ.

MOLIÈRE

Committing

Commitment is defined by action. The committed writer is the one who writes, who broods about dialogue, who raises his hand when someone says, "Is there a writer in the room?"

You cannot sit still and commit. Forget it. "You are committing" means you are actively entangled in that thing to which you claim to be committed. The artist is clear about this and therefore understands how often he is *not* committed and hence not authentically alive. When he is engaged in no action, inner or outer, in support of his wish, he sheds bitter tears; he does not tell himself the lie that he is incubating something.

Commitment is an entanglement, and so is starting. If you refuse to become entangled, you will not start.

Encountering

To encounter is to confront, but in an open, unguarded, and anything but angry way. The artist's encounter with her work is silent and humane. Encounter as the artist means the word is always the opposite of an adversarial proceeding. It is a "Yes!" and not a "No!", a give-and-take and not a pummeling of the canvas or the blank sheet of paper.

This is not to say that the artist's encounter lacks intensity. Anything but! To encounter means to marry life. It is a marrying of self and work as the poet W. H. Auden explained it: "The poet marries the language, and out of this marriage the poem is born."

For an artist, starting is a marriage, not an affair or a date.

Acting

Jean-Paul Sartre ends his seminal existential novel *Nausea* in the following way. In the depths of despair the protagonist, Antoine Roquetin, convinced that life is meaningless, sits in a café. He hears a jazz singer and something suddenly comes over him. "In the next instant," Sartre writes, "Roquetin, biographer and historian by trade, thinks of writing a book entirely new to him, a personal narrative: a novel."

At first glance this seems like a terribly slight answer to questions of nihilism and existential despair. But it is a truthful answer to an artist. When a person acts—writes a song, sings it, writes a novel—that is the human being at his best, not transcending the human condition but making real his human potential. Yes, that act is dwarfed into insignificance by the fact of a dozen billion other lives. Yes, as an answer it hardly provides a cathartic jolt. But it is still a true answer. Authentic acting redeems us a little and allows us, in Sartre's words, "to remember our life without repugnance."

An artist may despair, but he finds in art a way to live his life without repugnance. And when he acts, he despairs less.

Affirming

The artist affirms her own voice and her own being. Out of an abiding humanitarianism, she also affirms the voices and beings of others. Both her self-interest and her other-interest may be attacked: on the first score that she is egoistic, grandiose, arrogant, and selfish; on the second score that she is idealistic and unrealistic. Thus she will be *blamed* for affirming, when of course she should be praised.

This saddens the artist but does not surprise her. She knows that affirming is a dangerous, disliked activity and that disappearing is much more acceptable. But affirming is life itself and she will not do less.

The disaffirming person never starts. Starting is an affirmation, never a negation.

The great end of life is not knowledge but action.
THOMAS HUXLEY

As writers we are guilty of treason in the eyes of history if we do not denounce what deserves to be denounced.
ARTHUR KOESTLER

Rebelling

We only decide to enter the draft or evade it, have an abortion or not have it, create or not create, according to the astonishing gestalt in which we find ourselves embedded. How can a person so entangled muster the necessary clarity and courage to joust with just the right windmills, to sculpt the true and not the tried sculpture?

By always remaining right on the brink of rebellion.

Rebellion is central to an artist's job description. His role in life is as much to become some tyrant's worst nightmare as it is to create art. He hears a falsehood and he reacts with the truth: that makes him a rebel. Because he is in constant rebellion, he is always speaking out; and hence always starting.

Starting is a necessary consequence of an artist's need to rebel. Rebel more, and starting will follow.

Looking

Casting agents, whose job it is to recognize charisma in an actor, know that one sure measure of it is the aliveness of an actor's eyes. Most people, because they fear looking out at the world, have dead eyes. Their blank eyes, shut by fear, reflect what's inside them: utter boredom.

But an artist, as frightened as anyone, demands of herself that she keep looking. With her eyes open she can improvise, she can change course, she can see down the road a hundred miles and know what turnings to take here and now. Bright eyes are proof of aliveness.

To start you must look in the direction of your work. Open your eyes: brave what you see.

Learning

The artist is his own creation, and in order to create himself he must always be educating himself. He can't afford to join with those who prefer to remain ignorant; he moves from leeches to laser surgery and from classical mechanics to quantum mechanics, not because he believes in progress but because it is incumbent upon him to know the truth.

The eye—is it not the mirror of the soul in all living creatures?

ROSA BONHEUR

As a youth of fourteen, the poet Adonis (Ali Ahmed Said) went to hear the first president of the new republic of Syria speak. He brought with him a poem and was told that he could recite it after the dignitaries had spoken. Several hours later he got his chance. Adonis's biographer Samuel Kazo explained:

There are a million things in music I know nothing about. I just want to narrow down that figure.

ANDRE PREVIN

> The boy strode to the rostrum and recited his poem from memory. The poem was an appeal for cooperation between the newly elected president and a people never before permitted to participate in the running of their own country. Both sides, urged the young poet, needed trust, patience, and a sense of civic values. When Said concluded, the president left his seat, approached the boy, kissed him, and asked, "Tell me, what do you want?"
>
> The boy replied, "I want an education."

This is an artist in action. He is bold, smart, humane; and he demands an education.

Stopping

Stopping is the thing you do when you get up and work: you stop sitting and you start creating. Stopping is the thing you do when you end a bad habit. Stopping is at the heart of change, because to begin something new means to stop something old.

The artist respects her ability to stop. Her play is performed and reviewers excoriate it: she thinks about those reviews and then she stops thinking about them. That she can stop guarantees that she can start again. Stopping means saying "no," "no" to critics, "no" to phantoms, "no" to negative thoughts. There is nothing finer than being able to stop what ought to be stopped; which is why an artist values this quality so highly.

An artist trusts that she can stop. If she didn't trust herself in this regard, she wouldn't be able to start.

EXERCISE
CREATING ONE AMAZING SENTENCE

Take these fifteen qualities and make from them one amazing sentence, a sentence that you can memorize and affirm, a sentence that will remind you of who you want to be and who you need to be in order to start.

For example:

I affirm that even though I am a doubting creature I am committed to myself and others and committed to encountering my work; that I will act to make my time on this planet meaningful to me; that I will open to the love I feel without renouncing my true need to rebel; that I will dream more, think harder, and fear choosing less; that I will keep my eyes open and never end my education; and that when I come to the end of a sentence, I will stop.

Try your hand at creating a sentence you can affirm. Once you succeed, you'll have captured an artist's essence.

Art, like morality, consists in drawing the line somewhere.

G. K. CHESTERTON

THE MOST IMPORTANT SPLIT SECOND OF YOUR LIFE

Even a productive artist is much of the time saying "no" to his work.

An artist wakes up and says his first "no" of the day. He reads the morning paper, has a cup of coffee, reads another section of the

paper, has another cup of coffee. All the while, the pressure to work and the pressure not to work are building. It is becoming harder every second *not* to work and harder every second *to* work. An explosion is brewing. Then, finally, the most important split second of the artist's day arrives. He must say "yes" to the work or find an entirely new way to say "no." He must work or run: he just can't sit still any longer.

For thousands upon thousands of creative people, this is the saddest moment of the day. It may have been frustrating to read the paper for longer than one wanted, but this next "no" is not just an added frustration. It is a self-betrayal, a failure of will, an act of cowardice. The first wasted hour could be excused as "getting ready" time, but the next wasted hours are different. They mean that you've lost one whole day of your life.

It is by coming to recognize the importance of that split second, when you say a final "no" to the work and effectively eliminate that day from your life, or else say "yes" to the work and start, that you can do the most to turn your creative life around. If you can isolate that moment, really see it coming and really understand its arrival, you can ready yourself, affirm yourself, rehearse your "Yes!" and say it. "Yes!"

In that split second, your day is made or broken. If you pay attention to no other moments in your life, pay attention to these. In the course of a year they amount to no more than twenty minutes; in the course of a working lifetime to no more than a single day.

> Stop!
> Don't let this idea go by. "The most important split second of your day." Do you tend to recognize it? Do you tend to see it approaching? Are you aware of that terrible, final "no" creeping closer? Do you know how it sounds as you whisper it and run from the table?
> Kill to arrive at "yes" instead. Kill; or do something subtle and gentle. Or just get lucky! It hardly matters whether you arrive at that "yes" by brute force, luck, or a miracle. Just remember: on days that you say "no," you're no better off than a zombie.

I'll walk down to the beach, then call somebody up. I'll sleep for a while, go into town, go to a movie. Then I'll get back to painting, but with tremendous resistance, like I'm in a pressure cooker. Finally it pops, a seam breaks, and I'm cooking.

ED MOSES

It's one little step between being happy and being depressed.

ISAAC BASHEVIS SINGER

The Most Important Short Walk
of Your Life

You need this "yes." It is vitally important. It is the mother of all affirmations. But this "yes" must also be sustained, for you can't begin to work instantly. First you have to walk to the studio or the computer. You have to get your palette together, boot the computer up, collect your notes, get the clay ready, find where you are in the symphony. You have to turn the lights on, open the window, make the tea. A certain number of seconds or minutes stand between your "yes" and actually working.

Think of the following metaphor. A comet in empty space has an orbit that is affected by the gravitational forces of other objects in space. One fine day that comet may find itself on a collision course with one or another of those larger objects. All along, the comet had drive and direction, but the drive and direction that it acquires when it is pulled to collide with a planet, as the Shoemaker-Levy comet did before it struck Jupiter in the summer of 1994, has special significance for us.

Think of that comet flying toward Jupiter. In every instant it can be described as a vector, as a quantity with magnitude *and* direction. It can be described as an arrow of a certain length pointing in a certain direction. *You,* if you are to make the short journey from where you are now to where you will work, are that comet. Starting means having momentum *and* direction. Starting means flying across space right at a target and with sufficient velocity to strike it a real blow.

Point yourself in the direction of your work. Is just doing that hard—pointing yourself at the piano, your painting studio, your darkroom, your desk? How profound is our resistance to starting! Right now, do whatever it takes to point yourself in the direction of your work.

Good! You've aimed the arrow. But with what force will your arrow fly? With what force will your comet strike Jupiter? Modestly? With only a little puff? Or so explosively that the dust cloud can be seen on Earth? Will your arrow bite deep into the work?

You had the wish to create: that was you orbiting in empty space, circling the sun, not yet on a collision course with the work.

When I start a play what's of concern to me is telling an enormous story, an incredible story. I need to tell a remarkable story and to tell it in whatever way I can.

CHARLES FULLER

Creativity occurs in an act of encounter and is to be understood with this encounter as its center.

ROLLO MAY

As soon as your mind knows that it's on and it's supposed to produce some lines, either it doesn't *or it produces things that are very predictable. You want your mind to wander, that's really what you want to happen.*

PAUL SIMON

Then you began: you hushed, you began to hold ideas, you began to choose among them, your imagination ignited, you began to work outside of conscious awareness, you oriented this way and that in the galaxy, coming ever nearer to the single idea that, like Jupiter, would exert a final gravitational pull.

Jupiter is pulling! Aim yourself in its direction. Feel the pull. Your work is pulling! To get to it, you must leave your feet, fly through the air, surrender to the pull, provide direction and accept direction, provide momentum and accept the acceleration that the work provides. It is a big thing, the work, and can pull like Jupiter! Grant it this power. Consider the movement from "yes" to "starting" an event as dramatic as any the universe has to offer.

Much happens in this short space of time, as you journey across the room to your work space. You think about the work. You make calculations out of conscious awareness about where exactly to start, what the work will look like, how to resolve a plot problem. You obsess about the word you still haven't found that is needed to finish the third line of the poem. You try desperately not to forget the bit of melody on your tongue.

Or you avoid thinking about the work and find your mind on autoscan. You grow weak, anxious, uncertain. You think about your evening date, about how hard it will be to stage your opera, about how much you hate your husband, about the bad streak of weather.

What is going on? Either you are preparing to work or preparing to leave the work. You are gearing up or already shutting down. The "yes" is front and center, or the "no" is returning.

If ontogeny recapitulates phylogeny, this walk to the computer screen or sculpture studio recapitulates all that has gone before, all the wishing, choosing, dreaming, doubting, all the self-affirming or self-dismissing, your whole life as a creative or fearful person. One day it recapitulates your life one way, building on successes, strengths, and optimism; another day it recapitulates your life differently, building on failures, weaknesses, and pessimism. Both walks are true, both walks are you.

Can you master this recapitulating, this short walk to the work, so that you're more often building on your strengths? If af-

firming the "yes" was the most important split second of your life, this walk is the most important short journey of your life.

EXERCISE
WORKING WHILE WALKING

Can you recognize the difference between maintaining the "yes" or slipping into "no" as you walk the short distance to the work?

Practice walking across a large room. You're on your way to work, striding out, affirming the "yes." This is not a walking meditation, you're not after "no mind" or pinpoint concentration. What you want is the experience of feeling as if you are *already working*.

Your brain is on, working. Your juices are flowing. You can hardly wait. How long it takes for the computer to boot up! How long it takes to make new clay! You're ready, eager to put in an hour, eager to push the project along, eager to make the beautiful thing, eager to tell a big truth brilliantly.

Walk across the room in one direction, then walk back. The moment of encounter is soon! Butterflies? Doubts? Yes—but continue gearing up. Come alive: your body ready to battle a lion, your heart ready to burst, your mind revving, eustress and not distress, the good fight and not the foolish fight, the work beckoning, the work beginning.

Walk! Can you hardly wait to work? What will you do first? Where will you jump in? Is that a snatch of dialogue you hear? A vision, an apparition you see? What was that? Was that the starting place? Maybe! Oh, if only the computer were on already! Then don't wait—jot it down on a slip of paper!

Walk! Grab a pad, make notes, run to the clay, grab a pencil, walk! "Yes" is not a dull, crippled, dutiful thing. It is like this! It is the work starting already. Learn to employ this short journey as part of your work time, as the grand entrance to the spectacle, as the electric beginning. Run! Learn to move quickly, learn to be *always* working.

Art requires work to come into being. But unlike most of the jobs and chores that occupy our lives, the act of creating art involves the whole person.

VICTORIA NELSON

THE MOST IMPORTANT TWO MINUTES
OF YOUR LIFE

A poem may be worked over once it is in being, but may not be worried into being.
ROBERT FROST

Worrying about the whole *piece, you are weighed down by the effort ahead, by the confusion. Inevitably you lose all in your thoughts that is bright, ardent, and true as you painstakingly put down instead a line of drab prose.*
BRENDA UELAND

Between the time you arrive at your work space and the time you enter into the trance of working, some seconds or minutes will elapse.

What happens during those first few seconds? The sculptor Jacob Epstein explained:

> The beautiful sitter has arrived. To give an impression of how the sculptor works, the state of mind, and the moods by which the successive stages are achieved, imagine him then in a state in which critical analysis of the form and emotional exaltation are present at the same time. To the exclusion of all else his vision is concentrated on the model, and he begins (a state of high nervous tension).

This can be a state of concentration, high nervous tension, emotional exaltation, critical analysis, and more. Or also less. It can also be a time of weakened-mind anxiety, blankness, and self-doubt, of impatience, sadness, and heightened autoscan mind, of emptiness of the worst kind. If in the walk to the computer screen you recapitulated a lifetime of being, both positive and negative, so too do you recapitulate all of that in those first minutes of sitting. Given that reality, how can a person start cleanly with so much history and so much personality as integral parts of her?

The answer is that only sometimes do we manage to start well. Often we engage in starting tactics and not real starting, we turn to our shallowest ideas and poorest personality parts, we turn over the sacred task of creating to the trickster inside of us who delights in ruining everything and squandering our resources, we start falsely, dully, all too easily.

We decide in that split second to do ironic, easy work, something arch and ridiculous, something that will not tax us—sign a blank canvas, stencil a few letters on the canvas, pour cement dung—and, done in no time, rush off to find a patron. Or, intending to work honorably, we nevertheless "preamble." As Bonnie Friedman explained in *Writing Past Dark*:

If I say enough beautiful things, I feel, I will earn the right
to say what I really mean. Then I can take that risk. It is pos-
sible to write whole novels this way. I have written a few this
way myself, the whole thing one gigantic preamble to what
I really mean to write about. . . . In the back of her mind the
writer cries, "Wait! Wait! The good part is about to come!
Just a few more chapters!" so that when the reader at last ar-
rives . . . it is with predictable fatigue, and the writer rushes
the crucial scenes.

*The first hole made through a
piece of stone is a revelation.*
HENRY MOORE

Such a vital two minutes! How will you get into the trance of
working and support the best and truest work you have in you, the
most original, the most revealing, the most important? You only
have twenty seconds, forty seconds, sixty seconds, and then you
will start somewhere. What do you mean to do? Describe your
plan of attack:

IN MEDIAS MAZE

You are not a blank slate. To really "start at the beginning" in that
first moment at the computer screen, you would need to possess
more freedom *from* personality than any of us possesses.

The actor arriving to write his performance piece is hampered
by his uncertainty about whether he has the right to be there, by
his lack of identity as a creator. The player arriving to compose a

Thinkers of today are much more ready to speak of the condition rather than the nature of man. By his condition they mean all the limitations *which define his fundamental situation in the universe.*

JEAN-PAUL SARTRE

My work doesn't exist separately from my life.

RICHARD FORD

song is hampered by her uncertainty about whether she has it in her to lead, since she has always followed. The short-story writer arriving to start his novel feels all of a sudden overwhelmed by the magnitude of the project, by the four hundred and not twelve pages ahead of him. Every artist arriving is hampered by his or her own personality.

This is a special moment in the gestalt, a moment of real conflict: you want to work freely, but you are only partially free. You are not on top of a hill looking down on that which you might create; you are caught in the middle of things, caught by your personality; and caught by the work as well.

For the work you mean to create has already begun to take shape. That you have this idea *means* that you've been working already, that you've started, that this idea has a life of its own. You're only partly free to dictate to it—it is already dictating to you.

You already know that there will be four pears in the still life and not three, although at a conscious level you do not know that there will be any pears at all. You already know that Marcia will kill John, although at a conscious level you believe that John will kill Mary. You already know that the climax of the play is unconvincing, although if asked you would protest that not only don't you know what that climax is, you don't even know what the play's about.

You lack options in both these senses. You lack options because you are *you,* because you haven't mastered this or that technique, because certain feelings are unavailable to you, because you can't empathize with this or that sort of person, because you haven't experienced this or that enough, because you're really in a foul or ironic mood, because of a thousand naturally occurring constraints. And you lack options because the work already has some shape, it comes with its own unfreedom attached, it is *this* idea and not *that* idea. It *boxes* you in: if it is a novel of the Old West, it is not also a novel of the New Deal or the contemporary treatment of transsexuals.

It is as if you were starting in a maze. You aren't straitjacketed, but neither are you as free as our romantic ideals would have it! The trance of working is a state of ease and grace, and yet it is still defined by our flawed personality, our limited history, and by the unfreedom of the work already taking shape. Imagine yourself

dropped down into this maze. The space is narrow, claustrophobic. Maybe it's an English maze made out of tall hedges or maybe it's a Kafkaesque maze made out of windowless, neon-lit corporate corridors. What will help you negotiate this maze?

1. You can listen for clues. Where will these clues come from? From the universe, from your own inner knowing. You hear a rushing river just the other side of the wall and know to turn right and not left. You have an intuition so clear that you smile at the simplicity of the solution. When you shut your eyes and listen like this, what exactly are you doing? *You are hushing and holding.* You are turning your mind into a sensitive, receptive instrument. You are controlling your own breathing, your being, in order to be able to hear.

2. You can move forward, choose a turning, try it out, hit a dead end, come back, choose another turning. You may feel bored, hopeless, empty-headed, and tired, but you still keep your feet moving and your flagging spirits up. You think that you're making progress; then sometimes you sense that you're further from the exit than ever. You stop, but only to shake your head sardonically. Then you move forward again, not with any great enthusiasm but not exactly listlessly either. At the very least, you keep putting one foot in front of the other.

3. You can determine to enjoy the puzzleness of the maze, the process, the challenge. How interesting! What a maze it is, so convoluted, so dense, so difficult. Might there be no exit? How interesting! How existential! How postmodern! What sort of hedges are these? Who built this maze? Is there a God? How interesting! *That* was a beautiful stretch, a beautiful passage, how delicious that it turned this way and that, that it ended so fancifully and abruptly! Am I lost? How interesting!

Writing a novel is like driving at night. You can only see as far as your headlights let you, but you can make the whole trip that way.

E. L. DOCTOROW

*Writing is an exploration.
You start from nothing and
learn as you go.*

E. L. DOCTOROW

EXERCISE
YOUR OPERATING INSTRUCTIONS

How do you want to negotiate this maze? Please spend a little time with this metaphor. Create your own set of operating instructions and post them where you can see them.

Example 1.

1. I will hush and hold.
2 I will remain patient.
3. I will say "no" to preambling.
4. I will be wild.
5. I know that if I just remain positive, the trance of work will come.

Example 2.

1. The maze has an exit. I know it.
2. I will enjoy it here. I wanted to be here.
3. Sometimes I can sit down and mope. But only for a few seconds.
4. Getting to the end is important. There is nothing more important.
5. I have the resources. I can do it.

Return to the amazing sentence you made earlier out of the fifteen qualities of an artist. Meditate on that sentence a bit and then create your own instructions.

My operating instructions:

1. _____

2. _____

I merely took the energy it takes to pout and wrote some blues.

DUKE ELLINGTON

3. _____

4. _____

5. _____

Please examine this metaphor a little. It is a great victory to have gotten to the computer screen at all, but the nature of that first minute of work is such that we are easily defeated or sent precipitously in a false direction. Learn about this maze: it is the starting point of all your adventures.

STARTING EACH NEW DAY

The deep things of personal experience make us know that a man's life is not any sort of intellectual puzzle to be ferreted out but a gift to be received and a task to be fulfilled.

NATHAN A. SCOTT

The artist knows that the process of creation can today hardly be complete and he sees the act of world creation stretching from the past to the future. Genesis eternal!

PAUL KLEE

We've spent the last 119 pages working toward one moment and one moment only: the moment of starting. That may seem like a lot of pages, but starting is *the* issue for millions of would-be creators and a vital issue for working artists, too. If you better master starting, you'll have dramatically increased your chances of creating.

Starting means either working on an idea or directly encountering the work without an idea. Many people would say that cleaning off their desk, formatting a disk, or buying their favorite watercolor paper are also starts. They aren't. You must define starting as working: nothing else counts as starting.

That isn't to say that there aren't things to do before you start. You need to stretch canvas. Stretching canvas is not painting, but neither is it nothing. What shall we call it? Anything but starting! Priming, preparing, first-things-first, getting ready, building up momentum, building up steam, anything you like, just not starting! You must reserve the word "starting" for direct encounters with the work. Otherwise the word become diluted, altered, suspect. Don't do that to a perfectly fine, serviceable word like "starting."

EXERCISE
SETTING YOUR INNER ALARM CLOCK

How do you wake yourself up without an alarm clock at exactly the time you want to arise? How do human beings do that? Because somewhere inside you, you can hold the time perfectly. You know that. You are a perfect clock.

You're also a perfect holder of the wish to create, if you're willing. It's exactly like setting your internal clock, like saying to yourself, "I'll get up at six tomorrow morning." What you say in order to orient yourself to your own wish to create is, "I mean to create."

"I mean to create this evening."

"I mean to create now."

"I mean to create first thing tomorrow morning."

"I mean to create right now!"

Set your internal mechanism to create.

If you set it but don't mean it, you'll oversleep. You won't wake up. You won't really be nurturing the wish. So, first of all, sincerely set your internal mechanism. Second, make use of a mechanical backup. Set the stereo to come on with booming reggae. Then create. Set the kitchen timer to chime. Then create. Have your collaborator call at an appointed hour. When the wake-up call comes, say, "I mean to create!" Mean it. Say "yes" to the work and start striding in the direction of your work space.

There are probably as many ways to get started as there are ways of chasing the blues. Use anything that works even if it seems ridiculous or not what an artist does.

ANNA HELD AUDETTE

Take the next week to practice "starting." Keep a "starting notebook" and track the following.

1. Did you say "no" to the work loudly and clearly when you wished not to work on it? Did you avoid "maybe's?"

2. How well did you tolerate active aloneness? Were you able to surrender to that state, live for hours in it, exorcise your demons or coexist with them?

3. Did you feel belligerently committed, modestly committed, or hardly committed? Did you make the connection between committing and starting?

4. Were you able to identify the split second each day when you said "No!" or "Yes!" to the work? *Was* there such a split second? Were there many such split seconds? Or none that you could isolate and identify?

5. Were you able to make the short walk to your work productive and passionate, supportive of the "yes!", an all-in-all good beginning?

6. Were you able to encounter the work? Did you bring more of your riches and fewer of your deficiencies to the first two minutes of work?

7. Did you start out caught in a maze? If so, how did you negotiate it?

8. Did you eventually enter the trance of working?

9. Did you experience weakened-mind anxiety? What appropriate strengths did you bring to bear on it? Did you effectively manage to hush, hold, and start?

10. What have you learned about "starting"? What do you still need to learn?

The next time we meet, in Chapter Four, you will have been working on starting. You will, in short, be working: on your novel, poem, play, screenplay, sculpture, symphony, song, nonfiction book, painting, tapestry, film, suite of photographs.

Please don't read on until you've managed to start, at least for two or three days running. If you can't start, stop. Surrender. Begin all over again. But don't read on until you've begun to master starting at least a little.

CREATURES FROM THE SEA

Working

*b*ecause this chapter has felt like the most difficult to write, I haven't wanted to work on it. I completed Chapter Three on Tuesday. This is Saturday. Instead of starting on this chapter on Wednesday, I gathered margin quotes. Instead of starting on this chapter on Thursday, I outlined the next chapter, on completing. Instead of starting on this chapter yesterday, I organized the Appendix.

I worked all week, but not on this chapter. Was I working or blocked? Both. Did I feel bad or good about the progress of this book? Both. Wasn't it reasonable and even smart that I not leap right into this chapter the very day after ending Chapter Three? Yes! Was I easy with that fact? No.

To understand my own work rhythms even this well is unusual. Most people are quite in the dark about how they work or why they fail to work. They come up against a part of the work

> *Here's how you write a play. You do a lot of writing to figure out what the hell the play's about and throw out three-quarters of that and write it again and find out what* that *play's about and throw out three-quarters of* it *and write it again.*
>
> **DAVID MAMET**

123

more complex than the previous part, run from it because it feels horribly hard, and, finding themselves in bed with the blues or at a café with an affair in mind, have no idea why they ran or when or if they will return. Even seasoned artists who regularly work are quite bad at the task of meta-work analysis: that is, ineffective at analyzing those psychological and practical components of their work life that influence how well or how poorly they create.

They are ineffective at this because the challenges to knowing come in so many shapes and sizes that a cloud of fog envelops them. An artist has to know if he is too distracted to work, too disturbed to work, if perhaps he has come to hate the work, if a conflict has arisen between his original idea and the reality of the work in progress, if the very idea of routine, discipline, or organization are anathema to him, or if he needs a day off to incubate the work. On top of grappling with these meta-issues he must wrestle with the work itself, with *its* difficult reality. The fog or chaotic-mind anxiety that these challenges provoke cloud his ability to choose what concrete things he will do in order to fearlessly create.

I do hope that you're now working on your novel, opera, sculpture, or screenplay. I hope that you've been out photographing this past week, that you've gotten a song entirely written except for the bridge, that you've created a pair of characters for your performance piece, that your four-by-eight canvas is gessoed, underpainted, and drawn on. I hope that you've been working for at least a few days now.

But if this isn't the case, if anxiety has gotten in the way, don't despair. Start now with some small baby step. Work again on starting. Say "yes!" to the work. Say "yes" without the exclamation point, if you prefer, but please say yes.

It's hard making art. It hurts my eyes. I can't figure out whether my finger is stiff from arthritis or from drawing. Possibly I'm drawing with a nervousness in my pinkie.

HANNAH WILKE

I'd say, "Okay, I'll do something and then I'll write." And then I don't write that day. I don't write the next day. After a month of not writing, I don't know how to write. I forget. If you write every day, it's like another kind of existence.

MARIA IRENE FORNES

EXERCISE
KEEPING A WORKING NOTEBOOK

Begin to keep a working notebook in which you monitor not only the subject matter of your work but also meta-work issues.

Jot down any thoughts that reveal something about your process and your true circumstances. "Stopped working; I lost the

thread." "Phone rang; I ran to it, welcoming the distraction!" "The subject's too painful, I feel like I'm falling apart." "I hated what I wrote this morning—every sentence felt stupid! Couldn't return to it in the afternoon. How can I work in the afternoon when I hate what I do in the morning?"

Learning about how you work is a crucial part of your job. It is more important than getting an M.A. or an M.F.A. This is the sort of vital self-knowledge that precious few artists ever obtain. Can you feel how this self-knowledge is an integral part of working well?

Will it make your heart hurt to learn about your own work rhythms? Possibly. Self-knowledge is often a painful and not a pleasurable experience. But acting authentically means confronting the tacks embedded in our chairs that prick our behind and make us run from the work.

Start your working notebook now. If you haven't begun your work yet, let your first entry be "I am starting."

There are images which suddenly get hold of me and I really want to do them. But the excitement and the possibilities are in the working and obviously can only come in the working.

FRANCIS BACON

WORKING IN THE MOMENT

"Working" is best conceptualized as all three of following: working in the moment, working on a given day, and working over time. Each refers to the same work in progress but in a distinct and different way.

Artists tend to hold these three concepts in mind and judge themselves against some standard with regard to each one of them. They are either working well in the moment or they aren't. They have either done enough work on a given day or they haven't. The project is either coming along well, generally speaking, or it isn't. To feel as if they are measuring up, artists must meet their own standards in each regard.

But though an artist will naturally judge herself in these three ways, *she must not do so in the moment.* When an artist is creating in the moment, directly engaged with the living work, no greater disaster can befall her than that her mind wander and that she innocently think of how the work is going "over time." To look at it over time, she will have to think about the revisions that still have

to be done in act I and the challenges that face her in Act III, all of which she *knows nothing about* in this instant. She tries to hold the whole project and judge it, but she can't because these challenges presently have no solutions. What does she then imagine? That the project is going "badly." Always "badly"!

If I think about the problem of defining "completing" that I will come up against in Chapter Five, a problem that I can't presently answer while I'm engaged in writing this paragraph, I'm easily provoked to feel that the book is going "badly." Why, then, should I do such a thing to myself? Why present myself with a heartbreaking conundrum, a problem without a satisfactory solution, just because, like all human beings, I have the habit of looking away from the work right in front of me? Nothing kills the will to work more surely than contemplating the entirety of the work when all we need to do is engage the work right before our eyes.

I just say to myself, "Just give it another hour. Just plod along, one foot in front of the other." And then six months later I see it's a beautiful piece.

VIRGINIA CARTWRIGHT

EXERCISE
INCREMENTS OF WORK

We all know some variation of the phrase "Even the longest journey begins with a single step," variations like the twelve-step slogans "One day at a time" and "First things first."

No matter how immense the project you've carved out for yourself may be—no matter that the movie you're directing has a budget of $50 million or the mural you're painting will be a thousand square feet in size, no matter that the idea you're holding is as earth-shattering as the theories of relativity or the laws of classical mechanics before them—*still most of the time you must focus on the increment of work right before your eyes, the part and not the whole.*

Look at an object in your room, your computer hutch, for instance, or your drafting table. Imagine constructing it. First there'd be a plan. Throughout the building of it, there'd be continued attention to the plan, an awareness of the whole. But most of the time you would be sanding, screwing, or sawing with your eyes entranced by the mechanics of a given joint, the requirements of a given mitered edge.

> Focus now on one part of this object, just one joint. Get up close, within two feet of it. How do the two boards go together? Feel the way your eyes focus on the joint, the way your mind turns its attention to the joint and excludes everything else, the way your body quiets and your breath deepens.
>
> Just stare at the joint. Feel how it can be held as a small miracle, an object of devotion. Each joint is a whole increment of work. It is real, it is important—in a sense, *it is all there is.*
>
> Whenever you find yourself thinking fearfully about the enormity of your project, return to this joint. Stare at it and study it. Then return to your work, mindful not of your destination but of the next step in your journey.

The problem of creative writing is essentially one of concentration, and the supposed eccentricities of poets are usually due to mechanical habits or rituals developed in order to concentrate.

STEPHEN SPENDER

Would that we could at once paint with our eyes! In the long way from the eye through the arm to the pencil, how much is lost!

GOTTHOLD LESSING

But despite our correct desire to keep our eyes focused directly in front of us, we are faced with an apparent paradox: that even as we need to lose ourselves in the trance of working, still we must monitor the work as a whole. We do, after all, need to comprehend the whole in order to judge the rightness of the part in front of us. We really can't suppose that everything that needs to be accomplished can be accomplished flawlessly in the trance of working.

Aren't we stuck having to appraise as we go? The simple answer is "yes." Those few exceptional times when we dream the work whole and need do nothing but rush to get it down are glorious but still exceptional. The rule is that we will have to appraise as we go, even though that appraising endangers our ability to work. It endangers it on two scores: by dragging us out of the trance of working, and by forcing us to see the work's flaws.

But though this is a dangerous state of affairs, no paradox exists. Trance moments and appraising moments are simply different moments. One second you are inside the work, the next second you are outside the work. For the length of a sentence you are inside; as soon as you drop in the period you step outside. You exit the work and appraise. Were those the right words? Have you sent the book down a terrible detour by saying that? If a moment before you were fully engrossed, now you're in danger of wanting to run off and escape.

127

EXERCISE

TRANCE AND UNTRANCE

High joy is to enter into the trance of working with a rich, clear idea (or in rich relationship to the work-to-be), and to then work effortlessly, entranced, until, hours later, you emerge with an increment of work completely done, whole, intact, unmarred, right, beautiful.

This is possible. But for all of those times when this happy synergy is missing, you need a way of negotiating the states of trance and appraisal such that you stay in right relationship with the work, neither fleeing it nor closing a blind eye to it.

Practice in the following way. Get some paper, an ink wash, and a brush. Hush, hold, and begin to meet the paper, but with your eyes shut. Feel entranced, follow an idea, work with no idea. Work until your self-consciousness evaporates.

Now *ready yourself to stop.* In this readying moment, you must watch your self-talk, for most people prepare in this pre-appraising moment to criticize themselves. Hold the following affirmation: "I am happy to look." Look. Look both gently and firmly. Is it a mess? Fine. Is there an amazing accident, a handful of strokes like a beautiful crane? Fine. *Either result is all right.*

Count to ten and as you count make a decision, whether you will work on the crane or whether you will toss away this sheet of paper. Count with an easy and not a heavy heart; either decision is fine. Do not frighten yourself by saying, "If I touch the crane, I'll ruin it." Do not harm yourself by saying, "I certainly screwed that up." Hold that you want to return to the trance of working because you love it there.

At the count of ten, work again. Recover your trance state. Practice this exercise as many times as you can. It is vitally important that you learn how to recover this trance state and return to work, even after you have looked the work in the eye.

Of course if you come out of the trance of working after every phrase or brush stroke, you'll drive yourself mad. Nor is it even clear that you've been entranced. It's imperative that we not be distracted too easily. If we allow ourselves to get into that terrible

habit, if we fail to zealously guard the sanctity of our working trance, we're bound to second-guess ourselves into impotence, kill off ideas growing underneath, and commit creative suicide.

So the artist must learn not to look up too quickly. The longer she doesn't look up, the better. Of course, thoughts will intrude— that she really ought to be writing that *other* book, that the scene she's writing is arousing or disturbing her, that the day is muggy, and all the rest—but still she continues to work, entranced or nearly entranced. Then, finally, she looks up; and that next split second is *entirely different* from the second that went before it. She looks at the work and hopes to love it, but she may not love it. Now she must say "no," "yes," or "maybe" to the work.

She is forced to ask herself, "How is it going?" All along, even as she worked entranced, she had feelings about this—a kind of elation and optimism about the work, a kind of downheartedness and pessimism about the work—but now she must deal with the matter deliberately and directly. She wants to love the work in progress, but she also must judge if it is worth loving. She wants to lavish her generosity on it, but at the same time she doesn't want to be sold a bill of goods by it. She takes to heart Pablo Picasso's warning, which is easier to assert than it is to follow: "Do not become your own connoisseur. Sell yourself nothing."

She looks at the work. Possibly something about it is wrong. Isn't that usually the case? But wrong in what way? Does it just need revising? Should she handle that later? Is it better not to think about it now? Is the answer to just keep working? Or is there a real problem that must be addressed immediately? Must this section be catapulted overboard, destroyed? Is the problem even more dire than that? Is the very idea the problem?

Or is there no problem at all? Is it just that what has emerged is *unexpected?* Which is it? Can she continue to invest in it if she suspects it of failing? But *is* it failing?

She can't decide? What to do? She screws up her courage and manages to reenter the trance of working. She works again. But now she is nagged by doubts and her concentration is imperfect. She works dutifully, not blissfully; pessimistically, not optimistically. She works; but this time she looks up quickly.

How is it going? Has she saved it? Is it worse? Is it really failing?

To draw, you must close your eyes and sing.

PABLO PICASSO

All my plays engage this issue—how to sustain ambiguity in your conscious life without allowing it to plunge you into feelings of loss and confusion.

RICHARD FOREMAN

She means to appraise the work but she discovers that she can't. She can't look at it. No. She needs a shower. She needs a milk shake. What mortal can keep appraising the work if each time she looks at it she's confronted by the chance that the work will appear hateful and need destroying? No! A shower first. Then maybe later . . .

She takes another peek. Maybe it isn't so bad. Maybe it's even O.K. Maybe it's even fine in parts. Maybe the big form is actually working and it's just the little forms that are rotten. Maybe Helen's lively enough and it's only Jack who's dead. She peeks—anxiously—and her gaze lands on something she likes. She can go on working! Or her eye lands on something silly and awkward. Can her heart stand it?

She looks at it and it appears a mess. Did she really sell herself that Florida swampland? Did the idea really mislead her that badly? A moment before, it had seemed so reasonable, so necessary! Now she's got swampland, mosquitoes, and alligators. What can she do? Look for a sucker who'll buy it? Sucker herself and deny what she's seeing? Bravely take the loss? But the loss is such a hard one to take! For she herself created this swampland.

This is the artist at work in the moment. Certainly some work episodes are more pleasant than this one; but the dynamic is always the same. "Working in the moment" is a dance of doing and looking, creating and appraising, affirming the self and criticizing the self. It's the artist saying in one breath, "I am god," and saying in the next breath, "Am I ever human!"

Moment-by-moment working involves a second dance as well. The artist as he works must deal with the work in progress, which makes real demands on him. The novel, opera, painting is alive—perhaps only metaphorically, but tell that to the artist! As the sculptor Reuben Nakian explained it, "A new sculpture is like a strange thing fought from the sea." The writer Paul Goodman elaborated on this metaphor in a prose poem:

> My way of composition is like a beast or fish over which is cast a net. The animal with unexpected force—not equal to *my* force, but I should never have hunted him if I thought he had so much as this—he strains to writhe away ever in a new direction. Before he was quiescent, it is the tightening net

that has infuriated him. Writhe as he will, he nevertheless tightens the net: in a paroxysm he rears up, into a posture unknown and also against his nature. He tears a few meshes of the net. Next moment he dies, with his limbs rigid in a fantastic attitude and on his countenance a grimace. And it is this grimacing dead body that I would offer to the reader as a work of art—except that, in fact, it is only the net, with its unequal strains and a few cords torn, that I have to offer, for the live animal escaped and the corpse stank long ago.

The artist may begin his work by imagining that he is merely cobbling or crafting something. But, like Geppetto in the Pinocchio story, his intent isn't to create a mere wooden boy. He wants a living, breathing thing, something worth loving, something to love. But that living thing, as life is breathed into it, really does come *alive:* it may fall into bad company and go where it shouldn't, it may disappoint, it may surprise, it may bring the artist pain and not pleasure.

Each moment something new is there that wasn't there before. Genesis eternal! Was that a good thing to be born or a bad thing? Good or bad, now it lives! Now Sam the cat has a role in the play. Now the torso has a third arm coming out of it. Now the poem has a new image in it, of black leaves. Now the oboe has an exceptionally long solo part. All of this now exists. Exists, lives— just try getting rid of Sam the cat now!

What does this metaphor really mean? Not that the song has two legs and can literally run away. It means that we have two obligations to perform as we work, obligations which, if we are lucky, amount to one, but which usually remain separate and distinct. The first obligation is to honor the idea that we came to the work with, the idea that prompted it and enlivens it, the idea that is complete inside of us even as it remains no more than a vapor. The second obligation is to *go in the right direction* according to where we are now, free of the idea, to create as deeply now as we created when the idea first came to us.

Say that the idea with which you started your novel was: "a mother slaps her child." You know that that event is the very center of the book and you suppose that you will write that scene at some point. But in the working out of the idea, you find yourself

Have you ever seen a fish swimming in still water? I can "see" what I want to convey very clearly in front of me. But when I plunge in with my hands and try to grab it, it zips off and I'm left with rough water clouded by the mud I've stirred up.

WILLIAM ELLIS

*In order to paint a still life,
there must be confrontation
and mutual adjustment be-
tween a painter and an apple.*

ALBERT CAMUS

writing about a picnic in an apple orchard. The picnic is peopled by characters you don't recognize. Is the child among them? The mother? What's going on?

You could of course just proceed and presume that you will get where you're going. Possibly that is the right thing to do. But you're feeling a certain doubt that the idea really is being supported by this picnic scene. What to do? This picnic scene keeps growing, with no end in sight! Now it seems the characters want to swim in the lake. But why? Will you let them? Is their afternoon swim in support of the idea? But they do so want to swim, and you do so want to write that scene!

The characters are going off to swim, and let's see what you can do about it! In terms of the first dance, the dance of trance and appraisal, the questions the artist asks are, "Have I handled the picnic scene well? Now can I handle the swimming scene?" In terms of the second dance, the wrestling with the strange thing from the sea, the questions are different: "Is the picnic scene valid? Will the swimming scene be valid? Should I deny this strange thing or give it free reign?"

Taken together, these two dances amount to the following four points. "Working in the moment" means:

1. Entering the trance of working. The first and most important step each time you approach the work is to hush, hold, and vanish into the trance of working.

2. Balancing trance moments and appraisal moments. Trance moments must predominate, but appraisal moments must get their due. All trance and no appraisal is denial. All appraisal and no trance is self-hatred.

3. Returning to the work after each appraisal. If you judge the work dead, that is one thing. If you judge the work merely flawed, you must find the will and the way to work on.

4. Wrestling with the strange thing from the sea. You must strive to deal with the inevitable tension that exists between your love of and connection to the idea that initiated the work and the freedom

to go wherever you must go, according to the shape of the work directly in front of you.

To take the ideal case of "working in the moment," you would have your fine idea supported by the living work, the trance of working would persist nicely, the appraisal would properly occur but all that your appraising eye would find would be well-made work, and several hours would pass excellently, a mighty accumulation of well-spent moments.

This is the ideal! Yes, such work episodes are real miracles. But the productive artist who can hush and hold knows that she can sometimes—even often—realize them. She can work, and please herself with her work. She can work, vanish, and return with something strange, exceptional, and new.

It seems that I am considered a top artist and that doesn't surprise me. But that doesn't help me to make a new work. I go to work every time thinking, "What on earth am I going to do? How will I make something that works?"
ROBERT RAUSCHENBERG

INTERVIEWER: *"How do you feel about people who paint all these great de Koonings?"*

DE KOONING: *"But they can't do the bad ones."*

Stop!

Do not read on. Instead, work for a few days. Learn about moment-to-moment working from your own labors and your own observations. Have a variety of episodes, some ecstatic, some traumatizing. Work. Write in your working notebook. Come back in a week.

See you then.

MISTAKES

Welcome back!

Possibly in this week of working, it has become clearer to you that when you fight for the original idea, fight to retain it even as the work veers elsewhere, sometimes that decision is a mistake. Or you opt to let the creature lead, in the tense struggle you give it more line, and sometimes *that* is a mistake. What is the answer? *To be easy, not with mistakes, but with creating as a mistake-making adventure.*

It goes without saying that an artist will make mistakes.

Human beings make mistakes and artists make more of them and bigger ones than do accountants or teachers, plumbers or bakers. This is because artists do not know for certain what they need to do until *after* they have done it. They are like astronauts flying off to a planet that can't be seen from Earth. Certainly they know to bring food, water, and oxygen. But what if they encounter snowstorms on the planet's surface? What will they do then? What if the surface temperature is 1000° F? Was the whole trip a mistake?

I work continuously within the shadow of failure.

GAIL GODWIN

Artists *will* make mistakes and will then handle these mistakes in one of three ways, only the last of which is helpful to them:

1. They'll deny that a mistake has been made.
2. They'll admit the mistake, but at the high cost of lost self-esteem and blockage.
3. They'll admit the mistake at some psychic cost but not permit themselves to become blocked or damaged.

As a variation of the third approach, the artist may determine to incorporate the work's flaws and blemishes right into it. This is at the heart of the Japanese idea of *wabi*: that a work of art—a pottery bowl or an ink drawing—is made unique by its flaws and even elevated to the rank of art because it is flawed.

But Western artists, too, regularly attempt to turn the concept of "mistake" on its head. Sometimes they do this to take the sting out of having made mistakes, sometimes they do it as justification for leaving work unfinished or badly done, but sometimes they do it simply in recognition of the inexorable presence and potential power of "mistakes." The painter and sculptor Marisol, for example, explained:

> I never get stuck or bogged down on a piece because I trained myself that a mistake is not a mistake; so I don't make mistakes. Mistakes become part of my work and are OK. In school I was taught a philosophy of good and bad and that you always have to erase and do it again. I didn't want to have that problem; so I made up a kind of art that is either all a mistake or all not a mistake. I never erase or start over or redo something. I just leave it and work it through. I feel it's almost meant to be; it becomes part of the piece, and

it never looks that bad because I'm not doing a kind of art
that is so pure that if I chip it, there is a problem. If my work
is a little bit dilapidated it looks better.

Artists have as a first task accepting *the fact* that they will
make mistakes, even if, because of the kind of work they do,
they manage to incorporate uncorrected mistakes right into the
piece. But their second task is even harder: overcoming *the fear*
of making mistakes, a fear that afflicts even people who know
full well that everyone makes mistakes. Some people can make
mistakes and (relatively speaking) *not care:* they are armored
against the sting. Most people *care too much* about their mistakes
and experience mistakes as wounds out of which their precious
blood escapes.

*If you shut your door to all
errors truth will be shut out.*
RABINDRANATH TAGORE

It is in this last regard that the problem of mistake-making
takes its greatest toll. The would-be artist, who understands full
well that everyone makes mistakes, fails to start because, *despite
that knowledge,* he still fears making mistakes, fears what the work
will look like, what people will say, what he will think of himself.
Why does he fear this so much? Because of the contours of his per-
sonality and his history: all the injunctions he received against
making messes, all the times he felt inferior to someone else, a
lifetime of feeling not special, not worthy, not capable, not good.
To the would-be artist or the working artist who already feels too
ordinary—too little like a god, too little like a real artist—a mis-
take is *payment* for his presumed mediocrity. It is not a fly to be
brushed away; it is the very currency of his life.

EXERCISE
OVERCOMING THE FEAR OF MISTAKES

Practice the following exercise on the linoleum floor of your
kitchen or on some similar surface. Thoroughly clean a three-by-
three-foot square of the floor. Get out the old dirt, the grit, the
caked-on debris. Dry the square and then wax it. Work on it until it
shines.

Now mix up a little mud.

The crack—the beautiful, distinctive flaw that distinguishes the spirit of the moment in which this object was created from all other moments in eternity—might be the very feature that causes a connoisseur to remark, "This pot has wabi.*"*

HOWARD RHEINGOLD

With a heavy heart but a strong will, muddy the floor. Ruin its shine, destroy its beauty.

Look at the floor. *You did that.* But although you did that, *why should it lower your self-esteem?*

You muddied the floor. But you did it as an exercise, to help you learn something. *That is exactly the way to hold mistakes.* You are making the mistakes but no one may judge you on the basis of the mistakes you make. For you are making them *in the service* of something vital, the creation of something true and beautiful, the very salvation of the world.

Clean the floor again. This is work, but not scary work. Your self-worth need not be implicated in the cleaning and dirtying of this floor. What if you misjudge and break a fingernail? What if you clumsily get your cuff muddy? What if you get a slight rash from the mud? What if you ruin the whole floor by accident? *It does not matter,* because you are cleaning and muddying this floor heroically and honorably, as an exercise to help you recover your courage.

Mistakes made when you create are not mistakes. Do not fear them.

A fear of making mistakes translates into an inability to risk, to think, to start, to work. A fear of making mistakes leads to the making of only small investments, the making of a short story and not a novel, a pencil sketch and not a mural, for a big mistake in a pencil sketch is not like a big mistake in a mural. Certainly the artist must make a short story if she must; but she must make a novel and not a short story if she is making short stories to avoid the sting that really big mistakes would bring.

As to the mistakes themselves, there are only two kinds: those that ruin the work and those that don't. There are mistakes that can be corrected, incorporated into the work, ignored, or even prized, and then there are mistakes that are killers. Handling the small- and medium-sized mistakes, the ones that fail to kill the work, involves courage, patience, and technique. This careful handling is nothing more or less than a major component of the

artist's job description. She does not abandon the work, if it is worth saving; she instead loves it and corrects it.

But some mistakes are really big and ruinous. The writer who has chosen to write a novel which she mistakenly thought had at its heart a rich premise, and who discovers that the novel is really stone-cold dead, has made a "mistake" which can't be corrected. What will she do? She may deny that she has a problem and write on, until, three years later, she gives up, the novel now "completed" or abandoned. Or, just as unfortunately, she may determine to abandon it as soon as she is certain of its deadness, but so charge herself with the failure that her writing life is broken.

If she is luckier, she will put the work away, experience pain, recover, and write again. She will say to herself that that was one of her works that, as Thornton Wilder put it, "got thrown away halfway through because it failed to engross the whole of me." It will remain a product that provokes anxiety by its very existence; but every artist's closet is full of such skeletons!

Mistakes cause sadness and blockage. A novel that collapses or never comes to life is a sad affair and we need to mourn it . . . and then move on. *Cry for the mistakes you've made and the ones you still will make.* Take a moment and shed salty tears.

What if three novels in a row die? A dozen poems? A score of paintings? Simply mourn each one and move on. Cry and move on.

But do not:

1. Ignore mistakes.

2. Defend mistakes.

3. Leave mistakes uncorrected.

4. Accept mistakes as your just due.

5. Slash your wrists over mistakes.

Even a Mozart concerto in which no note is wrong (because he could not write a wrong note) may be stone-cold dead. All right! What is a Mozart to do? What are any of us to do? Abandon the work or complete it, learn from the experience, cry, forgive ourselves, and move on.

Half my life is an act of revision.

JOHN IRVING

Please take a moment to shed bitter tears. So many mistakes, so much sadness! Now dry your eyes. There's work to be done.

EXERCISE
CRY AND MOVE ON

Make a mistake right now. Go ahead! Devote real time, say ten minutes, to creating something awful, something really miserable. (With such permission to fail, you'll probably create a small masterpiece.) Spend ten minutes on something sandy and inert. Then destroy it, mourn it, cry, and move on. Make both experiences real, both the tears and the *restarting*.

CHOOSING WHILE IN THE TRANCE OF WORKING

But of course it would be much more pleasant not to make mistakes!

A mistake is a choice you make. After all, you choose to make this mark or that mark: it doesn't appear from nowhere. You choose to record this line of poetry and not that line of poetry: no one puts a gun to your head. You hear a snatch of melody in your inner ear and rather than let it go, as you've done a thousand times before, you choose to hold it. No genie does that. You do.

Every right move is a choice and every wrong move is a choice.

That is why we covered the territory of choosing so many thousand of words' worth. All that goes into choosing in connection with arriving at a rich idea obtains throughout the process and activity of creating. Remember the gestalt test, the burned-down-barn test, the turn-the-idea-around test? All of that testing goes on in the microseconds between muscle movement, in the instant you move your brush from palette to canvas, in the instant between the ending of one sentence and the beginning of the next.

If you think that a computer is fascinating, reconsider that the human mind can do this.

The way not to make mistakes is to make correct choices in

the microseconds between actions. And how is that done? You go to the mailbox for the mail: that is simple. You go to the refrigerator for the mineral water: that is simple. But where do you go for the right word to complete the poem? How absurd! *How* do you go for a word, what sort of hunt is it, and *why* do you go for that word (which you already know, after all!) and not its synonym? Why, as F. Scott Fitzgerald did, will you regularly retrieve "vanish" and not "disappear" when you need a word like that to complete the sentence?

The answer is the following. Creators manage to make right choices in the trance of working because they are *practiced* in testing their choices, so that such testing now goes on virtually instantaneously, and because they are committed to and have surrendered to the idea of testing. How otherwise can a mathematician arrive at a right answer when there are a billion wrong ones that might have captured his fancy? The French mathematician Henri Poincaré puzzled over this question and concluded that a good working mind has a fantastic ability to test and to reject whole armies of possibilities out of hand and accept for further review only those solutions that reside in the family of right answers.

A fearless creator who begins to succeed at choice-making balks less and less often at the prospect of having to choose. He *gains trust* in the process and fears choosing less. And by trusting more and fearing less, he chooses that much more efficiently, so that his work improves and he is encouraged all over again.

To create consists precisely in not making useless combinations and in making the small minority which are useful. Invention is discernment, choice.

HENRI POINCARÉ

EXERCISE
TESTING AND TECHNIQUE

Do something in your art discipline a hundred different ways.
Write one sentence a hundred different ways.
Orchestrate a camera shot a hundred different ways.
Draw a fingernail a hundred different ways.
Play two notes with a hundred incrementally different pauses between them.
Feel the differences between the sentences. Study them without

analyzing them. Feel how a six-word sentence differs from a ten-word sentence. Feel what a comma does. Express an idea in three sentences of varying lengths. Feel the profound differences between the sentences.

Sentence one (long).

Sentence two (medium).

Sentence three (short).

This is the learning of technique. This is the acquisition of voice. This is the sort of trial-and-error testing that, when it goes on instantaneously in the trance of working, allows you to write a thousand well-crafted words without looking up.

Useful combinations are the most beautiful, I mean those best able to charm the special sensibility that all mathematicians possess.

HENRI POINCARÉ

At the moment when art reaches beyond its medium of words or paints or music, the artist finds himself realizing that these instruments are inadequate to the spirit of what he is trying to say.

STEPHEN SPENDER

IMPOSSIBLE WORK

But wait. As proficient as a creator gets at choosing, as strong as he grows in technique, there remains another tear he must shed as he struggles with his work.

An artist will make mistakes, some that can be corrected and some that can't. He'll make difficult choices out of a pool of choices as large as the universe. These challenges speak to the enormous difficulty of creating—but not to its literal impossibility. And yet artists often feel as if what they are attempting to do is not merely difficult but quite impossible. What is the meaning of this often-felt feeling? Is it a sense of difficulty made catastrophic by an inadvertent use of the word "impossible"? Or is it something else?

This feeling arises from two facts. First, a work of art has its limitations. Second, a human being and not a god is creating. It is

this sense of double limitation that an artist is experiencing when he says that it is simply impossible to paint a living portrait or to write a novel that reveals the intricacies of a human relationship.

Because he feels so much like a god, an effective creator forgets that he is only human. That forgetfulness is splendid, except when he looks at his work and compares it to his intention. Because he believes so strongly in paintings, songs, movies, or poems, he forgets that each is "only" a work of art. That forgetfulness is splendid, except when he looks at his poem or film, feels its limitations, and cries out, "Is that all there is?"

He creates like a god in his heart and produces a work done by a human being, not a god. He saves the whole human race from famine in his heart and can't save a single child by taking beautiful photographs. He is innocent in his heart and brings guile to the song, trading on sure-fire chords. He is everything in his bursting heart, and that much less in his book. He takes it upon himself to be god, but he is after all only a human being.

This state of affairs need not and must not be held as tragic. Think of it instead as a cognitive matter in need of reframing. Creating is "impossible work" only insofar as it is defined as such. Better think of a work of art as miraculous and not transcendent, splendid and not perfect. If you ask your work to be what it cannot be, *you* will have transformed it into impossible work.

Fearless creators neither renounce their aspirations nor rise above their humanity. The first would be a sin, the second a literal impossibility. There is only this painful truth, which the artist embraces and to which the artist surrenders: that he is mortal. His work is a great gift and a miracle, but it is also only a short story, a sculpture, a documentary. It is both a miracle and a simple artifact: let that truth gladden and not depress him.

This landscape is diabolical, with a line that doesn't allow any approximation and a light you can never capture.

BERTHE MORISOT

CHAOTIC-MIND ANXIETY, INAPPROPRIATE AND APPROPRIATE ORDER

Strange to say, the anxiety an artist experiences as he confronts choices, makes mistakes, wrestles with the strange thing from the sea, and all the rest, while chaotic-mind anxiety, most often *feels* like blankness or emptiness.

When I am, as it were, completely myself, entirely alone, and of good cheer—say, travelling in a carriage, or walking after a good meal—it is on such occasions that my ideas flow best and most abundantly.

WOLFGANG AMADEUS
MOZART

It's as if a crowd has to walk through the damn painting and shift around before I can lock any parts into place. Their sex, race, gesture, and expression are all up for grabs until the very last strokes. A live painting is always open to this kind of change.

ROBERT BIRMELIN

As often as not, he feels blank and empty, rather than agitated, because his defenses, thrown up to ward off the chaos, act as an anesthetic. It is in the nature of our defensive structure, a structure that allows us to live an orderly life not worrying about the exact hour of our death or the precise number of stockpiled nuclear weapons, to protect us from the chaotic feelings that attend to creating.

But an artist cannot let this state of affairs obtain. He cannot let his defenses do their defensive work. He must undefend himself and surrender, not to the chaos itself in a terrible cry of "You win!" but to the fact of the chaos, to the feelings of chaotic uncertainty. He must see what is going on, not blind himself, even though what he sees at first glance are billowing clouds of dust and what he experiences are motes flying right into his eyes.

As an artist writes or sculpts, his defenses remain on alert. They guard him in the trance of working and when he appraises the work. This explains why he so often solves his creative problems *away* from the work, where he is more undefended, where his mind is more free to wander. Answers come to him not at the computer screen but as he sleeps, peels potatoes, washes the dishes, tools down the open road: when he thinks of nothing and when he thinks of something—anything—other than the work.

If he asks himself directly, "What is the next step I must take in order to create a thing of truth and beauty?" little yeoman soldiers, trained to protect him from danger, rush in to stop him from trying to answer. To find the answer he would have to tumble into the chaos, and his army of defenders will not permit that! He is both king and prisoner, a prisoner-king who must slip away in the middle of the night if he is to learn what is happening in his own kingdom. It is only when the soldiers are in their barracks for the night that he can raise the question—innocently, as it were, so as not to raise the alarm—and then successfully answer it.

To really work, we have to let down our defenses and enter dangerous territory. But at the same time, we want to feel safe. How do we handle this challenge? Too often we mishandle it and opt for safety. Instead of bravely engaging the chaos and working until there is order, we protect ourselves and "make order" in one or another of the following ways.

▾ *We create order by throwing the work away.* If we are not working on a project, life is that much safer (and that much deader). No messy paints, no messy pages of notes, no messy confusion. This is the choice that would-be artists make (and seasoned artists some of the time), to avoid the chaos of working and gain perfect safety by tabling their ideas, at the mere cost of an unlived life.

▾ *We create order by walling the work off.* This variation of the first amounts to the difference between throwing the work into the ocean or leaving it in a corner of our bedroom, boxed, where it haunts and reproaches us. Order is created but so is inner conflict, for we can neither forget about the work nor quite face it. The room remains clean, no unsightly mess is visible, but we feel tormented, not safe, and guilty, not relieved.

▾ *We create order by acting "as if" we were creating.* Why do we first clean our desk so that then we can make a mess? Certainly we don't need our desk clean in order to work. We clean our desk in order to start off on the right foot, so to speak; but we also clean it because the act of cleaning is a rehearsal for the real work of ordering to come. Too often, however, rehearsing substitutes for working. Organizing our research notes, creating files and folders, and all the rest are either meaningful acts or else avoidance tactics. Can you tell when they're the one and when the other?

▾ *We create order by obsessively ordering a corner of the work.* Both artists who appropriately seek order and artists who seek it inappropriately will find themselves toiling away on a given corner of the work. Working, after all, is nothing else but working in a corner, painting this spot, writing this sentence, composing this measure. The difference is that the less-afraid artist works in a corner for the sake of the whole, while the afraid artist works there compulsively and without pleasure. The first is hungry to move on; the second, constipated.

▾ *We create order by suffocating the work.* If we approach the chaos with a straitjacket under our arm—with a theory, a formula—we may be able to pin the chaos down and wrap it up, but at the cost of killing our own spirited ideas. Art always comes in boxes: the

Even a pencil sketch consisting of six lines or a four-line poem aims boldly and blindly at the impossible: a striving for totality, an attempt to enclose chaos in a nutshell!

HERMANN HESSE

symphony is a box, the sonnet, the haiku, the rectangular canvas, a Joseph Cornell box, this book, which is contracted for 85,000 words. But to work *in* a box *with* the chaos is one thing; to arrive with a straitjacket and the firm intention to subdue the work quite another.

▾ *We create order by working defensively.* It isn't only against the chaos of work that we defend ourselves. We also defend ourselves against the chaos that is our "self." If we are doubly unlucky, we are frightened of the work and also frightened of ourselves. What else can we do but approach the work wearing the thick armor of our favorite defense? We don't think, we intellectualize. We don't dream, we dissociate. We don't maintain tension, we work rigidly. We don't bring wildness to the work, we tyrannize the work.

These are all unfortunate ways of ordering the chaos. There is only one fortunate way: to grow freer and less defended, to surrender to the chaos and to work in its midst bravely and strongly. This fortunate surrender doesn't eliminate the anxiety the first time or even the second time an artist risks it, but eventually the threat will dissolve. The work remains arduous, but it is no longer frightening.

If, when you surrender, you see that to order chaos you must make a hundred sketches before you start the painting you have in mind, then you make a hundred sketches. If, when you surrender, you see that you must outline your novel before you write it, then you outline it. If, when you surrender, you see that you must dip into your old plays and pull out scenes for a collage, then you dip into your old plays. *Real order is created only by truthfully doing what is necessary.*

Imagine ordering an enormous pile of screws, nuts, bolts, nails, pennies, paper clips, pushpins, canceled stamps, dry kidney beans, and the multitude of nameless things living in all the garages in your neighborhood. Imagine it all dumped onto your living room floor in one big pile.

Could you order it in your mind only? Look at the pile. Make any mental calculations you like. Make categories, put all the paper clips into one part of your mind, all the kidney beans into another. Have you ordered *the pile?* No! You've only thought

I go slowly, recalling the word of my teacher, "eventually." In the clay's own time it will show me the place to press, to open the work.

WILLIAM GALBREATH

Anxiety is ignorance. Non-anxiety is also ignorance.

EUGENE IONESCO

about the pile. Make all the fascinating connections and create all the brilliant categories you like: nothing about the pile has changed. Nothing. You might say, "I know more about the pile now," or "I never knew that kidney beans were exactly that shape!" But you haven't ordered the pile. Picking up one paper clip goes further to ordering the pile than does a year of such study.

Now try this. Turn away from the pile. Give it your back. Doesn't that feel better? The pile has vanished. Shall we collude in saying that now it is ordered?

I think not.

The pile can only be ordered in reality, through action. You may in fact not want to do that, on the grounds that you haven't the time or the inclination. Fine. You can dump it all into an enormous box and haul the box to the garage. You'll certainly have created "better order" in the living room. But you won't have *ordered the pile.*

Pledge to yourself that you will create order out of chaos one paper clip at a time, one kidney bean at a time, one line at a time, one brush stroke at a time. You might even use this as your mantra: "One kidney bean at a time."

Opportunity is missed by most people because it is dressed in overalls and looks like work.
THOMAS EDISON

E X E R C I S E
MAKING ORDER

Invest in four tall, skinny erasable boards, each about two feet wide by five feet high. This is a real expense but worth it.

Arrange the four boards on a blank wall, separating each from the next by about two feet. (If you can't find the right-sized boards, get one large one and divide it into four tall columns.)

Use the four boards in the following way:

On the first board, chart the next several things you mean to do on this project.

On the second board, keep track of your other creative projects.

On the third board, create a business "to do" list.

Keep the fourth board blank. When something comes up, use this board to jot it down.

The four boards together might look something like this:

Board 1	Board 2	Board 3	Board 4
▾ Begin chapter two of novel	▾ Send out short story to three magazines	▾ Call agent I met at conference and introduce novel	Beautiful Heine quote: "Where books are burned, people will be burned."
▾ Revise chapter one? Or wait?	▾ Work on screenplay idea this weekend?	▾ Practice saying what the novel is about. Can I describe it in two or three clear sentences?	Use in chapter four?
▾ Work in notebook and sketch some scenes. With Juliette? Or Harry scenes?			

I hope you won't sneer at such an organizational scheme. Affirming your intentions in bold letters on the wall actually works wonders.

You don't get better by worrying. You get better by writing and you have to do it every day—for hours.

JOHN P. MARQUAND

WORKING ON A GIVEN DAY

So far, we've been exploring working in the moment. Next on our agenda is looking at that fascinating unit of time, the day.

A day is so very short and also so very long. If one worked "all day," one could write a slim novel every three or four weeks, as the Belgian novelist Georges Simenon did. So a day is a vast amount of time. But if we run three errands and watch a few TV shows, the day is gone.

The day is the unit of time the artist squanders. If he squanders months or years, it is only because he has managed to squander days. *It is not, however, that he has squandered a series of moments.* Moments are meant to be squandered. An artist, like every human being, is meant to squander moments loving, crying, dreaming,

witnessing, obsessing, complaining, and all the rest. We shouldn't feel guilty about squandering moments, for we understand how absurd it would be to attempt to "make every second count." What if the artist wanted to pour himself a whiskey? What if he wanted to watch a game show? Of course he can squander time! He is not a meaning-making machine that can make meaning 86,400 seconds a day.

But, on the other hand, he needs to make some meaning each and every day, just as he needs to eat and drink each and every day. That meaning-making may not be creating: it may be fighting a forest fire back from his home, learning a new thing, or listening to his children tell stories. But if, as the day goes along, the sense grows in him that no meaning has been made, a dull ache begins. It is in this regard that a day ends up feeling well-used or squandered, happily long or interminably long.

Try to think with a fresh mind about this fascinating creature, a day.

If you're lucky, the meaning-making part of your day starts as soon as you awake. Nor is this so astounding an idea. Why, after all, should it take a billion on-the-alert neurons all that long to fire up, so long as one is turning oneself on as one awakes and not shutting oneself off? Aren't we all capable of picking up threads from the day before?—the argument of last night, the lingering insult? Why can't we pick up our creative work in exactly the same way?

We are tricked by a phenomenon of time: hours and days pass slowly, but years pass quickly.

SALLY WARNER

There are only two important kinds of courage: the courage to die and the courage to get up in the morning.

JEAN-LOUIS SERVAN-SCHREIBER

EXERCISE
WAKING UP WORKING

Train yourself to wake up working. *As your body moves off the bed, your mind turns to the work.* Try it.

Hop into bed. Pull up the covers. Shut your eyes and dream a bit. Rest. Think of nothing, think of anything you like. Snuggle in. Toss restlessly. If new ideas invite themselves in, entertain them. If you fall asleep, sleep.

Spend at least ten minutes in bed, thinking of nothing, thinking up a storm. Then, *as soon as you begin to slip out of bed,* think

Three o'clock is always too late or too early for anything you want to do.

JEAN-PAUL SARTRE

of nothing but the work. Do not think about working, think about *the work.*

Will you work on the portrait's eyes?

Will you cut out Sam the cat from the play and add a raccoon?

Consider it a foregone conclusion that you will work as soon as you get up. Have no doubts. Feel your feet hit the floor. Go directly to the work. Do not stop for a glass of water, a quick check of the answering machine, a quick check to see if the mail's arrived. Go directly to the work.

Work. Stop when you must. Then get back into bed and practice again. Have pleasant dreams or nightmares, whatever your psyche demands, but as soon as your body begins its slide out of bed, slide your mind to the work. Your mantra as your feet hit the floor is "Off to work!"

Remind yourself tonight. Tomorrow, first thing, fly right at the work.

If you have a day job that you must get to by nine, can you get up at six, write for an hour, set down three or four hundred words, and then get ready for the office? In two hundred days, you'd have the draft of your novel. And every day you'd have made some meaning first thing that morning!

Maybe you presently use the first hour of the day to write in your journal, meditate, or do yoga. It's hard to take issue with such righteous activities, but it's also the case that many people use such activities as a substitute for work. If you're in the habit of working creatively only once a day, which is quite normal, and you use that work time to write in your journal, you are effectively putting off your creating. Can you both journal and write a screenplay? Of course. Are you doing both? You must be the judge of that.

Let's say that you create for that first hour. How much more meaning must you make that day? Perhaps none! For most artists, carving out one work period a day is the rule, and for that work

period to last only an hour or two is average. For it to last three hours is excellent. Certainly some artists work four, six, eight, ten hours a day, taking only the shortest breaks, and certainly others manage to come back to the work a second or a third time in a given day and accumulate a fistful of hours that way. As I revise this book, that is what I must do, because there is a deadline on the horizon.

When I stop working the rest of the day is posthumous.

TENNESSEE WILLIAMS

But many accomplished artists are done (and done in) after only a few hours of work. More than a few artists would dance for joy if they managed to work for three full hours. What is true for you? What does your intuition say is a lot of meaning-making for one day? Jot down your answer here.

Does your routine change from week to week? From decade to decade? Is it very different now from what it was when you started out, twenty years ago? Is it less influenced today by your moods? Do you need less time off? Do you only work really hard before deadlines or only during manic-like periods of heightened obsession with the work? Is working very much an on-again, off-again affair, such that one day you are immersed in the work, the next day a million miles away? What is true for you? Make a few notes about your work rhythms here:

To sustain the same attitude long enough to pull off a piece that takes months and months to do gets tiresome, which means that I can't worry about how I feel when I paint. I have to go into the studio and paint whether I feel like it or not.

CHUCK CLOSE

EXERCISE
REAL AND IDEAL ROUTINES

Describe your work day. If there is no typical day, describe some of your various work days. Spend a few hundred words learning about this often-squandered block of time, the day. Think about the following:

- Do you have a routine?

- Are you working an adequate number of hours?

- Do you take the kind of breaks that effectively kill your work day? Have you mastered the art of taking only small breaks?

- Do you restart relatively easily after a break? Or is it more like pulling teeth?

- What prevents you from having a routine?

- Can you create a routine?

A routine is the embodiment of regular hushing and holding. Create your ideal routine—in your mind first, then in reality. Pare it down to its essentials and articulate it in a simple sentence. For me the sentence is, "Work three hours every morning, and then once again some days." What is the simple sentence that describes your ideal routine?

Remember: if you're looking for a holy word, "routine" is not a bad choice.

The artist has worked. Now what will she do with the rest of her day?

The answer is not given to her. She must figure that out. The more she is an artist, the better she has learned how to create her life, moment in and moment out. She knows which things feel empty of meaning and which things full. She also knows that on a given day a thing that's always felt invested with meaning may suddenly feel drained of it. Such things happen. She may suddenly slump down, blue and defeated. Then for no reason she can name, she rises up again. Up and down, down and up, buffeted, powerless, but always needing to create her own existence!

DISTRACTIONS

What is most likely to interfere with an artist's ability to work on a given day? The following three impediments: that he gets distracted, that he gets disturbed, or that he hates the work.

The distractions that destroy concentration and make work impossible are not environmental ones. An artist in the trance of working can create while a jackhammer pounds away outside or a plane crashes into the next building. The distractions that destroy concentration are the *internal ones* that take hold of his mind and shove the work aside.

Silence is the mother of truth.
BENJAMIN DISRAELI

Consider the following. Most artists maintain day jobs or second careers. The eight hours a day they spend doing that work is one real impediment to creating; but when they come home, they're likely to have brought distracting dramas from the workplace back with them. *They are still at work* and will be until eight or nine in the evening, when, after two glasses of wine and a few innocuous TV dramas, they finally calm down.

Does an editor who means to write leave his editing job at the office and get right to penning his novel in the evening? Rarely. He is still in the work environment, drafting memos in his mind, replaying the conversation with an author that ended poorly, replaying the conversation with the marketing manager that left him worried about the fate of a forthcoming title. Or, rather than think about any of this, he goes out for a good meal, a few beers, and a movie; which is to say, the distractions are pleasantly silenced but at a cost of the rest of the evening.

It is not fair to say that an artist invents these distractions so as to avoid encountering his creative work, although that motive may be a part of the equation sometimes. Nor is it fair to say that his inner conversations serve no purpose, for out of them may come an insight about how to handle his angry author or his unenthusiastic marketing manager. But despite these disclaimers, it is also true that *every single day* that proceeds like this is a day that his own creative work goes undone.

Nor is the artist who is fortunate enough not to need a day job spared such inner distractions. One of my clients, a sometimes productive screenwriter, possessed the financial resources to write every day, first thing, if he so chose. But instead he spent hours

distracted. Guilty feelings about being free to write distracted him. Dark thoughts about his agent's loyalty distracted him. Worries about his disturbed sister and her two disturbed children distracted him. Tiring mornings passed in troubled reveries; by noon he needed a nap.

This should sound to your ears like classic blockage. The blocked artist is anxious, and these distracting thoughts, which themselves make him anxious, mask his deeper anxieties. This is our original equation repeated again: the anxiety associated *with* creating makes him more anxious than does the anxiety associated with *not* creating. So he rushes off to the bakery for rolls, into an inner fight with a former friend, back to the bathroom for a quick shower, off to worry about a piece of mail that seems lost, down to the 7-Eleven for cookies, back to a worry about the nail of his big toe, which looks to be turning blue. This state of perpetual distraction, caused by anxiety and masking deeper anxiety, completely prevents him from hushing, holding, or doing anything in support of his work.

This is why *the practice of hushing* is so vital to the artist's well-being. I said right off the bat that quieting an autoscan mind was the most important practice an artist could begin, and I'll say it again now. Distractions, the noisy products of anxiety, can't be scolded or charmed away. They must be quieted. They vanish only when the mind grows silent, when it surrenders, reorients, hushes.

To arrive at silence you must invite silence in. You are the instrument who focuses and you are the instrument that is focused. You are the silencer and the silenced.

In beginning to throw pots, I worked for a long time to get the clay centered. I soon discovered that if I were not centered myself, the clay would not become centered.

WILLIAM GALBREATH

There is always a slight tendency of the body to sabotage the attention of the mind by providing some distraction.

STEPHEN SPENDER

EXERCISE
SNAPPING BACK

If distractions are a problem for you, start to wear a rubber band around one of your wrists. When you catch yourself replaying your morning run-in with the meter maid or brooding about the phone call that hasn't come yet, *snap the rubber band hard.*

Wake yourself up with that snap.

Thus awakened, exclaim, "To work!" Focus on the work, go to it, cross the room to your computer, pick up your guitar. Start to hush. Go right into the trance of working.

If the distractions remain, if the meter maid simply won't leave your mind, snap the rubber band again. Again exclaim, "To work!" Let your mind go blank. Empty the screen of your mind and pray that the next image will be work-related. If it is, charge off. If it's the meter maid again, you know what to do. Using a rubber band in this way is an extremely effective tactic, and you don't have to bruise your wrist to make it work.

My God, these anxieties—who can live in the modern world without catching his share of them?

VINCENT VAN GOGH

PERSONALITY DISTURBANCES

The difference between chronic distractability and chronic personality disturbance may or may not be one of kind. But it certainly is one of degree. Real disturbances of the mind, real depressions with psychotic features, real full-blown mania, retain as their hallmark their *severity;* a snap of the rubber band will not bring the disturbed person back to his easel or symphony score.

Nor are these severe disturbances so rare in the lives of creators. I could easily spend the next several pages listing the poets, painters, composers, novelists, actors, dancers, and other artists who either suffered from manic-depressive illiness, were committed to asylums, attempted suicide, or committed suicide. Dr. Kay Jamison has generated just such a list of two hundred names at the end of her book *Touched with Fire: Manic-Depressive Illness and the Artistic Temperament* and you are welcome to browse there if you doubt the reality of this problem.

I won't drop those names here. Instead I mean to say a simple thing. If you are an artist, be prepared for real disturbances. Be prepared especially to be visited by depression. How extreme or incapacitating that depression will be, I cannot say. To what extent that depression may be hereditary in nature, I cannot say. Whether or not it will be accompanied by mania, I cannot say. All I can say is, if you are an artist, get ready for it. It is probably coming.

People create in moments when they are elated about express-ing their depression!

AARON COPLAND

And when it comes? Today, the first line of defense is medication. If you have manic-depressive illness and are someone who benefits from lithium, you will discover in lithium a lifesaver. If you suffer from a severe depression that is relieved by the newest antidepressants, you owe it to yourself to investigate them. Medication may seem like an unheroic solution to a challenge you would prefer to meet by mastering your mind, but here again surrender and not control is the path. If the medications available are indicated and if they work for you, you as a person will benefit, even if some heroic subpersonality in you feels embarrassed or defeated.

We've talked at length about anxiety, both directly and between the lines. Depression is the second greatest challenge after anxiety in an artist's life, and also deserves your real attention. We have to function even if we're sweating fearfully and we have to function even with the blues. But just as we can't create in the middle of a panic attack, neither can we create in the middle of a severe depression.

Your first job is to recognize the severity of your depression. *If it is severe, seek help.* When you are feeling lethargic, empty, even suicidal, seeking help will not be high on your agenda. But perhaps you can still manage to honor your creative self, the you that knows that there is still work to be done, the you that is not completely defeated by your true circumstances. To seek help in this condition is tantamount to dragging a boulder to the doctor's office, an effort of superhuman proportions. But perhaps you can do it nevertheless, for the sake of your work to come.

But less severe depressions, small- and medium-sized cases of the blues, may in fact be in your power to alter. Are they? Have you learned what to do to combat the blues?

EXERCISE
THE BLUES: A PERSONAL INDEX

How much can we ask of ourselves? If we're severely depressed and suicidal, perhaps very little. Let's call such an extreme state a "10." It is a horror to experience. To imagine that work is possi-

ble when you are "10" depressed or "10" mad is to misunderstand how incapacitating such a state is.

Try to fathom this severe state of depression (but don't dwell on it!). Now think of a less severe state of depression, a "9." You still feel horrible, dismal, empty. But you only weigh eight hundred pounds, not a thousand. Your mind is wracked but you aren't seeing visions. The sky is a dark charcoal gray rather than a pitiless black.

Now try an "8." Could you work feeling this way? What about a "7"? A "6"?

Find the level of blueness where creative work seems possible. For you that may be a "6" or a "2." Feel that state now and try to answer the question "What would it take for me to work, feeling this way?"

Would crying help? Meditating? Affirming the work? Screaming? Exercising? Showering?

Probably you are used to these cases of the blues just passing. But how many days are robbed while you wait? Try a more active and affirmative approach by creating a small plan to deal with the blues. Think; experiment; devote real time and effort to planning for the blues. Jot down the skeleton of your plan here:

Unless we agree to suffer we cannot be free from suffering.
D. T. SUZUKI

Preparing for personality disturbances is not like preparing for an earthquake. You can't store up bandages, canned food, and water in a garbage can by the garage door. But what you can do is hold the willingness to seek help, a willingness that is one part surrender and one part optimism; and the willingness to confront those disturbances mild enough to dispute. Have a plan ready for the "2"-sized blues; for the "7" and "8," commit to seeking a helping hand.

HATING THE WORK

It is horrible but altogether likely that for long stretches of time you will hate your work in progress. How will you manage to continue working if you think your work in progress is a rotten failure?

Without an answer to this question, you can spend five years on your first novel, not really writing it, and then flee to law school. Without an answer to this question, you can make a career out of abandoning quarter-finished work or living with a constant case of the blues, always a little depressed about the badness of your current screenplay or sculpture. If you don't know how to deal with work that smells (or that you think smells), your creative life is in jeopardy.

Let's begin by confessing that our work can stink. Say it out loud: "My work can stink."

"It is entirely possible that my work stinks."

"Many times I will utterly screw up."

"I may write three bad novels for every decent one."

"I may make six ordinary movies for every masterpiece."

"I may capture the radiance of light in only one out of ten of my paintings."

"I will produce many ugly, stupid things."

"My work can stink!"

Is that enough confessing? I doubt it. I think we could profitably spend hours and hours admitting that we are human.

Think about the work you're creating. Are you secretly holding that it is badly flawed? Is that secret preventing you from really working on it? If it is, please let that secret out of the bag. Please confess that you hate the work. *You are not confessing that you hate yourself or that you are a failure.* You are only and exactly confessing that the work you are presently committed to appears not to be succeeding. That is hard to say, but not quite a direct stab wound to the heart.

It is worse to keep this a secret. Confess that the work smells as bad as anything you've ever removed from your refrigerator. Once you utter your confession and return to the work, you may even discover that the work isn't that awful. Wasn't keeping the secret

The smallest atom of truth represents some man's bitter toil and agony. For every ponderable chunk of it there is a brave truth-seeker's grave upon some lonely ash-dump and a soul roasting in hell.

H. L. MENCKEN

the worst part? Maybe now you can hold the work without holding your nose against the smell. Maybe the smell has evaporated!

But if the smell remains, there is only one question to address. Do you mean to abandon this work? Yes or no? If you're not abandoning it, then you must affirm it. You must go to it, love it, work on it, work with it, wrestle with it, be with it. You must marry it again, love it each day, visit it each day, hold it and think about it.

Unless you are moving on to new work, you must engage this work even if you hate it.

Put up the following sign in a conspicuous place in your work space: "I will work with my whole being no matter how the work is going" or "I will work at all times with my whole being" or just "I will work." Say it any way you like. What you're saying is that you refuse to let the fact that you're bound sometimes to stink up the room rob you of your creative life.

It is easy—terribly easy—to shake a man's faith in himself.

GEORGE BERNARD SHAW

WORKING OVER TIME

In the moment, you encounter the work. On a given day, you work for so many hours. Over time, you persist in your efforts.

Pages fall off the calendar. Still you wrestle with your characters. Leaves fall off the trees. Still you struggle to abstract nature. Working over time is about the artist's backbone. You can surrender to the fact that the work requires exactly as much time as it requires or you can despair about it, but in either case you must work on.

Everything that we've discussed so far is recapitulated in this working over time. The person you are, the person who is more anxious than calm, more depressed than elated, more wounded than intact, will configure this painting or writing year exactly in accordance with your being. That it takes a year to write the draft of your novel and not three months or three years is an autobiographical statement. That as you work with less zeal you start to crave a love affair or a liquor store visit is an autobiographical statement. *You,* the you of our equation—

$$\rightarrow \text{person} \rightarrow \text{process} \rightarrow \text{act} \rightarrow \text{product} \rightarrow \text{world} \rightarrow$$

—determine what your working over time will look, feel, taste, and smell like. There is no Platonic ideal or God-given way, there is only the real you in your real circumstances.

The man's the work. Something doesn't come out of nothing.

EDWARD HOPPER

E X E R C I S E

MINI SELF-ASSESSMENT

Answer the following questions as honestly and fully as you can.

"What about *you* affects the way you work over time?"

"What is the relationship between your person and your process?"

Take real time to examine these two questions. Devote pages in your working journal to their answer. Surrender to the pain that honest reflection brings.

What have you learned from your self-examination? That you're burdened by afflictions with names like "lack of discipline," "a habit to procrastinate," "severe mood swings," or "a lack of focus"? That in all honesty you're frightened, or too irritable to work regularly, or too angry? Congratulations on your honest reality-checking!

Now what will you do?

One answer is to continue working exactly as you are, irritable as a Beethoven, anxious as a Dostoyevsky, sad as a van Gogh, and white-knuckle life as you produce fine work. The house gets built but the carpenter crucifies himself in the process.

Or you can work to transform yourself. The artist transforms herself not only so that she can work better over time, but so that she can be as free as possible. Disabling anger, anxiety, and sadness, a disabling worldview formed in the crucible of an unfair childhood, disabling behaviors and habits are all losses of freedom which she would prefer to jettison.

How can she manage this transformation? Finding the answer is her life project. Virtually anybody can learn to put paint on a canvas or string words together. The artist's goal is a different one: to become the person who, when she creates, creates freely. What

emerges may be an ugly thing of beauty or a beautiful thing of beauty, something her audience flees from or embraces. Who can say what will appear! All the artist hopes she can say is, "I worked deeply and truthfully; and I am not a cripple."

It naturally saddens us to recognize that we are the millstone around our own neck. How heartbreaking to see that our depressions not only depress us, but steal months and sap energy from our working over time. How heartbreaking to see that for a decade we did work that we could have skipped, that we *knew* we could have skipped even as we did it, but that out of pride, ignorance, youthfulness, and who-knows-what-else we refused to skip. How heartbreaking to look back!

For the artist intent on transforming herself, working over time is a heart-mending operation. Alone, she must perform her own surgery and provide her own nursing care.

Let us so live that when we come to die even the undertaker will be sorry.

MARK TWAIN

The artistic impulse seems not to wish to produce finished work. It certainly deserts us halfway, after the idea is born; and if we go on, art is labor.

CLARENCE DAY

CREEPING COLDNESS

As you work over time, you encounter natural events in the life of the work. One such event of special importance is the creeping "coldness" described by the painter Emil Nolde:

> I frequently find it very difficult—after reaching the high point of a picture, something which often happens quite early while painting—to preserve the tension until the work is completely finished. When the pure sensuous power of vision relaxes, a rational coldness is all too eager to continue the work, to weaken it, and sometimes to destroy it.

An artist can't help but wax hot and cold as he works over time. He perceives a mistake; coldness sets in. He has no idea what to do next; coldness sets in. The original idea fades; coldness sets in. The living work takes him in the direction of red when his heart had been set on blue; coldness sets in. The work is *difficult:* ice forms around his heart.

How will you rekindle the fire each time the coldness sets in? How will you maintain tension when, inevitably, laxness creeps in? *What will you do when the high point of the work has passed?*

After about fifteen years or so, you develop your own style and sound and your own boring routines.

JANIS IAN

EXERCISE
A PERSONAL ETERNAL FLAME

Get a poster board or a piece of newsprint paper and paint an eternal flame in reds, yellows, and oranges. Make it Fauve brilliant, yellow as the sun, red as a sunrise. Invest it with all the tropical heat, all the lava-red fire you'll need to defrost your heart when the coldness sets in. Tack your eternal flame up and warm your hands in front of it whenever the work bores you, confuses you, or fills you with revulsion.

Or paint a miniature eternal flame as small as a candle flame. Or keep a lamp on next to the work. Or keep a heater on to warm your hands by. Or designate a sunny spot in the garden as the place you'll escape to for warmth. Or put up a picture of your daughter at the age of two, your cat half-hidden in a grocery bag, your most surprising lover: anything that can make you smile, anything that can warm your heart when the chill sets in.

To combat the coldness, you must provide your own warmth. Let your personal eternal flame warm you and mark the way.

BREAKS

Working over time is like a dance or a boxing match. You are in intimate contact with the work, maintaining its tension as best you can, holding it day and night, lovingly holding hands with it, banging it about the neck and shoulders. But sometimes you must part from the work and take a break. How long are these pauses between rounds to be? Roughly as long as the following.

Start by calculating the amount of time it'll take you to complete this project. Yes, that's an intuitive stretch! But seasoned artists regularly make such calculations, often with remarkable accuracy. Just take a deep breath and feel the whole symphony, the whole documentary, the whole self-help guide book. Relax. Sur-

render. Will you be done in three months? Six months? Nine months? It's entirely possible to know.

Next, do the following.

E X E R C I S E
FREE PASSES

Make yourself a collection of passes with an expiration date that matches the deadline you anticipate needing. If today is January 1, 1996, and you estimate that the draft of your nonfiction book will take you six months to write, write at the bottom of each pass: "Expires June 30, 1996."

Include in the collection all of the following:

4 "I am too dull and stupid to work today" passes

6 "I need a break to let my unconscious work" passes

4 "I really worked hard yesterday, and today I'm going fishing" passes

6 "Other things are important in life, and I'm doing one of these things today" passes

2 "I'll go to the library today" passes

2 "I'm entertaining company" passes

2 "The hell with everything" passes

Often nothing good is accomplished at the first attack. You take a rest, sit down anew to the work, and during the first hour, as before, nothing is found. Then all of a sudden the decisive idea presents itself to the mind.

HENRI POINCARÉ

That's twenty-six days off during the twenty-six weeks. You also get one weekend day off free of charge. That's two days off each and every week.

Are these arbitrary numbers? Of course! Are they reasonable numbers? They are. Try not to take off more than two days a week from your work. As soon as three- and four-day stretches vanish, so do months and years.

WHAT WORKING MEANS

Please continue to work. You can move on to Chapter Five, on completing your work, anytime you like; but do work. Work through the dull days, the blue days, the catastrophic days. Please work on.

Remember that your work entails all of the following:

- Working means holding the work.
- Working means hushing.
- Working means starting.
- Working means mastering the disinclination to work.
- Working means working in the moment.
- Working means entering the trance of working.
- Working means appraising.
- Working means choosing.
- Working means negotiating a maze.
- Working means living with chaotic-mind anxiety.
- Working means ordering the work.
- Working means wrestling with the thing from the sea.
- Working means manifesting drive and direction.
- Working means reframing the impossible as possible.
- Working means making and correcting mistakes.
- Working means waking up working.
- Working means working on a given day.
- Working means silencing distractions.
- Working means surviving disturbances.
- Working means loving the work, not hating it.
- Working means providing your own warmth.
- Working means maintaining tension.
- Working means working over time.
- Working means surrendering.

Good luck!

You search, and in the process of searching you may never get anything but you may learn something about yourself, about life.

MARTIN SCORSESE

FROM WISH
TO WORLD

5

Completing Your Work

*W*hen was this book completed? The first ideas for it came together in March of 1994. Was the book completed as soon as those ideas had some depth and clarity? In a certain sense, it was. It *felt* done, as if it were in the past tense already. It only still had to be written.

I finished the book proposal, which included a detailed table of contents and twenty thousand words of text, in April of 1994. Was the book completed then? Yes! I surely had a sense of accomplishment and completion. But in the course of a few conversations with the book's editor and its publisher, the shape and content of the book changed significantly. For instance, in the proposal there had been little mention of, and certainly no chapter on, "starting." Now the book contains twelve thousand words on the subject. Had the book really been completed when the proposal was done?

I know a painting is finished when it looks all greasy and shiny and I'm happy.
JAMES ROSENQUIST

Perhaps, then, this book was complete when I turned in the draft of it in October of 1994? You already know the answer! It *felt* complete and *was* complete, in several senses of the word. It was certainly complete enough to prompt me to open a bottle of champagne and celebrate. But did I know that the editor and publisher were going to suggest changes? Yes. Did I imagine that new ideas would incubate as I took a break from the book? Yes. Did I suppose that the process of working on this book was over because I had turned in a "complete" draft? No, of course not.

And what about now? What if—as is surely the case—I've left something important out of the book? Can I consider it complete *even now* if I suddenly become aware of a gross omission or a bad mistake? What if I've put in too much for the would-be artist and not enough for the seasoned artist? Does that possible lack of balance steal from me the right to call the book finished? What if I haven't addressed the consequences of childhood trauma enough? What if I haven't communicated the relationship between "surrender" and "control" clearly enough? Can I *ever* complete this book?

Doesn't this sound all too familiar? Don't you spend sleepless nights wondering if your play is finally finished, even though opening night has passed? Don't you wish that you could abandon your sculpture once it's in your friend's home, nicely purchased and positioned there? Can't the beautiful film be left alone, even though it's long at one hundred forty minutes? When is a thing done? Is it ever done? Who's to say? How does one know?

So the artist paces, worries, stews, gets headaches. He completes a corner of the painting, isn't sure, goes back, tries to fix it, and ruins it. He finishes a song, takes a nap, plays it again, and hates it. He gets to page one hundred of his screenplay, opens the newspaper, and discovers that a movie just like his will open on Friday. He starts the last scene of his mystery, the one in which the killer is unveiled, and discovers that he's unconvinced that the butler did it. But he fingers him anyway. What else can he do? All the clues are planted!

These conundrums are real and true. But there's also another important way to frame the matter. Rather than ask right off the bat, "Can a work of art *ever* be completed?" we can ask the equally proper question, "How many times may a work of art be com-

Making a movie is like climbing a mountain. The higher you get, the more tired and breathless you become, but your view becomes much more extensive.

INGMAR BERGMAN

pleted?" Is the answer "never" or more truly "scores and hundreds of times"? If it's the latter, what joys await the creator!

SUCCESSIVE COMPLETIONS

A creative work is completed *many times over.* It is completed each time the creator comes to a subjective sense of completion (even if that sense lasts only for an instant) and each time the work reaches an objective stage of completion (even the most "trivial," like the gessoing of a canvas, the sprucing up of a single sentence, the righting of a single chord progression).

Having completed a task means having become eternal.
LAO-TZU

All these subjective and objective completions *count.*

Stop!

If you do not permit these completions to count, you may not derive enough satisfaction from the creative process and, not deriving enough satisfaction, abandon art. This is not a trivial matter!

Stop now and do a small thing connected to your project. Write and rewrite a single sentence until it is completed. Mix pigments until you arrive at a beautiful green. Play one chord, magnificent in its own right. Find another magnificent chord, one suited to the first. Put them together, just as they should go together. *Feel their completeness.* Feel the satisfaction.

These completions count. If you do not allow them to count, one day your wish to create will evaporate.

Unfortunately these successive completions do not add up in any simple way. Each is an event, a milestone, and a marker, but none is a guarantee. The mixing of a beautiful green, which, when completed, is a definite completion, does not guarantee that the painting will be well done. In fact, you may have to make that beautiful green ugly before you can use it in the work you are creating. The making of it mattered, and what remains of it on the palette are beauty marks in their own right. But the making of that green guaranteed nothing.

These are the tensions and difficulties embedded in the processes of working and completing. A sentence is well-crafted, smart, elegant, complete. But it has nothing to do with the book. Out it goes! For a moment you celebrate the sentence, brag a little and praise yourself, and *feel the completion.* Then you burst into tears, for the sentence must be abandoned, certainly for now, probably forever. How much joy did *that* completion bring!

But even though that sentence had to be abandoned along with a hundred other beautiful sentences that had no place in the book, nevertheless, as a consequence of your serious efforts, you experienced countless completions while you worked. Did you further the work toward its ultimate end? Possibly. Do you have completions to honor and celebrate? Yes, absolutely.

I thought I was a revolutionary and learned that I was only an evolutionary.

KÄTHE KOLLWITZ

GROUP ACTION

Gather your artists' group again. Give the group the following instruction. "Describe the successive completions you experience as you create. Are you in the habit of recognizing them? Are you in the habit of honoring and celebrating them?"

Each person writes for half an hour in silence. Then each person reads his or her piece aloud. There is no cross talk and no discussion. As you remember, this is an exercise in speaking and listening, not in commenting, converting, helping, or commiserating.

Each artist speaks and then listens. When everyone has spoken, thank the group for its efforts. Then repair to your potluck dinner, celebrating and honoring the completions that have occurred that very evening.

SHOWING YOURSELF THE WORK

These successive completions are true and valuable, and ought to be honored. But they are not the ultimate answer to the question "When is the work completed?" To answer that question, you must appraise the work with an unclouded eye and a set of criteria.

Of course you've been showing yourself the work all along, even if you haven't stopped a single time to really examine it. You know something about its obvious flaws and even a little about its secret flaws. You know which parts seem to excite you whenever you reencounter them. You know, if only you dared think about them, which scenes feel mechanical and which alive, which pear is incidental in the still life and which essential. You know all these things in exactly the same way that you know everything: guardedly and imperfectly.

Maybe you're largely done with the work right now. Maybe you're overdone and merely tinkering. Maybe you're trying to turn a sow's ear into a silk purse or a silk purse into a sow's ear. How hard it is to actually look and see! Defensive like everyone else, artists naturally defend themselves against acquiring too clear and complete a knowledge of their own work. To look is to take such a terrible risk. The work may need work—a lot of work, a year of revisions. The work may have suffocated to death last month. The work may not match your dream of it. The work may be so very ugly . . .

This blindness is perfectly natural. Does it surprise anyone that eyewitness testimony is regularly so unreliable? A man with a gun appears, we go blind with anxiety, and then we look foolish on the witness stand when we have to say, "Yes, I looked directly at him, and I have *no idea* what he looked like." So, in order not to look foolish, we often fabricate testimony.

The same thing happens when he appraise our work. Because of anxiety, we do not really see the work, but so as not to look foolish to ourselves we invent some judgment, positive or negative, that meets our wish of the moment. If we wish to quit we say, "Rotten work!" If we wish to proceed we say, "Seems all right." But in neither case have we really *seen* the work.

Take as a second example of blindness caused by anxiety the following classic: hysterical blindness in combat pilots and other military personnel during World War I. Because we no longer "believe" in being struck blind, this psychological disorder has practically disappeared; but during World War I, hysterical blindness was the *most prevalent* psychological reaction to stress and anxiety seen among service personnel. So as not to see the horrors of war and so as to exempt themselves from further participa-

Learning when "enough is enough" is the discipline of a lifetime.

GAIL GODWIN

tion in those horrors, these soldiers went blind. An entirely natural form of this dramatic disability often strikes artists as they attempt to look at their work. Fearful that what they are about to scrutinize may be awful or miles from completion, they are struck blind and see nothing.

This is especially true if an artist harbors the suspicion that he started off on the wrong foot. If appraising generally raises an artist's anxiety level, anxiety is hardly the word for the terrible experience one must sometimes endure: the experience of recognizing that the work can't possibly be completed because it was never started properly. This is a very difficult special case of appraising, but one that artists must honorably confront.

> *The old masters were not so nervous as we are, that is why they could hold on better to the big masses.*
>
> **ROBERT HENRI**

EXERCISE
LOOKING AT YOUR WORK CALMLY

Choose one part of your work to look at. Say to yourself, "I can do this." Read the sentence, scrutinize the apple, sing the lyrics, but do so with your attention focused not on the work but on the sensation you want to nurture, the sensation of calmness. Try to *appraise calmly,* holding that this is not a combat situation, not a life-threatening encounter. Find the psychological distance that allows you to look at the work and remain calm.

If what you're looking at starts to raise your anxiety, work to quiet your nerves. Go right now to the Appendix and find a technique that works to reduce your experience of anxiety. Find one and use it. If you succeed, you will have learned a great enduring lesson—that it's possible to look at your work without panic.

The anxiety connected with discovering that you are on the wrong track, that the painting is not powerful, that the poem is dull, produces a veil over your senses, so that, while you manage to continue working, you do so with too little appraising effort. You work; you see; but you are in reality half-blind.

You would simply rather not look. You say to yourself, "Soon." Better not to interrupt the flow, you say: you'll look soon.

Better not to look with tired eyes, you say. Better not to look until after the exterminator leaves. Better not to look until April, when the sun comes out. Soon. Later. Better to work. Better not to look. Later. Soon.

But then, inevitably, a moment comes when you finally whisper, "Now." What a moment that is, considering all that has gone before! So many anxious moments survived, so many more evaded. How momentous the moment becomes, this moment of looking! How fraught with terrors!

For the painter Philip Guston, that moment came with each new painting day. He explained, "I'm a night painter, so when I come into the studio the next morning, the delirium is over. I know I won't remember details, but I will remember the feeling of the whole thing. I come into the studio very fearfully, I creep in to see what happened the night before. And the feeling is one of 'My God, did I do *that?*'"

Does the strange thing from the sea look anything like you intended it to look? Is the book muddled but still alive, or muddled and quite dead? Is it much more juvenile, pessimistic, or without point than you had hoped? Is it too long? Too short? Just *off* somehow? *How do you judge?*

Is the painting perfectly fine but exactly like one you did last week? *Is that a problem?* Is it not fine at all but unbalanced, two-dimensional, awkward, amateurish? *How can you tell?* Is the symphony like that soup you once made with too much water, so that no matter what you added to it, it still tasted flavorless and thin? You know a flavorless soup when you taste one, but can you recognize a thin, flavorless symphony?

There the work is. You encounter it both as creator and audience member. You need to know: how is it? You need to know: is it finished? But a special inarticulateness overcomes you. It is as if, subtle as a creator, you were reduced in the moment of looking to the level of grunting: good, bad. Yes, no. Love, hate. Keep, destroy. Grunt.

Why this extra inarticulateness, above and beyond the normal trance-of-working muteness that accompanies creating? Because few artists do the two things that would help them effectively frame their thoughts and feelings at such moments. First, they do not strive to consciously manage their anxiety. Second, they do not

In order to be a great composer, one needs an enormous amount of knowledge, which one does not acquire from listening only to other people's work, but even more from listening to one's own.

FRÉDÉRIC CHOPIN

come to the moment equipped with a sense of what will count as success, with a sense of what criteria they mean to use to measure the work's completeness. Let's start with the second point first.

CRITERIA FOR COMPLETION

How will you evaluate the work? What is your *basis* for evaluation? According to what criteria will you judge that the work is worth saving or in need of abandoning? How do you know when to burn your own work, when and how to correct it, in what direction to steer it, how to complete it? In terms of what criteria have you been judging the progress of the work all along? Have you actually articulated any?

More likely than not, you haven't. It would have been nice to name them when you started, if they were nameable, but in fact you had little more than an idea, a sensation, a starting point back then. It might have been nice to name them while you were working, if they were nameable and if you'd found just the right moment to step back and judge the project. But be that as it may, here you are now. What are you supposed to do?

Are you suddenly supposed to generate a final checklist, a "completing" checklist, like one you might use at the end of an assembly line? "Your vehicle has undergone a hundred and one final checks." Are the criteria which have so far never been articulated, which may have eluded you all along, now to be listed? Is that the idea?

No and yes.

Remember that there is no right brain or left brain to bring to the work, only a whole brain. There is no aspect of personality like an "inner critic" to bring to the work, only your whole being and all your faculties. Nor are there any "criteria" by which you may judge a work, if that idea is held too narrowly or mechanically. You can't make a quality control checklist and run your pencil down it. *All you can do is hush and hold all over again.*

That is the "no." But there is also a "yes." Underlying an ability to think critically is an ability to create, name, rank, sort among, and comprehend the criteria one is using to evaluate a given thing. What are the criteria by which one judges if an alco-

hol treatment program is working, if money spent on school lunches is money well spent, or if financial aid to countries south of the Sahara ought to be increased? People evaluating such programs need to know, if they are to be respectable thinkers.

You, too, need a basic sense of what criteria you will employ when evaluating your own work. You need to know which criteria are more important than which others, and which are the most important of all. You need to know which are reasonable and which unreasonable, which consistent and which contradictory. If you want your genre romance to investigate the psychological and philosophical roots of nihilism, that is unreasonable. If you want your movie to brilliantly portray an incestuous relationship between Christ and Mary and also please Christians, you are operating unreasonably, with contradictory criteria.

It is really quite amazing how often artists do just that: start right off the bat working from unreasonable or contradictory criteria. They want to write a piano concerto that no one with a mere ten fingers can play, and at the same time have excellent ten-fingered pianists line up for the chance to play it. They want to write a successful genre novel that also violates the rules of the genre, so as to stretch the genre and make it larger and more serious. They want to make an idiosyncratic movie with universal appeal.

These impulses are perfectly understandable. I've had all of them myself. I've embarked on books and spent years on books that could not possibly be resolved satisfactorily. Artists fall into this trap all the time. The problem may be that the artist is in a muddle or that he is an idealist who wants to make converts or stretch genre readers. This may be you and you may even want to continue on your idealistic path. But it is important that you speak such intentions out loud; when they remain secret, they only produce muddles.

Earlier we spent considerable time on starting—on choosing, determining the rightness of an idea, and the like. The more the starting place was a right one, the more you've had a sense all along of what constituted the work's strengths and weaknesses. The better, too, has been your ability to look at the work. Because it felt right to begin with, you could look at it more openly and more lovingly. How much easier it is to look at work that still in-

Very often some of the greatest composers do not understand the instruments. They ask the trumpets, trombones and horns to play fortissimo, and then the second clarinet cannot be heard at all.

LEOPOLD STOKOWSKI

terests you, that you still love! Work which is wrong from day one gets looked at with one eye shut every day thereafter.

But whether you started off on the right foot or not, whether you're optimistic about the work or pessimistic, you remain with the task of evaluating it. Evaluation means keeping your eye on the following six points:

1. *Matching the work to the original idea* to see if the work is still connected; and if it isn't, seeing if that is all right

2. *Examining the strange beast from the sea* to see what it is and where it wants to go, if it should be given more line or seriously reeled in

3. *Considering the marketplace,* wondering in a corner of consciousness if you are doing what you need to do in order to produce a work that can be sold

4. *Maintaining technique and correcting mistakes,* including everything from straightening a sentence to removing hundreds of unwanted pages, adding a comma to reorganizing the book along more logical lines

5. *Analyzing the gestalt by hushing, holding, and stepping back,* by bringing your whole undefended being to the task of judging whether the work is large enough, good enough, and truthful enough

6. *Checking the work against a list of criteria specific to this work*

It is of course this sixth test that we are presently discussing.

A screenwriter told the following story. Some years back he'd been asked if he had any interest in producing a script for a "tits on a bus" movie (this is apparently a genre). The producer explained to him that the movie, to be set in Turkey, could be about anything at all just so long as it included four specific scenes: a shower scene, a rape scene, a strip-search scene, and a lesbian scene.

Why these "criteria"? We know perfectly well why. And often we know perfectly well what our own work ought specifically to include. Think for a minute about a genre adventure novel, a

Writing a book is an adventure. To begin with, it is a toy and an amusement. Then it becomes a mistress, then it becomes a master, then it becomes a tyrant.

WINSTON CHURCHILL

novel of the sort that a Tom Clancy might write. What are the criteria specific to such a book? Probably each of the following:

1. A good plot, smart and without holes
2. Lively characters (including a lively villain)
3. Speed
4. Action
5. Local color
6. Suspense

The freest art and the most rebellious will be the most classical; it will reward the greatest effort.

ALBERT CAMUS

These are certainly reasonable criteria for such a book. Therefore, if you worked on such a book and found yourself saying, "This part is slow but necessary," or "This is a plot hole, but who cares," warning sirens ought to go off in your head. It might be that the slowness is justified or the plot hole permissible, *but not on the face of it,* not since it violated your own reasonable criteria. Such deviations must be *double-checked.* The slowness and the plot hole are, on the face of it, unreasonable. The burden of proof rests squarely on the slow passage: why should it be permitted to survive?

Creating such a list of criteria is of course easier to do with respect to a genre novel than a psychological novel, abstract painting, or piano concerto. But what about an abstract painting? Might not a painter of such a work determine that he wanted his current painting to be:

1. Alive
2. Powerful
3. Suggestive
4. Resonant
5. Wild

These are reasonable criteria. They do not contradict one another. They capture the painter's intent and help remind him of what he is after. They help him remember that a certain splotch that could be turned into a hand or a spider need not be turned

into anything in particular unless he really wished that splotch to take that turn. The painting could not be judged weak or strong, wrong or right, according to whether it contained a given spider or hand but according to whether it was alive, resonant, and wild. No spider need dictate to him!

This is a vital point. When we are aware of our basic intentions, no spider or hand can dictate to us. No phrase can dictate to us, no scene, no clause, no limb, no color patch, no snatch of melody. All such things either serve the central intention or else they are eliminated: they are not the bosses.

Would these particular criteria—that the painting be alive, powerful, suggestive, resonant, and wild—satisfy or make sense to any given abstract expressionist painter? I do not know and cannot know. Every artist must generate his or her own criteria, must examine them to discover if they capture his goals and intentions, must eye them to see if they contain any contradictions, must judge them sensible or unreasonable.

I realized that were I to paint flowers small, no one would look at them because I was unknown. So I thought I'll make them big, like the huge buildings going up. People will be startled; they'll have to look at them—and they did.

GEORGIA O'KEEFFE

EXERCISE
CREATING COMPLETION CRITERIA

As an exercise, try your hand at creating "completion criteria" for the following works. Imagine yourself creating the work. What are some reasonable criteria you might employ in evaluating the work? I'll do the first; you do the next six.

A Nonfiction Self-help Book

1. Take-away-ability (that there are ideas for the reader to take away, remember, use, etc.)

2. Rhetorical power

3. The creation of a map that clearly describes the territory

4. The presentation of solutions in addition to the naming of problems

5. A concern that the reader be *helped,* that exercises and theoretical constructs serve the purpose of helping and not entertaining, seducing, or impressing the reader

Try your hand at the following ones. Name some reasonable working or completing criteria for:

A Still-life Painting

1. _____

2. _____

3. _____

4. _____

5. _____

A Sculpture of a Father Embracing His Son

1. _____

2. _____

3. _____

4. _____

A certain artist's love of nature made his pictures charming. Soon he was the darling of the middle classes. His art had nothing to do with the restless ugliness of the present. Therefore he was quite successful financially.

HEINRICH VOGELER

5. _____

A "Cozy" Mystery Featuring a Female Amateur Sleuth

1. _____

2. _____

3. _____

4. _____

5. _____

A Half-hour Sitcom Teleplay

1. _____

2. _____

3. _____

4. _____

5. _____

A Poem About Sitting on a Curb, the Dance Long Over,
Waiting for your Alcoholic Mother to Pick You Up

1. _____

2. _____

3. _____

4. _____

5. _____

A Country-Western Song About Betrayal and Lost Love

1. _____

2. _____

3. _____

4. _____

5. _____

Imagine other sorts of works. Get into the skin and shoes of a
whole host of creators.

One of the things that I try to be conscious about in crafting a song is the concept of bringing it home. I like to bring it somewhere familiar, someplace that people feel it's resolved, it's settled.

CAROLE KING

Doubtless you did an excellent job of manufacturing these criteria. But let's imagine that instead of creating a fine, functional list, you created a problematic list, one that more hindered and confounded you than helped you. What might such a list look like? An artist, not thinking too clearly about the matter, might demand of his work that it be:

1. Thoroughly inspired

2. Consistently excellent

3. Trouble-free

4. Without room for improvement

5. To everyone's liking

What sort of artist might create this wrong-headed list? Any one of us! You, me—certainly me! Any one of us might wish to demand of the work that it be thoroughly inspired, excellent in every regard, blemish-free, unimprovable, unimpeachable, and guaranteed an immense popularity. Yes! But, sad to say, no. These are not criteria but idealized hopes and dreams.

Criteria must speak to the real, not the ideal. A plot without holes is possible. An intense, alive painting is possible. A strong, powerful, truthful novel is possible. A perfect work, not only perfect but perfect in every light, perfect both for the graybeard and the adolescent, the postmodernist and the priest—please. Do not generate such criteria. If you do, you're not only unlikely to finish the work, but unlikely even to start.

I did two sketches, large interiors, trying to unify the thought of the whole wood in the bit I was depicting. I did not make a good fist of it but I felt connections more than ever before.

EMILY CARR

EXERCISE
WHAT CRITERIA WILL YOU USE TO JUDGE YOUR WORK?

I would like the beginning artist and the seasoned artist to tackle this question in different ways.

If you're a beginning artist, I'd like you to think about the works of a few artists you love. Name three of those works here.

1. _____

2. _____

3. _____

Can you tease from these works the criteria by which its creator might have judged its rightness or completeness? Make a real effort to generate a list of criteria for each work, imagining that you are the artist asking yourself the question, "How am I to judge if I'm succeeding here?"

Work 1. _____

Completion criteria:

1. _____

2. _____

3. _____

4. _____

5. _____

Work 2. _____

Completion criteria:

1. _____

2. _____

How do you know when to stop telling it as it is, or was, and make it into what it ought to be—or what would make a better story? Choices, choices.

GAIL GODWIN

When I make something simple, something monumental, part of nature's face is stripped of its wrinkles and little hairs. This process signifies an exaltation of my individuality to a status equal to nature, person to person.

ERNST BARLACH

3. _____

4. _____

5. _____

Work 3. _____

Completion criteria:

1. _____

2. _____

3. _____

4. _____

5. _____

Think about these criteria. Hush and hold what you've learned. Now think about your current project. What are the reasonable criteria you will use to judge its completeness? I'll provide you with five lines, but of course the exact number of criteria are for you to determine.

Your criteria for completion:

1. _____

2. _____

3. _____

4. _____

5. _____

The artist moves in a circle to reclaim the past.

ELEANOR MUNRO

If you have a body of completed work, instead of thinking about the works of others please think about your own past work. Choose four works, two that in your estimation turned out successfully and two that turned out unsuccessfully. For each of these four works, try to tease out what you asked of it and wanted from it back then; and what, in retrospect, you might have better asked of it and wanted from it.

Work 1

Criteria used then *Criteria you would use now*

1. _____ _____

_____ _____

2. _____ _____

_____ _____

3. _____ _____

_____ _____

4. _____ _____

_____ _____

5. _____ _____

_____ _____

Work 2

Criteria used then *Criteria you would use now*

1. _____ _____

_____ _____

*Art is neither complete rejec-
tion nor complete acceptance of
what is. It is simultaneously
rejection and acceptance, and
this is why it must be a per-
petually renewed wrenching
apart. The artist constantly
lives in such a state of
ambiguity.*

ALBERT CAMUS

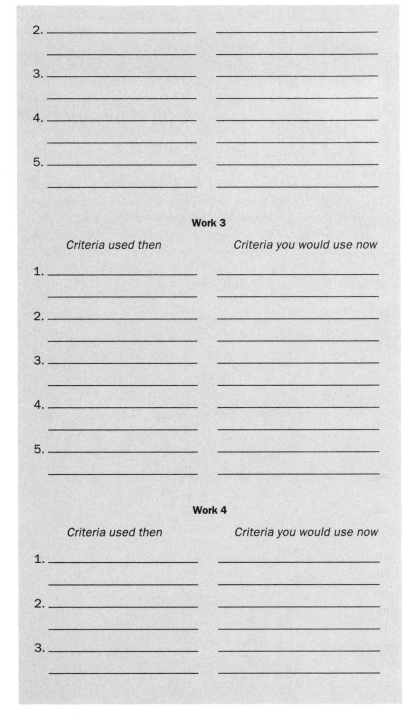

2. _____ _____
 _____ _____
3. _____ _____
 _____ _____
4. _____ _____
 _____ _____
5. _____ _____
 _____ _____

Work 3

Criteria used then *Criteria you would use now*

1. _____ _____
 _____ _____
2. _____ _____
 _____ _____
3. _____ _____
 _____ _____
4. _____ _____
 _____ _____
5. _____ _____
 _____ _____

Work 4

Criteria used then *Criteria you would use now*

1. _____ _____
 _____ _____
2. _____ _____
 _____ _____
3. _____ _____
 _____ _____

4. _____ _____

_____ _____

5. _____ _____

_____ _____

Does it seem that your successful works were based on sounder criteria? What are your observations on this score?

What completion criteria would you like to use with respect to your current work?

1. _____

2. _____

3. _____

4. _____

5. _____

As I have gotten braver I have censored myself less.

GRETCHEN CRYER

No one could possibly draw this scene of young oaks and maples, interspersed with alders and other shrubs, as it actually appears. All that can be done is to take the existing material and discard nine-tenths of it.

FRANK RINES

You look at your painting and exclaim, "Wonderful, the painting feels alive, powerful, wild . . . *but.* But there's a damned yellow-near-the-red-near-the-bottom-edge spot that's awful! Great! Now what? Is the painting 'complete,' except for that spot? Should I tamper with that yellow-from-hell and risk losing everything? Do I have a choice? What am I supposed to do? What good are my 'criteria'? It's not finished and I don't know what to do!"

It's not possible for an observer to know if the object or the creator has the problem. Nor, all too often, does the creator know who or which has the problem. But while this is true and while we

My inner critic began to play hara-kiri with my insides. With ironic words like, "It has a nice professional look about it," an inward demon was prone to ridicule or tear down my work in just those terms in which I was wont to admire it.

BEN SHAHN

need to address this challenge next, it doesn't contradict the idea that criteria are valuable for the artist to possess. They may not help him answer any particular question about yellows-from-hell and they may not help him know if the problem is in his outlook or in the work. But such criteria can certainly remind him that he wanted his work to capture the essence of the desert, not the particular spines of a prickly pear cactus; or that he meant to illuminate the relationship between a prisoner and her torturer, not provide the movie-goer with a titillating shower scene.

CRITICAL-MIND ANXIETY, INAPPROPRIATE AND APPROPRIATE JUDGING

In appraising, there is an object—the work of art; a human subject—the appraiser; and the relationship between the two—the appraisal process, a series of encounters between subject and object. This process may go on when the artist stands in front of his painting or during out-of-conscious awareness in the middle of the night, when he is traveling home from a football game or two years later, when the painting is hanging in a museum.

What is going on in this person who does the appraising, who knows he must appraise, who is appraising whether he consciously puts his mind to it or not? First, he is likely someone confronted by a task he hates. To a builder, building is a joy. But it is much less of a joy if at any minute he stands the chance of having to say to himself, "Tear the deck out," or, "The roof line is all wrong." To build under such a threat, to be menaced in such a way, naturally colors the process of building and puts the builder in a bad mood.

Second, as the editor of his own work, he reasonably supposes that there is a certain way he is supposed to be *as* editor, that there is an inner stance he is supposed to adopt, a "critical stance." It is exactly the difference between being asked to dine at a restaurant and being asked to write a restaurant review. When you dine, you naturally evaluate. You know if you would come again, if you enjoyed yourself, if the noise level was too loud, if the food tasted

good, if the prices seemed fair. You naturally review as an integral part of living.

But if you enter the restaurant knowing that you have a restaurant review to write, a knot forms in your stomach and your natural ability to review tends to desert you as you fumble for a "professional" or "critical" way to be. You suppose that you will have to say things about Afro-Bavarian cuisine as a cultural artifact, about the strengths of the wine list and the subtleties of seasonings hardly discernible in the food, seasonings that you presume it is your job to identify. In a single breath you become less a person and more a critic. A critic may be good at identifying tarragon, but that he is looking for the tarragon means that he is squinting.

Third, an artist may well feel the need to criticize himself, but safely and indirectly by criticizing the work. Like the madman who conjures up the devil and then blames the devil for injecting him with feelings of hatred, the artist-as-self-prosecutor gets to express self-loathing safely and indirectly when he attacks his own work. In the privacy of his studio he can slash the painting, not because it is bad, but because he has bad feelings about himself, others, and the universe. If the canvas were alive, we would call this encounter sadistic.

This maneuver, projecting a world of bad feelings onto the canvas or short story and safely displacing the feelings that we might otherwise let loose on the world, is a fine example of how our defenses work. Our defenses naturally come into play when we evaluate our work because we more want to survive the encounter intact, our self-image no worse than when we began, than we want to get the work "right." If the choice is between looking at the work squarely, seeing its flaws, and losing respect for ourselves, or looking at the work vaguely, giving it our stamp of approval or cursing it, and in the process preserving our self-esteem, all too often we will do the latter.

An artist denies, rationalizes, represses his thoughts and feelings, intellectualizes, acts out, and all the rest. But even if he's more open and less defended than this, he's still likely to experience confusion as he apprehends the work. Even if he's expert at appraisal, he will still be left wondering how to evaluate the

Every time I see an artist's retrospective, I come home and destroy more of my work. Most artists keep too much of their bad work.

BENNY ANDREWS

Music is a cummulative art. It is not the art for amnesiacs.

WILLIAM MAYER

I began to realize that however professional my work might appear, even how original it might be, it still did not contain the central person which, for good or ill, was myself.

BEN SHAHN

atomic parts of the work. How *is* a sentence to be appraised? Or the blades of grass in the foreground? Or that infamous yellow-near-the-red-near-the-bottom of the painting?

Think for a second about the opening sentence of Franz Kafka's short story "The Metamorphosis." The story begins, "As Gregor Samsa awoke one morning from uneasy dreams he found himself transformed in his bed into a gigantic insect." We have a grammatically correct sentence. It is to the point, it provides the reader with useful information, it sets up a fantastic situation. But all of that could be said about another sentence, for instance, "When Gregor Samsa awoke from a restless night of bad dreams, he discovered that he had become a black bug of enormous proportions." What makes the first sentence the sentence worth keeping? Can a satisfactory answer be given?

And if it can't be given with regard to this sentence, how can it be given with regard to any other sentence in the story, or any sentence in any story, or any color patch on any canvas, or any phrase in any musical composition, or any frame of any movie? The challenge is to evaluate every atom, but perhaps atoms can't be evaluated in any systematic or logical way. We return to the fact that the whole person, with a whole brain, whole heart, and whole history, must do that work. If he stops to ask himself the question, *"How* am I to judge?" he must reply, "I don't know. I just am!"

These then are the roots of critical-mind anxiety, the anxiety that attaches to the appraisal process. The person who is to appraise knows that he's about to be put in a subtle (or not so subtle) bad mood, that he's about to don his "critic" hat, whose fit he hates, that he's in danger of losing self-esteem and also in danger of defending himself against that loss by doing a dishonorable job of appraising, and that, as much as he desires and demands to know the bases of his judgments, he can only know them poorly at best.

He therefore sweats. This is not fun! Filled with anxiety, he avoids appraising or arrives in a panic. Unequal to the task, he does exactly what he'd hoped he wouldn't do: he criticizes the work instead of evaluating it, he closes his eyes and blindly gives it his stamp of approval, he defends himself and examines the

work through clouded glass. This is the anxious artist inappropriately judging.

What is an artist to do?

If an artist is to know if her work is complete, she should indeed attempt to analyze it. She should attempt to judge its relationship to the idea that sparked it. She should attempt to gauge its technical flaws and merits and its marketplace weaknesses and strengths. All of this she can profitably do. But in the final analysis it is not her analysis of the work that assures her that the work is done. *It is rather her walking anew on the ridge line, risking everything again and bringing her whole being to the appraisal process.*

She remains a creator. She does not become a critic. She is lover, counselor, parent, supervisor, conductor, thinker, feeler, artist, but not a critic. She manages her anxiety as best she can and creates anew. This is an "artful" and not a "critical" appraisal process. Everything is held at once, the tarragon and basil but also the food, narrow marketplace demands but also the future of the world. This is our simple, natural appraisal process, built right into us.

What I have set down in a moment of ardour I must then critically examine, improve, extend, condense. Sometimes I must do myself violence before I can mercilessly erase things thought out with love and enthusiasm.
PYOTR ILICH TCHAIKOVSKY

EXERCISE
ARTFUL EVALUATION

Can you feel the difference between judging artfully and judging critically? Take a little time and try your hand at producing an artful review of a movie, restaurant, book, painting, or song.

To begin with, you may have no idea what you're supposed to do. What is this sort of review to look like? What does it include? What does it leave out? Is it to be a tome or an aphorism?

But try anyway. Bring to the process the mantra "I am not a critic, I am an artist." When you've learned something from this exercise, approach your own work and artfully evaluate it. Return to the ridge line where the drop is great and the view infinite, and freshly evaluate your work.

REVISING

The evaluation process sets the stage for revising.

To rewrite ten times is not un-usual.

SAUL BELLOW

Some artists feel friendly toward the revision process while other balk at it and struggle against that necessary work. Part of the process of maturing as an artist is growing more willing to revise. Revision is not tinkering and not a method of putting off completing; revision is the process of taking the fruits of your unblinded evaluation, your new thoughts, feelings, and hunches, your new criteria, and bringing them back to the work for sake of bettering it and completing it.

When an artist revises, he has a new idea of what he wants, an idea not clear and distinct like a blueprint, but clear and powerful like the ideas we discussed in the chapter on choosing. In the revision process of this book, all of the material on showing, embedded in the first draft in this chapter, was extracted and given its own place; many dialogues were jettisoned; five thousand words on existentialism were removed; and many sections, including this section on revision, were added.

The revision process is what comes after you have been through the work *completely* once and have gotten to the end. Much reworking goes on before this, but it will pay us to save the word "revision" for the special instance of reworking that follows the completion of a draft of the novel or the opera, the basic forming of the sculpture, the filling of the canvas with paint, the making of a whole poem or a whole screenplay.

An artist is naturally likely to feel drained at the end of the completion of her first draft. But after the break that she reasonably needs and certainly should take, it is her job to reaffirm her readiness to work.

EXERCISE
AFFIRMING THE REVISION PROCESS

If the draft of your work is not yet completed, imagine it completed.

Step 1. *Calming your mind and scrutinizing the work.* Affirm your willingness to evaluate the work by saying out loud, "I am ready to look at the draft."

Step 2. *Arriving at the concrete changes you mean to make.* Affirm this willingness by saying out loud, "I am ready to make specific changes."

Step 3. *Preparing to revise.* Affirm your willingness to prepare by saying out loud, "I am ready to hush and hold all over again."

Step 4. *Doing the work of revising.* Affirm your willingness to work by saying out loud, "I am ready to revise."

Step 5. *Completing.* Affirm your willingness to complete by saying out loud, "I am ready to finish."

"I am ready to look at the draft."

"I am ready to make specific changes."

"I am ready to hush and hold all over again."

"I am ready to revise."

"I am ready to finish."

Affirm the revision process and finish your project.

The important thing is that my paintings get done.
MARIA MIJARES

Revision is an aspect of working that nine times out of ten (editors would say ten times out of ten) improves the work. It is dirty work, it is work in the trenches, it is a manifestation of technique and discipline, it is not the antithesis of inspiration but it is more about cobbling than about dreaming. Affirm the process and honorably engage in it.

I believe that with enough practice and good faith, you can learn to recognize when the work is achieved.

GAIL GODWIN

♦ ♦

It is time now to complete your work. Do not read on until you have done so. If we do not meet again for a month, so be it. If it is two months, four months, six months, then it will be a while before we meet again. But when we do, you will have completed your ambitious project.

The process of completing incorporates and recapitulates the stages that went before. The creature has been dragged from the sea and the traces of that magnificent struggle now exist for you to scrutinize and appreciate. It stands; it is good; it is bad; it exists. Finally you must step back and whisper, "Done."

Please complete your project before you read on. Grow friendly with the Appendix and master some anxiety-management techniques as you work. Put a special marker here and return to this spot after you've finished your work. Whether you've managed to generate criteria for completion or not, whether you've managed to quell your critical-mind anxiety or not, the work must be completed. If it is dead, unworkable, not worth pursuing, then abandon it. If it is alive, then wrestle with it to the end, to its completion.

If the work must be abandoned, then start over. What other choice is there? Not to create? Hardly! Start over, complete *that* work, and then return to this page. In any case, do not read on until you have completed your work.

♦ ♦

ATTACHED-MIND ANXIETY, INAPPROPRIATE AND APPROPRIATE DETACHING

A last question remains: Is the artist *psychologically* ready to complete her work?

Is she ready to free it from her grasp? Is she ready to detach from it and aid it on its journey in search of an audience? Is she ready to do what a good parent must do: let her child live independently, out in the world?

There are many telling reasons why an artist might be unwilling to let her creation go. First, since her views change from day to

day, since she is a different person each new morning, the finished work also changes; and on some days no longer appears finished. As Picasso put it, "A picture is not thought out and settled beforehand. While it is being done, it changes as one's thoughts change. And when it is finished, it still goes on changing, according to the state of mind of whoever is looking at it."

Today you say it is complete. Tomorrow you aren't so sure.

Second, the artist naturally begins to fret about marketplace issues. If it is finished, it should be shown, exchanged, sold. Does she want to face the marketplace? No, probably not. What easier way to avoid the marketplace than to call the work unfinished? If it is finished, it must be marketed; and rather than face that can of worms, she withholds her stamp of completion.

I live with the people I create and it has always made my essential loneliness less keen.
CARSON McCULLERS

Third, she may well remember, somewhere out of conscious awareness, that she is accustomed to experiencing a bad letdown following the completion of important work. She may expect that a bout of inertia, a period of meaninglessness, a full-blown depression, or even the sort of grief that follows a death is right around the corner.

Fourth, if the work is done, she must think about what work will come next, and almost certainly she is not ready for such thoughts. Working may be her norm and vacations not at all successful or pleasant; but even if she would rather work than rest, it is unlikely that she is really primed to think deeply about a new subject. She is hardly primed to have a new, bright idea strike her, hardly primed to do her magic once more. Not feeling primed, she nurses the current work a little longer.

Any of this can precipitate a bout of attached-mind anxiety, an anxious state defined by the artist's desire to hold on to the work even though it is ready for the world. This constipation, this sweat-drenched clenching, as unpleasant as it feels, is nevertheless hard to recognize and name. But it is vitally important that an artist recognize this phenomenon when it occurs and provide herself with good detachment strategies that can lower her anxiety and send the work moving into the world.

The most common way to defend against this anxiety, inappropriate and self-defeating in the extreme, is to abandon the work. What a relief! No more worries! The artist puts the manuscript away and pledges to return to it in a year or two, to give it a

final tweaking and get that ending just right, when the stars are better situated. He puts the canvas aside and begins a new one, as fast as he can. He leaves the symphony a beat short of finished and takes a job selling stocks and bonds in Russia. He abandons the work and succeeds in reducing his anxiety, at the cost of guilt, new anxieties, and complete marketplace failure.

Or rather than abandon the work outright, he carelessly detaches from it. He prints the book up with an old ribbon, proofreads every other page, shuts his eyes, throws a dart at his *Writer's Marketplace,* and sends his hard-boiled mystery to a religious press. Too anxious to proceed carefully, he markets his work poorly, haphazardly, and only as often as is necessary to assuage his guilty conscience.

To detach appropriately you need to recognize the challenge, practice your anxiety-management skills, and redefine your relationship with your product. Denial, here, is the killer. If you deny that completing is making you sweat, if you deny that you have pressing reasons for preferring not to be finished, if you abandon the work or carelessly detach from it and deny what you've done, your ship is sunk.

A piece of sculpture or a painting is never a finished work. Simultaneously it answers a question which has been asked, and asks a new question.

ROBERT ENGMAN

EXERCISE
CREATING DETACHMENT MANTRAS

Think about what expressions of encouragement you might create to help quell your anxiety and help you carefully detach from your completed work. Here are some possibilities.

1. Done.
2. The work's ready now.
3. It's finished.
4. It's ready.
5. I dub thee completed.

6. It's not perfect, but it's not imperfect either.

7. Forward.

8. Done.

Create some detachment mantras of your own that capture the flavor of the relationship you want to engineer between you and your completed work.

I do not admire giving up.
JANET BURROWAY

1. _____

2. _____

3. _____

4. _____

5. _____

6. _____

Try out both sets of mantras. Hone the list down to an essential few and put them into practice. Let them encourage you as you steadfastly detach from your completed work.

Acknowledging that you are inappropriately attached to the work or that you have inappropriately detached from the work is a vital step in psychologically completing your project. Try to look squarely at this issue. Then surrender. Surrender to the fact that the work must be completed.

Is the work perfect in every regard? No. Surrendering means saying to the work, "I'm done. I'll still look after you, even though

you're out in the world. *Au revoir!* And remember—come back anytime!" Surrendering means heaving a sigh or two, casting wistful glances at the work, mourning a little for all that it isn't, and then throwing it an enthusiastic going-away party.

If art is created with the whole person, then the art will come out whole.
STEPHEN NACHMANOVITCH

EXERCISE
THROWING A BON VOYAGE PARTY

The work is finished. Hurrah!

Get cookies and champagne. Get noisemakers, balloons, party favors. Invite some friends over or just invite in the cat. Put on some music. Open the champagne. Toast the work and wish it a safe, happy, and profitable voyage. It is off to China, India, New York, the Marquesas Islands. *Bon voyage!*

Have you decided where it's going? Of course you have! You've done your work on showing, exchanging, and selling, and you know what you mean to do next. An editor is ready to receive it. *Bon voyage!* Judges at a competition are ready to scrutinize it. *Bon voyage!* A film agent has deigned to glance at it. *Bon voyage!* Tomorrow you'll roll it up under your arm and march right down to the office of the president of the Wiget Corporation, you'll march into his palatial office and bravely unroll it. *Bon voyage!*

Have a small but really festive party. Congratulate yourself. Toast the work. And don't forget to take some pictures.

ACCUMULATING PRODUCTS

After a while an artist begins to accumulate finished, half-finished, and quarter-finished things; and fragments, lyric fragments, sketches, journals, jottings, musings on napkins, every manner of glorious tidbit and tired leftover.

Finished paintings begin to accumulate. Poems begin to accumulate. Thousands of photographic negatives begin to accumulate. Wooden sculptures, short stories, songs now exist, each requiring care and attention, or at least a place in the house to reside. Fragments begin to accumulate, the beautiful passages that

had no place in the novel, the part-drafts of plays that could not, in their time, be finished, the musical ideas not yet put into final form, the sculptural ideas sketched in two dimensions.

All of these things, whether finished or unfinished, generate anxiety and bad feelings. Why bad feelings? Consider the following. You clean out your desk, trying to get organized, and come upon file after file of old papers. Suddenly you are face to face again with thousands of pages of . . . what to call them? Mistakes? Failures? Reminders of wasted time and effort?

Is there any positive frame to put around these accumulated things? To find such a frame is a valuable exercise, for encounters with our old products tend to make us want to stop working. Even if we don't encounter them directly, we nevertheless sense their presence around us. These accumulated things are like mice in the house: there are droppings everywhere and small, scurrying noises that can be heard behind closed doors.

So an artist's attention, unless and even if she is careful, is divided. She has the play that she's just finished, the hundred twenty pages of that, but also the next idea percolating, and a half-finished children's play that could possibly be mounted somewhere if only she worked on it for a month or two, and a quarter-finished play about gender politics that a director expressed interest in two years ago, and a respectable portion of a screenplay done, not to mention . . .

These old-but-not-buried things still have life in them, an agitated life as they rustle in drawers and closets. Alive especially are the finished pieces that fill up her studio space and computer disks, pieces that ought to receive real attention, pieces ready to be exchanged and sold. When, therefore, she confronts the issue of selling, she hasn't a simple answer to the question "What should I sell?" To an outside observer it may seem like the answer is an easy one: sell the last work completed. But the last work completed is no more alive, nor necessarily better, than a work completed last month or two years ago. The last thing completed is just one of her accumulated products, no more and no less.

The tension with which she worked on the piece has dissipated now that the work is finished. As the painter Mark Rothko put it, "Pictures must be miraculous: the instant one is completed the intimacy between the creation and the creator is ended." Her

I thought that to have a painting in a museum exhibit would be the ultimate. Then it happened and it wasn't the ultimate. The next day I was back in my studio still trying to figure out what I was doing.

BARBARA SIEGEL

completed works may be miracles, but she has lost interest in them now that the tension has dissipated. They are worth her attention but no longer pique her interest.

Still, *someone* must sell the product that now sits finished, if it is to be sold. Someone must sell each of the products hidden about the house. Someone must make use of all the fragments scurrying about, or else trap them and send them packing. Who is that someone? If it isn't the artist, who is it?

Of course it is the artist, and a central question that every artist must answer after she has worked for some time is, "How am I to relate to my finished products?" To construct a right relationship and to maintain it are ongoing challenges in the lives of artists, made a little easier if they can pay attention to the following three points:

1. There is a certain balance to be struck between focusing on any given product and maintaining a hovering attention with respect to all of one's products. Sometimes one must obsess about one thing. Sometimes one must get a little distance. Both stances are vital.

2. There is a commitment to be made (and remade) to showing, exchanging, and selling, and also to ridding the house of pesky fragments.

3. An artist's finished and unfinished products provide her with essential information, the best information available to her, about her own evolution and about the direction she may next want to take with her art.

The greatest respect an artist can pay to music is to give it life.

PABLO CASALS

EXERCISE

ME AND MY PRODUCTS

Describe in a few paragraphs the kind of relationship you want to create with your finished products and incomplete fragments.

▾ Do you want to keep a master list and consult it once a quarter to determine what needs attention?

▾ Do you want to create an anxiety-reduction mantra to use when you stumble upon an old poem or sketch, something like, "Hello. Nice to see you. I'm not at all disturbed by the sight of you"?

▾ Do you want to schedule a regular return to these things, say for a week between every project, so that you possess a routine way of devoting time and energy to your fragments?

I've started so I'll finish.
MAGNUS MAGNUSSON

Please consider these matters. Your accumulated products are your unsold inventory; your accumulated fragments are ore that may or may not deserve further mining. Every artist must deal with her unsold inventory and her mounds of ore, and so too must you.

SUCCESSIVE COMPLETIONS REVISITED

You have a single work of art completed or perhaps you've completed and accumulated many such works already. In either case, congratulations! Each, even if imperfect, is its own success story; you gave it your love and birthed it into being. It exists, it has a life of its own, and now it awaits your further attention.

The attention you must now give it involves showing it to others and attempting to sell it. If anxiety attended the creation of the work, that anxiety reaches new heights as you prepare to take your wares to market. Will anyone be willing to look at it? Will anyone care? Will it be criticized and rejected? Will your hopes be dashed?

It may not be possible to feel optimistic or anxiety-free as you approach these next challenges. But still you have no choice but to face them. You have rightly congratulated yourself on the completion of your work, but that completion is only one in a longer line, a line that continues after the paint has dried and the final period has punctuated the novel's final sentence. Courage, then; it is now time to tackle showing your work and selling it.

ECHO AND APPROVAL

Showing Your Work

*W*e *might have talked* earlier about showing your work in
progress to others, certainly in the chapter on working and
even in the chapter on starting. For the desire or pressure to show
your work has likely been with you from the start, from the mo-
ment your project began to take shape.

All along, as an artist works, this pressure builds to show his
work for the sake of echo, approval, and possible sale. He loves
parts of the work and would like to have those parts recognized by
another. He wants to thrill some other human beings, impress
them, seduce them. He wants his voice heard, his ideas recog-
nized. He dreams of a kind of exchange occurring, a giving and a
receiving, of immaterial currency and also of real currency.

But how to show only the good parts and not everything at
once! How to get the necessary echo and approval and not criti-
cism and rejection! Thus a great internal pressure countervails the

*Becoming a playwright in-
volves a very public learning
process. You have to be brave
to make mistakes in public.*
LOUISE PAGE

199

Oh, how difficult it is to make anyone see and feel in music what we see and feel ourselves!

PYOTR ILICH TCHAIKOVSKY

first and demands that the work *not* be shown. On both sides of the equation lurk anxieties. Just as a performer may be anxious *to* perform but also anxious *about* performing, so a creator is anxious to show his work but also anxious about the work's reception.

The artist is excited, but also doubtful. The doubts typically prevail and he concludes, "Not yet." By saying "not yet," he has certainly not stymied his creative process. Indeed, he may experience real relief, for to avoid doing something that produces anxiety naturally brings relief. Having decided not to show his work, he whistles a little tune and pours himself a little drink. He's dodged a bullet! He may even rush back to the studio to work, happy to be with his creation, free for the moment from thoughts about its reception in the world.

For insofar as art-making is a meditation, a personal odyssey, a working out of his life, an existential reckoning, the artist needs no audience. But eventually he stops whistling and begins to wonder anew whether he should show the work to somebody. He grows restless; he grows closer to showing; but a new doubt intrudes.

He realizes, quite realistically, that any feedback different from simple approval, different from a pat on the back, will make demands on him and on the work with which he may not want to deal. Does he want to learn that his best friend has doubts about chapter three, that his mate likes his previous painting style better, that his brilliant, alcoholic former teacher finds his musical ideas "inaccessible"? Feedback may be immensely valuable, entirely misleading, or anything in between: why exactly should he gamble on it being valuable?

Again he says, "Not yet."

But again the pressure builds to show. Isn't there a poetry, sonata, or painting competition coming up? Shouldn't he get the applications, shouldn't he prepare to show the work there? For part of the pressure to show, along with the desire for echo and approval, is generated by the fact that the work in progress is also an item of commerce. It is meant to be sold on the open market; and market rules allow him to sometimes sell his wares even when they remain unfinished.

He knows that a nonfiction book proposal can be submitted with only a chapter or two done, that second-stage play seasons are

set such-and-so-many months in advance. He knows that he could perhaps profitably send a chapter or two of his novel to an agent *right now* or stop everything and fine-tune several minutes of his documentary, so as to have a selling tool for further funding.

He could call the gallery owner who represents him but with whom he hasn't spoken in six months, to remind him of his existence and to presell the work in progress. He could show the draft of his string quartet to the players who expressed an interest in seeing it, even though it still needs work, because they're the best players around and their time may soon be so booked up as to prevent them from premiering it in the foreseeable future. In short, he could perhaps make some smart commercial or career moves with respect to showing, even though the work in progress is far from finished.

These internal pressures make for a dynamic tension characterized by episodes of pushing and pulling back, of edging the work a small way into the world and quickly retrieving it, of self-affirmation commingled with self-doubt. A writer, harboring the secret intention to show his three-quarters-finished epic poem, calls a friend, but then never mentions the poem in the conversation. A painter, harboring the intention to show his almost-finished monumental painting, invites a friend to the studio, but at the last minute turns the painting to the wall. The pressure to show is keen, but the artist remains fearful and not quite ready.

Yes? No? Damn!

The issue of showing remains as perpetual background noise in a creator's life. It is always there, sometimes so soft as to almost vanish, sometimes so loud that he feels as if the time must really have come, that he has no choice in the matter, that, ready or not, now he must show the work to someone. Finally an explosion occurs; and because he has not really prepared himself to show, he ends up showing the work impulsively.

> *I often used to say that a little room, with a grating in the door through which someone could pass me my food, would have satisfied me forever.*
>
> MARC CHAGALL

IMPULSIVE SHOWING

Impulsive showing takes many forms. The short-story writer, who knows that her story isn't finished, suddenly sends it out on a hope and a prayer to *The New Yorker*. The painter, in order to show her

new painting to a friend arriving from New Orleans, dashes off the finishing touches after having spent careful weeks creating the piece. The poet shows her almost-finished poem to the very next person who enters her life, to her mate as he walks in the door from work, to her best friend who came over to receive support for her upcoming operation. Having waited and waited, the artist now shows the work at the very worst moment.

If she shows the work impulsively, without preparing the work or preparing herself, without considering who the right audience might be or what she wants from the experience of showing, a painful experience awaits her. Consider the following imaginary conversation between a poet who hasn't yet given this subject much thought and one who has.

"I'm furious with the people in my writing group!"

"Why? What happened?"

"They were so incredibly critical! They were critical of everything, the lunch we had, the service, their jobs, men, everything. They made me crazy!"

"Yes?"

"I showed them a poem. I knew it needed work, but nobody's shown anything for two months. So I brought in a poem that I knew wasn't finished. And they trashed it! I couldn't believe my ears. Vitriol!—and all under the guise of 'giving honest feedback.'"

"That's what the group's about? 'Giving honest feedback'?"

"Of course. What do you mean?"

"Why is it organized that way, that a person brings in something and everyone dissects it?"

"I don't know. I mean, the idea is, we want the writing to improve. For that, we need analysis, suggestions, other points of view. Isn't that self-evident?"

"Not to me. Some writers would say never listen to anything said about your work while it's in progress. Some might even say that your willingness to listen to feedback means that you don't really trust your own judgment; that ultimately you won't get much writing done. So it isn't at all self-evident that feedback is desirable, that even *wanting* feedback is desirable."

"I suppose. But I bet a lot of the writers who say things like that are arrogant and in need of a little feedback! Maybe . . . par-

don me . . . maybe they're mostly men. Do those writers really grow? I wonder. I'm still inclined to believe that our way is the best way. And I don't think that wanting feedback is proof that I'm a cowardly writer!"

"All right. Let's say you write a poem that you know isn't finished, but you want to show it anyway. And you don't want to introduce it with any disclaimer, about how it isn't finished or about how they should treat it gently. So then mustn't you *expect* them to say, 'We don't like it, go home and finish it'?"

"No! Not at all. I want them to say, 'This is nearly great, take another shot at it and it'll be superb.'"

"And you expect them to point out where it still needs work?"

"Yes. Of course."

"And it'll be the same places *you* think need work?"

"I should hope so! If they want me to change things I like . . ."

"So not only do they have to praise it, and praise it highly, but they also have to point out *only* the problems that you already consider problems?"

". . . I suppose so. That may be exactly what I'm wanting."

"You do *not* want to hear that a line you love stinks?"

"I do not want to hear that. No, I do not."

"So it's hard for me to see under what conditions you would feel good about receiving this 'objective feedback' the group is organized to give."

"It's not that I *want* to hear it. But I *need* to hear it! That's the difference!"

"So last week's meeting was actually a good one, just what you needed? You were told things you didn't want to hear but that you needed to hear?"

"No. No! What I'm saying is true—abstractly. But in the group last week they were just *mean.* They weren't trying to get it right, they were just venting. Like the salad had too much dressing, the waiter was rude, and my poem sucked. Just venting. It was all of a piece. It wasn't a critique, it was just a massacre."

"You told them that?"

"Of course not. There's nothing sadder than a writer wailing, 'You were mean to my poem.' It's humiliating. They'd just smile—gotcha! Or then *they'd* get defensive. Forget it. Just take your criticism like a woman and get the hell out of there."

No one is more vain, more intent on echo and approval than the thinker, and indeed he is bitterly in need of echo and approval.

HERMANN HESSE

Although poets are vain and ambitious, their vanity and ambition are of the purest kind attainable in this world. They are ambitious to be accepted for what they ultimately are as revealed in their poetry.

STEPHEN SPENDER

Only a personality which is hard and aggressive, despite its apparent gentleness, can survive wearying periods of rejection and censure that whittle down any ego almost to its complete loss.

LAWRENCE HATTERER

"That's too bad."

"It is. It's terrible. I hate it."

"Yes."

"I do! You know, we're very careful. We never say 'should.' We never say, 'You know, dear, you really should change this line.' We're so careful never to say should, we've all been in therapy, we know not to say should! So we say, 'This image really doesn't work for me.' Which just translates as, 'This image doesn't work for me and you should do something about it. You'd *better* do something about it, or I'll *never* like this poem of yours or think very highly of you.' God, the things we do to each other!"

"The group is sometimes good?"

"Oh . . . sometimes. Rarely. When . . . when our hearts are in the right place. When we show some compassion."

"So when it works, it's not about 'objective feedback'? It's more about compassion?"

"It really is."

"So a group is good insofar as its members stay in right relationship to each other?"

"I suppose. To use your language."

"Try this mind experiment. What would a 'good group' look like? How would it operate? Would you read a poem and give feedback, or would you do something else?"

"That's a great question. But I haven't the slightest idea. We just have to get rid of all our envy, backbiting, criticism, hostility, sarcasm, and chivying for position! But what there *should* be . . . I don't know."

"You could be more generous?"

"Maybe. But I wouldn't. Not unilaterally. I don't feel that . . . safe."

"So someone else will have to turn supportive first?"

"Yes. If she could. Which I doubt."

"And until someone does, you won't? And so nothing will change?"

"Perfectly put."

"And no one will show work for the next month, because everyone feels how dangerous and unsupportive the environment is?"

"Exactly. We'll be a little cool, a little estranged, but we'll get

together. Only, nobody will show any writing for the *longest* time. You can bet on that. We'll just say that we happen not to have anything to show."

"Not a group, but women having dinner together?"

"Exactly."

"You have another poem you could show to the group?"

"I do. But I won't!"

"I wonder if we could talk about how showing it might be valuable? Valuable for you and valuable for them?"

"No!"

"We could rehearse how you'd introduce the poem—"

"No. I don't think so."

"Can you humor me a little?"

"A very little. I'm not leaving the group, so I suppose I should figure out how not to hate attending! But if you think I'll waltz in there full of milk and honey . . ."

"If you wanted to transform the group into a good, supportive, working group, what might you say?"

"God only knows!"

"Well, let's ask Her . . ."

It's highly unusual for an artist to think carefully about what showing might mean. For that reason artists often fall into the trap of showing their work at the wrong times and for the wrong reasons. The solution, of course, is planning.

If there is no recognition, there is no power. I loathe the idea of being powerless.

MARY BETH EDELSON

PLANNING FOR SHOWING

By not consciously planning for showing, by not sitting down and determining to whom she will show the work, why she is showing it, what the work needs before it can be shown, what parts of it she will show, and what she wants from the showing, the artist is making a significant mistake.

The following are the seven elements of a showing plan:

1. Judging when to show
2. Determining what an outcome will mean
3. Choosing an audience

4. Completing the work for the purposes of showing

5. Learning how to show

6. Showing

7. Evaluating feedback

It's my experience that very few writers, young or old, are really seeking advice when they give out their work to be read. They want support; they want someone to say, "Good job."

JOHN IRVING

Judging When to Show

Showing should not be an impulsive action but rather a calculation. This is true whether the person you're showing the work to is a friend or an agent, a mate or an art collector.

How is this calculation made? First, an artist needs to remember that showing produces any one, two, or three of the following outcomes: feedback (silence or a form letter rejection is also feedback), approval (or disapproval), and a sale (or no sale). Let's add to this mix that an artist's readiness for feedback and the value of the feedback received are different depending on whether the work is in its early stages or in its later stages. Therefore the first and most basic calculation is, *what* does the artist honestly want most: early feedback, late feedback, approval, or a sale?

Because they must trust themselves and judge for themselves, artists in fact rarely want feedback. This is a fine and even necessary rule by which to operate, but only insofar as an artist allows that he can make exceptions to his own rule. Over the course of a lifetime of creating, dozens, scores, and hundreds of moments will arise when feedback, rather than deterring or deflecting an artist from his path, instead will help him see his path more clearly. When an artist genuinely wants feedback and is genuinely willing to receive it, one sort of showing moment has arrived. He consciously disidentifies from the work and seeks out *feedback,* not approval.

Thus it is true, though scary to contemplate, that you can show your work for the purposes of feedback even if the work is off-track and even *especially* if the work is off track. The work may stink and you may have good reasons to show it. But by the same token it is much less sensible to show your work if you want approval or a sale and it is off-track. *If you want approval or a sale and not feedback, the work had better be in good shape.*

Therefore it is easy to be faced with the following sort of dilemma. You want to show an editor a proposal for *feedback* but you also want her to *like it* and even to *buy it*. When is the right moment to show it to her? Early on when it is in rough shape but when rich feedback might be invaluable? Or later on, when it is polished but when your investment in it is such that you don't really want to hear anything about it but praise?

The answer of course is: it depends. It depends, for instance, on whether you have a good, ongoing relationship with this editor such that you can say, "Mary, if you have some time, I'd really love feedback on this. There's a nugget of an idea here but I don't know if I'm doing it justice." If you have this sort of relationship and you can speak clearly, then early in the process may be exactly the right time to approach Mary. But if you're sending in a proposal to an editor who doesn't know you, it will hardly pay you to send her your first musings written on the backs of envelopes.

Feedback? Approval? A sale? You've determined which one you're in fact after. You would love approval but you *really want* feedback. Or you're willing to risk feedback, but you *really want a sale.* You're clear on this matter. Now you're ready to show the work, as soon as you determine what a given response to your work will *mean* to you.

An artist should not be troubled by the indifference of his contemporaries. He should go on working and say all he has been predestined to say.
PYOTR ILICH TCHAIKOVSKY

Determining What an Outcome Will Mean

If you show me a short story of yours and I say, "Nice work," what does my response mean to you?

First of all, it is a positive response or appears to be a positive response. But if I say, "Nice work, but I'm afraid I can't publish it," it's suddenly very hard to know whether I like it or whether I'm being polite. If I say, "Nice work," and then add any clause beginning with "but," you will be hard-pressed to know what my response really means.

But let's say that there's no "but" attached. There are just the two bald words: "Nice work." What do they mean to you? How do they make you feel? Does it sound like a round of applause or more like one hand clapping? To put the question differently, you want praise, of course, but what will sound like praise in your ears?

My goal is to write great songs. Not basic songs or hit songs but great songs.

JANIS IAN

EXERCISE

REAL AND IDEAL VOCABULARIES OF PRAISE

Think about language in this context. What do you want to hear? What do you want to hear about this work that you're working on or have completed? Produce a list of words that, should you hear any of them from a trustworthy person, would really please and satisfy you.

Your ideal vocabulary of praise

1. _____
2. _____
3. _____
4. _____
5. _____
6. _____
7. _____
8. _____
9. _____
10. _____

Whether you hear these or other, less pleasing words, you must judge if they reflect on the work or on the speaker. That is your job. And if, sometimes, you conclude that one of these words has been used fairly by the right person, rejoice!

What, to continue our analysis, do you intend rejection to mean? Will it depend on the wording and on the source? Will you choose to take rejection to mean that you must do something new with the work or will you continue to stand by the work but look for someone different to whom to show it? What, by the same token, do you intend criticism to mean? Will it depend on the nature of the criticism and the nature of the critic?

Can you know beforehand? In an important sense, yes. *By understanding your own work and your own intentions very well, you can gain clarity about these matters beforehand.* If your intention with your documentary is to excoriate the rich and someone criticizes it for doing just that, either directly or in disguise by calling the work "inappropriate" or "hard to market," that is *praise.* You may not be happy; but what did you expect? If your intention is to write a genre piece that transcends its genre and someone praises it for its conventionality, comparing it to a popular work that you hate, *that* is criticism.

Work to gain clarity about these matters beforehand. Start a special page in your working notebook and discuss these matters with yourself. The clarity you gain will also help you negotiate your next hurdle: choosing your audience.

If I show my husband a poem, he says, "I don't think that's too hotsy-totsy," which puts me off. I try not to do it too often. My in-laws don't approve of my poems at all.

ANNE SEXTON

Choosing an Audience

To whom will you show your work? Not, presumably, to someone just because she happens to cross your line of sight at the same moment that you decide to show the work. That of course eliminates your mate or your best friend, unless, on balance, you have good reasons for showing it to your mate or best friend.

I say "on balance" because in fact the choosing of a person to whom you show your work is a calculation: there are usually negatives as well as positives to consider. Imagine the following situation. You give your husband your latest poems to read. He reads them and says that he really likes them. A disagreeable afternoon follows. Why?

Certainly more than one answer is possible. You may have gotten from his body language, some hesitation on his part, or the half-baked smile he wore the sense that he lied to you. He said he liked the poems but really he didn't. You understand that he felt he had to be "supportive," but you hate him on three scores: for lying, for lying so poorly, and for having such poverty of soul as to fail to like poems he really ought to have appreciated.

Or the explanation may be a different one. You may indeed believe that he liked your new poems, but still bear him a grudge. Why? Because merely "liking" them simply didn't feel like

The first thing we have to do in our practice is to reveal things as they are.

THICH NHAT HANH

enough to you. You may have needed him to really love them. "Liking" rarely strikes an artist's ears as sufficient praise or even as praise at all.

And what if he did love them? What if, anxious and fully expecting to disappoint you, he simply stumbled through the exchange? What if these are his very worst moments, times when he inevitably goes dumb, because he simply hasn't available phrases like "I love this"? Instead he smiles stupidly, or intellectualizes, or asks a goofy question, or offers up meek, mild praise. What if he loved the poems but couldn't say so?

You feel rejected. He feels as if he's failed you. Whose problem is this? Both of yours, of course. Who is obliged to understand it? You, at the very least. You need to understand your audience, just as you're obligated to understand yourself.

You must understand them generally and specifically. You need to understand them in general and learn how editors, agents, artistic directors, producers, gallery owners, or record company executives *tend to respond.* You must understand them specifically as well, so that you know when to show work to this editor rather than that one, this friend rather than that one, this mate rather than that ex-mate.

If you want to make a sale, then you are looking less at the character of individuals and much more at who's who in the marketplace. "X" may be a you-know-what, but still may be *the* person to show your work to. But if you're looking for meaningful feedback, then you're indeed in a hunt for character. You want the person to whom you show the work to be discerning, thoughtful, sympathetic to your worldview, respectful, good at global thinking and good at details, savvy about the marketplace, and on your side. This may seem like a lot to ask of one person, but if you persevere you will find not one but two or three such people inhabiting your universe.

Remember that anyone you choose as an audience member is a person, nothing more and nothing less, someone with his or her own quirks and his or her own true circumstances. No one is a seer; no one transcends the human condition. But that hardly means that you can't be discriminating and choose smartly. The more you *think about the other person,* either generally if she is

anonymous or specifically because you know her, the better your chances will be of choosing someone who will serve the work and serve your purposes.

Completing the Work for the Purposes of Showing

You've chosen to show your work, you have a sense of what responses to the work will mean to you, and you've chosen the person or people to whom you will show it. What's next?

Next is completing the work for the purpose of showing it, not completing it "completely" but rather according to what a receiver needs it to be. Even if you're showing your work early on for feedback and it's in very rough shape, you still must determine the serving size you will show and arrange that serving so that it's at least manageable and maybe even palatable. This task, then, is as much about presentation, as in the presentation of a compelling argument or any product, as it is about completion.

This may well mean working on the project just so that it shows well. This effort can be anything from reprinting the poem using a new ribbon to cleaning up a corner of the studio so that the painting can be properly viewed. It may mean rewriting the first chapter three times so that it is really strong or investing in the right portfolio with which to make your rounds. It may require anything from the simplest work to the most arduous, the most mechanical work to the most inventive. The principle is obvious enough: *do whatever is required* to help and not hinder the work on its showing odyssey.

> The more forthright I become in my statements, the more I learn from the reactions of others.
>
> ALICE MILLER

EXERCISE
SPEAKING YOUR WORK

In an important sense, a work is not ready to be shown until you can speak about it clearly. There is a transition to be made from the inarticulate working stage, where no neat "rap" about your work is necessary or even desirable, to the showing stage, where it becomes important that you create, in one or two sentences, a

As, in full view of the world, the crown of the tree unfolds and spreads in time and space, so does the artist's work.

PAUL KLEE

clear, powerful word picture of your work, a compelling picture that a listener can see, become excited by, and even begin to fall in love with.

Complete your work in this special sense right now by arriving, through trial and error, at the few sentences that both describe it clearly and intrigue a listener. Do not think for a minute that these sentences will come easily: it may take you fifty tries. Be patient, hush your mind and hold the task, and arrive at something brilliant. Write your final version below.

"Hello, John? Hi! Let me tell you about my new work.

_____ "

Next, imagine what *you* would want if someone showed you his or her work. Wouldn't you want to know what was expected of you, how much time you had to consider the work, how much permission you had to be forthright in your feedback? Wouldn't you want to enter into a certain relationship with the giver, one of mutual equality and respect? Please do unto your audience as you would have them do unto you: that's both the honorable and wise thing to do.

Learning How to Show

Showing is a giving and then a leaving alone. It is not a hovering, a brooding, a questioning, a scrutinizing. You give the work to someone and iron out the details of the deal—that she'll read the poem and you'll return in ten minutes, that she'll listen to your tape and have something to report in three weeks—and then you leave that someone alone. You act exactly as a good real estate agent acts when he scrupulously leaves people alone to wander leisurely, in their own hushed way of holding, through the house he is showing.

EXERCISE
OPEN HOUSE

What does a real estate agent say when you walk in? "If you have any questions, feel free to ask. I'll be sitting right here." What does he say when you get ready to leave. "Any questions? No? Well, thank you for coming!"

Practice your own introductory and exit remarks. How will you introduce the work to a friend?

How will you introduce it to a marketplace player?

What will you say when your friend is finished, whether he's had much to tell you or not?

What will you say when the marketplace player is finished, whether she's had much to tell you or not?

Practice these little graces. They are an integral part of the process.

You must go on, I can't go on, I'll go on.

SAMUEL BECKETT

Showing

All of your thoughts and feelings about showing and all of your preparations to show are not the same as showing.

Showing is an *action.* Showing is saying out loud, "I'd like you

to take a look at this." To show means to take the work to another human being, to offer an invitation, to relate. To show means to make a phone call, to pack up your portfolio, to write a query letter.

To show is to do.

I get letters like: "The first act was my life but the second act wasn't my life." Well, write your own play. Leave me alone.

WENDY WASSERSTEIN

EXERCISE
SHOWING SOMETHING, ANYTHING

If you have work to show, splendid. Use the information in this chapter and proceed to show it. But whether or not you have work to show, make a resolution to show something, *anything* to someone tomorrow.

Show your mate how you can (or can't) juggle three oranges.

Show your office mates the box of pears you received for Christmas.

Show your friend the new shadow animals you can (or can't) make on the wall.

Experience showing. Experience saying, "I'd like to show you something." Experience saying, "Thanks for your time!" Commit to engaging in a small showing adventure.

Evaluating Feedback

If all an artist wants to hear is "Great job!" no reception short of that will ever manage to please her. More than that, no response will provide her with information, if she's in the habit of only really hearing news that pleases her.

What Rossini said of Wagner, that "Wagner is a composer who has beautiful moments but awful quarter hours," a truth full of damnation but also full of praise, will strike such an artist's ear as damnation only. What Rossini said of Beethoven and Mozart, that "Beethoven is the greatest composer, but Mozart is the only composer," a distinction full of praise for each, will feel to her like disparagement of both. If praise of the sort that Berlioz lavished on Bach when he cried, "Bach is Bach, as God is God," is what she requires, will she ever learn much from showing?

Showing one's work is a dramatic affair, not only because one's self-esteem is wrapped up in the transaction, not only because one's livelihood may be on the line, but because each response makes its demands on the artist and on the work. If you turn a deaf ear to the responses you get, you will remain safe but ignorant. If you listen, you will be put at risk. You may have to change the work; you may have to abandon the work; you may have to change or abandon your supposed friends! Make no mistake about it: these are very real risks.

Beyond all purist preconceptions about art is the imperious necessity to shout, to express oneself as one is.

ANTONIO SAURA

But despite these real risks, an artist must show, listen, and evaluate. Insofar as she understands her own work and her own intentions, insofar as her work is rich, strong, and well-crafted, and insofar as she is basically confident, in such measure will she be safeguarded from the dangers of receiving responses. But this is a lot; and even if all this obtained, the risks would never be eliminated entirely. That is why showing is anxiety-provoking: it will always be a risky business.

SHOWING, EXCHANGING, AND SELLING

What is the central impetus behind an artist's need to present her work to another person? Why does she need to receive something in exchange for it, some material or immaterial currency—a book contract or a word of praise, a movie deal or a not-indifferent nod? Why isn't it enough that she enjoy the process and revel in her product?

Imagine for a second a last person on earth. Such a person might well be moved to make art just to satisfy her own soul, in a language and a medium in keeping with her circumstances. She might carve from a branch the figure of a bird in flight, just to capture for her own satisfaction an image of that bird. This she would do strictly for herself.

But if suddenly another last person on earth appeared on the horizon, our artist would feel rise in her the strong desire to show him her carving. Why? To affirm herself, to be sure, to show him that she is special, that she has greatness in her, that she is a creator, a wonder. But for other basic, sincere, and simple motives too.

Experiencing the works of others is like experiencing nature.

WASSILY KANDINSKY

The carving is a gift, an offering. She has received many such gifts in her time—the books she has read and loved, the movies she has seen and loved, the music she has heard and loved—and they have pleased her enormously. Why not please this other human being? Why not share a beautiful thing? As the pianist Arthur Rubinstein put it, "Sometimes when I sit down to practice I have to stifle my impulse to ring for the elevator man and offer him money to come in and hear me." If you possess a beautiful thing, why wouldn't you want to share it?

Why wouldn't you? Perhaps because you aren't sure that it really is beautiful; perhaps because you aren't sure that the other person can be trusted to receive it kindly. Will this other person be in perfect or even decent sympathy with your art and your aims? What has your experience been? Were your parents? Your siblings? Your friends? Has anyone been?

We all learn that other people make less-than-perfect receivers. It is alienating and an enormous letdown to learn and relearn that our offerings are not really wanted, appreciated, or understood. It is even harder if, as is so often the case, not even a single person exists who will take what we have to offer and give us something of value in return.

This would mean a great deal, to have an audience even of one, if that person's response were adequate. If just one person appreciated and understood us! Although artists hunger for a large audience, it must be remembered that they are not creating for a crowd. They are creating first for themselves and then for another person like themselves, an artist alter ego, a like-minded witness, a person with whom exchanging work for praise is worth the effort.

As the playwright Harold Pinter put it, "I'm rather hostile toward audiences—I don't much care for large bodies of people collected together." The artist is essentially creating for individual persons, for the single reader, the single viewer, the single listener. Creating is dialogue, not oratory. Hence the importance to the artist of an answering echo, a personal response, the right smile on the face of the other last person on earth as he takes her carved bird for inspection.

She'd like to communicate, touch others, hear an echo. If only those were the sure results of showing, she'd show her work in a

flash! But, sadly enough, what usually happens when she shows her work is something else again. She is met by human beings who have not come into this world to provide her with echo and approval. They are themselves needy, busy, and burdened. They are themselves suspicious, disinterested, skeptical, critical, even vengeful. They are simply people.

I have some idea in mind, but the result is always very different from what I really had in mind.

RAPHAEL SOYER

Her audience will not hear her perfectly. It is also the case that her product will not speak to them perfectly. Even if her work is good, all that she had to say was changed and probably reduced in the process of saying it, and now neither she nor her listeners have that original splendid song to hear. As the novelist Hermann Hesse put it:

> When a writer receives praise or blame, when he arouses sympathy or is ridiculed, when he is loved or rejected, it is not on the strength of his thoughts and dreams as a whole, but only of that infinitesimal part which has been able to make its way through the narrow channel of language and the equally narrow channel of the reader's understanding.

Creating a real dialogue is thus both difficult and rare. But it is difficult and rare only insofar as the artist is the sender. As a receiver it has occurred in her life a thousand times over. In how many silent dialogues has she been with other artists, as a youth and as a young woman! She was not one of a crowd when she read a novel or watched a movie, she was alone with that creator. In the words of actress Ellen Burstyn: "When the actor is at a peak, the audience is in perfect harmony. All their attention is focused on one spot, like in a meditative experience, and I'm sure they're all breathing together." This is the essence of exchanging: two people (or two thousand) breathing in unison, person with person.

Now, as an adult artist, she wants that same experience, but the tables have turned. How much harder it is to find a receiver than to be a receiver! Nor does sending feel anything like receiving: receiving is a state of bliss, but sending, especially in its infernal incarnation as selling, possesses all the charm, warmth, and spirituality of hawking cars or refrigerators.

Still, this is work an artist must do. It is easy to receive and hard to send; but sending is the job of an adult artist. To exchange

Have I consideration for the listener? I have exactly as little as he has for me.

ARNOLD SCHOENBERG

she must get over her doubts and fears about how others will receive her work, the more of which she will have according to her life experiences. She must detach from her work and cease judging it. She must block from her thoughts the wonder about whether people will misinterpret her gesture of offering, turn their back on her, or smile indulgently. She must block from her thoughts the wonder about whether people are in the wrong mood or the wrong mind-set. She must work to exchange and to sell, simply because she has a real need to give and receive in return.

If she manages to quiet her anxieties and show the work, good things may happen. The very courage she manifests in daring to show the work is courage that she thereby cultivates and will bring back to the work, to make it or some subsequent work better. And by showing, she may find supporters, friends in the marketplace, advocates, buddies. She may acquire champions, as the composer Arnold Schoenberg found in his former student the composer and conductor Alban Berg.

For even an artist as reclusive and curmudgeonly as Schoenberg, nobody's idea of a fawning, audience-oriented artist, longed to experience this exchanging. Consider his reaction to a letter he received from Berg in the spring of 1912. Berg wrote from Vienna, after conducting one of his teacher's notorious "modern" pieces: "I have to write, dear, dear Herr Schoenberg, though I'm already in bed. But I am so drunk with the beauty of the music and with the unprecedented, unanimous success that I simply have to tell you a bit more about it."

Schoenberg, writing from Berlin, sang in reply, "I thank you very, very much for your exceptionally warm letter. Truly, I sensed how devoted you are to me and my works and that gives me an extraordinarily good feeling. As you describe it, it must really have been wonderful. Usually one only senses the audience's antipathy and resistance."

What artist needs less? The echo may come in the form of thanks, praise, recognition, money; an acceptance letter, an offer of a gallery show, an offer of a concert; a kind word, a little acknowledgment, a token of respect; anything under the sun, so long as it is given to him because he made *this* work, because *this* work is appreciated.

SELLING

In other cultures and other times the exchanging of ideas and artworks may have occurred in various ways, but in America this exchanging usually involves selling in the art marketplace.

For the artist to be heard, his book must be published, his public sculpture commissioned, his performance piece mounted, his quartet performed. The sale may result in no financial gain, but the act of submitting a short story or a poem to a literary magazine that pays only in copies is still more like selling than it is like anything else.

In our culture, selling precedes recognition and is even the equivalent of recognition. Selling becomes success; a lack of sales, failure. If an artist does not manage to sell what she creates, that negatively affects her ability to go on creating. Her ambition is not realized and her heart is wounded. She may continue to create because she loves it and because she must, because she is courageous, obsessed, and overflowing with ideas, but how long can she maintain mental health if she is relentlessly met by marketplace failures?

She must sell and succeed at selling. But of course selling art is a difficult and unpleasant business. It is never the seller's market. The odds of certain kinds of work being purchased in the marketplace are a thousand to one against. The selling cycle, from initial contact to sale, is often a very long one. What she is selling is likely to be rejected scores of times. Some of the rejections will be insulting.

To top it off, she may finally "sell" the product and not receive a penny: no advance on the book, no pay for the article, no pay for the poem, no pay for the painting (which is in a gallery, finally, but which isn't really sold yet), no pay for the sonata (which will be performed, finally, but not to anyone's financial benefit), no pay for the community-theater-produced play. These are typical "sales" in the arts, and the artist is hard pressed to consider them victories.

A host of practical and psychological challenges stand between an artist and successful selling. Consider the following imaginary conversation between a painter and his therapist, a conversation I've annotated so as to highlight the issues.

I didn't understand that I needed management and publicity and all those things that were anathema to the old me in order to be efficient and have people hear what I create.

JOAN BAEZ

▼ ▼ ▼

The urge to sell builds, dissipates, builds again. It vanishes for months on end, then returns with a fury.

But remember: It is merely an urge or a wish until you are willing to commit to the time and effort required to get the work done.

Even if and when a commitment exists, it is very hard to know precisely what to do. Some actions feel too small, some too large. This is the artist feeling like Goldilocks.

Doing business involves costs. It costs you time but may well also cost you money. Are you willing to pay to attend a conference and meet editors? Are you willing

"I feel jazzed up today! I really want to set some new short-terms goals and get my art selling. I'm ready to spend a lot more time on business!"

"Fine. You mean, you're willing to turn some of your quality painting time over to business?"

"Oh, no, not that! That time's too precious!"

"Then what? Maybe start each day a little earlier and get to business first thing?"

"No. I already get up too early. And then I need my coffee and I need to read the paper."

"Oh. Then you mean, what, in the evening—?"

"I'm too tired then."

"All right. You want to do more on the business end. What specifically do you mean?"

"I'm not sure. I don't know."

"Call gallery owners?"

"No. There's no earthly point to cold-calling. And I'm terrible at that."

"Update your mailing list?"

"I could do that. I suppose."

"You don't sound very enthusiastic."

"Well, I don't have a show, so what's the point? What would I mail out? And how do I get everybody's new address? I haven't touched that list in a year. Probably everybody's moved."

"Still, you think you should update your mailing list?"

"I don't know."

"What about making slides of your new paintings?"

"That'd be important."

"Yes?"

"But . . . I don't know."

"What?"

"It's so expensive to do! To have someone come in and photograph them. The last time I had it done professionally, it cost me almost a thousand dollars! And even then the slides were only maybe an eight on a scale of ten. But on the other hand, I can't do the photography myself—I always screw it up. The best slide I've ever made is only maybe a six. I never get the colors right."

"But still you need those slides in order to do business?"

"I suppose. Yes."

"Yes?"

"I don't know."

"What?"

"I hate this!"

"It's difficult."

"What I really want is to have somebody else sell my paintings!"

"Can you get that somebody else?"

"I've been in galleries. Nothing much happened. I've had representation. But it just hasn't amounted to much."

"Then what? What could you do?"

"I need a gimmick! I need to self-promote. I need to be a certain kind of aggressive exhibitionist."

"And? You mean to try that?"

"No!"

"So you don't mean to do what you say it's necessary to do?"

"I don't know if it *is* necessary. There must be another way."

"Such as?"

"I don't know!"

"You've thought about this a lot. What's one other way?"

"There isn't any other way! It's all who you know and how hard you sell yourself! The hell with it! I'm not going to make wild-man paintings with shards of pottery and broken glass just to sell! That's not why I'm an artist!"

to pay a string quartet yourself to hear your piece performed a first time? Will you pay to have an expensive brochure made, to help sell your paintings to a gallery? What is *your* sales budget?

An artist reasonably wonders, "Must I be a certain kind of person in order to sell my work?" The short answer is, "Yes, a brave one."

How important are connections? If you determine they are vital, then you must acquire them!

Those qualities that serve you as an artist—social witnessing, solitary dreaming, and the rest—are not the qualities that help you sell. Will you manufacture a second skin for the world? Can a salesperson be born in you?

The metaphors of "outside" and "inside" are powerful ones in an artist's life. Virtually all artists feel outside, certain if they are not selling, but often even if they are garnering sales. Is there an inside? Where is it? What does it look like? How does one get in? Does one want to get in?

"No?"

"No! I'm not a clown. I'm not an entertainer. I'm not . . . I'm not a hundred kinds of artist!"

"Of course."

"What I *do* know is that I don't like people all that much! I'm not very sociable, I hate chitchat, I just prefer being in the studio to being with people."

"And that serves you?"

"Of course not! But I can't change my stripes."

"Not even a little?"

"How? What little thing would be worth doing?"

"You tell me."

"Should I run naked into galleries throwing air kisses?"

"You tell me."

"I'm incredibly angry."

"Stop and think. Is there any little thing worth doing?"

"I'll make some angry paintings! That's what I'll do! There's nothing else to think about."

"You came in today enthusiastically wanting to set some short-term goals. Is that really an impossible task?"

"I'll tell you why it is. I see it now. Short-term goals, creating lists, making plans, they're all ridiculous ideas, because what's essentially true is that I'm *outside* and I'm going to stay *outside.* I will not be allowed inside. And if they let me in, I would want out! There, that's the other half of it. The people wealthy enough to collect me are actually my enemies!"

"It's an absurd situation."

"It *is* an absurd situation."

"Then look at it that way. What can you do in the face of absurdity?"

"Howl with laughter!"

"All right. What else?"

"Throw myself off a bridge."

"All right. What else?"

"This is stupid."

"Absurd, not stupid. What can a smart person do in the face of absurdity?"

"I'm too angry to think!"

"Whom are you angry at?"

"Everyone!"

"And sad?"

"Yes . . . yes, and sad. I had this dream . . ."

"Take a minute . . ."

"It can't ever happen, the dream. There's just . . . the odds are too stacked against me. My own personality is stacked against me. All my crazy anxieties. All my obsessions and compulsions. Every drink I've ever taken, every adventure, every lie I've ever told myself. Plus my art isn't needed. Plus no art is needed. It was such a really stupid idea . . ."

"I'll buy one of your paintings."

"What?"

"I said, 'I'll buy one of your paintings.' How did that make you feel?"

"It . . . Christ. Don't do that to me!"

"How did it feel?"

"Good. Christ, it was a real hit. I can't believe that's the bottom line, that selling would make me feel better. Incredible!"

"That's important information, isn't it?"

"Yes."

"Let's try again. Is it that you want to devote some of your quality time to doing business?"

"I don't want to. But I have to. I see that."

"And make cold calls to gallery owners?"

"God, no. But, yes."

The dream you began with was a pure one. How tarnished that dream can become, because of your own personality, because of the difficulty of creating, because of the harshness of the marketplace. But if it becomes tarnished, you must polish it and make it shine again.

"Nothing succeeds like success." The validation and sense of achievement that a sale brings are high inducements to try to sell again, to do whatever must be done to re-experience that feeling of success.

Whatever changes the artist wants to make with respect to doing a better job of selling, those changes must always be *actions*. After you dream a different route, you must then walk it.

"And work on a good, strong rap, so that you can talk about your art easily and fluently?"

"Oh, Christ. All right."

"And more—should we get a list going?"

"Fine. Great. I even bought myself a pad."

"I noticed that . . ."

It is easy enough, once the commercial success of a book is an established fact, to work out a convincing reason for the public's enthusiasm.

ELIZABETH HARDWICK

ACT

Create your own sales manifesto. Consult books about art marketing issues, consider your own experiences and the experiences of others, do all the grunt work and dirty work necessary in order to come up with a smart, personalized sales manifesto. *Do the work necessary to create your own sales manifesto.* No artist, courageous in general, should falter here out of repugnance or cowardice.

THINK

Consider the following questions:

- What will count as successful exchanging?
- What will count as successful selling?
- In what ways are exchanging and selling different phenomena?
- Is your sales manifesto reasonable? Complete? Up-to-date?
- Since you probably won't be able to earn a living by selling art, how will you live?
- What do you consider most repugnant about selling art? How will you handle that?
- Whose aid will you enlist? Is there anyone?
- How far will you go in meeting the marketplace? Further than before? No further?
- How will you pay simultaneous attention to selling this creation and working on your next creation?
- Will you honorably work at exchanging and selling?

FEEL

For artists, selling almost inevitably engenders bad feelings. What bad feelings arose in you as you worked to create your sales manifesto? Anger? Sadness? Outsider feelings? Hopelessness?

What will you do to combat these feelings? They must, after all, be handled. Consult the Appendix and see if some of the techniques described there—the emotional discharge techniques, disidentification techniques, relaxation techniques, etc.—can help you better handle the bad feelings that inevitably come with this territory.

I had a guilt complex about pushing my art, so much so that every time I was about to show I would have some sort of attack. So I decided it was better simply not to try. Nowadays, however, I am making an effort to change.

LOUISE BOURGEOIS

I've discussed the subject of selling only very briefly here. Please take the time to learn more about selling; you may want to consult a previous book of mine, *A Life in the Arts,* in which the subject of selling is discussed in greater detail.

SHY-MIND ANXIETY, INAPPROPRIATE AND APPROPRIATE PERFORMING

Because I facilitate a certain kind of workshop, I've witnessed the consequences of shy-mind anxiety hundreds upon hundreds of times. In the workshop, volunteers come forward to role-play business interactions in the arts, interactions of the sort that occur between a writer and an editor, a painter and a gallery owner, a documentary filmmaker and a patron, a songwriter and a singer. Here are some characteristic results:

- One writer, possessing marvelous credentials to write the article she wanted to write, did not even hint at those credentials until I teased them from her, long after the magazine editor across from her would in real life have hung up the phone.

- Another writer, awkwardly and laboriously describing to a book editor the book he was writing, took many

minutes, again long after a real-life editor would have
departed, to let slip the fact that he was writing a mys-
tery. For some reason, he felt it necessary to keep it a
mystery that he was writing a mystery! The thing that
he might reasonably be expected to say *first,* he with-
held and withheld, as if it were an embarrassment.

▾ A songwriter, pitching a song to a famous singer, could
produce only the vaguest of reasons and the emptiest of
flatteries in support of his new song, a pitch along the
lines of, "The song's terrific, you are terrific, you'd do a
terrific job with this terrific song and have a monster of
a hit!" It was a parody of a Hollywood pitch and the
singer, skeptical and disgusted, kept the songwriter at
arm's length. But after I coaxed, coached, and helped
quiet the songwriter, he was able to manage his anxiety
a little, an anxiety that was anything but apparent, and
drop his glib persona. Now better able to think on his
feet and encounter the singer, he could explain to her
why his new song and her style and strengths were well
matched. In reaction to his change, the singer also
changed: she became friendly and excited.

How difficult artists find these interactions! To be sure, "sell-
ing art" is hardly taught anywhere, and rarely at this level of de-
tail. Nor do artists see these moments enacted, except when they
themselves are involved—that is, only rarely, and then only when
their anxiety level is at its highest. It is therefore no wonder that
they shy away from these interactions, interactions which, the few
times they've engaged in them, may not have gone all that
smoothly.

But the reasons for their difficulties go deeper than these.
Artists do, after all, have a lifetime of experience in buying and
selling, just as everyone does. It isn't that they know nothing
about presenting themselves in a good light or nothing about ac-
tive listening. In their day jobs, they may even be salesmen and
saleswomen! Can't they extrapolate from their everyday experi-
ences and bring that knowledge to the art marketplace? And if
not, why not?

It is simply because artists find exchanging and selling in the art marketplace *so* important, *so* fraught with meaning and possibility, that paralysis sets in. It is a paralysis compounded by ignorance, to be sure, and by pride as well, but its central cause is the very *importance* artists attach to these interactions. An artist may sell his house without blinking, but if his poem is published he will celebrate with champagne.

Because artists are anxious and not thinking clearly, they tend to mythologize marketplace players and turn agents into ogres or gods, small-press editors into villains or saviors, patrons into idiots or royalty. They forget, blinded by anxiety, that the other person is simply a person, a person with likes and dislikes, needs and wants, a thin-skinned or thick-skinned, defensive or open human being inexorably caught up in his own gestalt.

The most unfortunate response to one's own shy-mind anxiety is to not perform at all; that is, to avoid the marketplace entirely. This, typically, is an artist's first line of defense. Avoidance is easy and quells shy-mind anxiety, but at the obvious expense of lost opportunities and zero marketplace successes.

But it is also inappropriate to handle one's shy-mind anxiety by engaging in marketplace interactions carelessly or defensively. It is psychologically understandable but not at all wise for an actor to act angrily toward auditors at an audition, for an artist to speak snidely to a gallery owner at an opening, for a writer to react sharply to an agent over the phone, for a filmmaker to speak ironically about the quality of movies and the antics of movie distributors at a distributors' convention.

The artist who does these things is not self-aware and not in control. He may say to himself, "Look how brave and free I am, to bite the hand that just might feed me!" But he is actually enslaved by his fears, his fear that if he doesn't act out he will hate himself for looking weak and servile.

A strong artist is one who performs appropriately and well, in role and in costume, as a public figure and as a spokesperson for his own work. He will need to manage his shy-mind anxiety in order to do this, but isn't anxiety management our basic theme?

It is impossible to attain absolute calmness of our mind without any effort. So it is necessary for us to encourage ourselves, and to make an effort up to the last moment, when all effort disappears.

D. T. SUZUKI

EXERCISE
GIVING A SALES PERFORMANCE

Unplug your phone and rehearse the selling of your work. Cold-call an editor, agent, patron, gallery owner, or producer. Prepare yourself, calm your nerves, clear your mind, and make your imaginary call.

- ▾ Did you really prepare yourself before you called?

- ▾ Did you know *how* to prepare yourself? If not, will you learn what you need to learn?

- ▾ Did you have a compelling way to speak about your work? Did you have a few simple sentences that communicated the work's substance and value? It's easy to poke fun at the Hollywood way of describing movies, where a current project is compared to two hit movies of the past: "I've got this idea for a Coast Guard movie. It's a cross between *Jaws* and *Police Academy!*" But such descriptions possess undeniable rhetorical power. Does the description of *your* work possess rhetorical power?

- ▾ Do you understand what is required of your public self, your selling self? Can you list those requirements?

- ▾ How will you handle your shy-mind anxiety? What will you do in addition to rehearsing?

Selling is hardly a bloodless, unemotional undertaking. It shakes one's nerves and engenders powerful feelings. Are you ready for that? Are you ready to feel all that must be felt, so that you can acquire an audience? Take your pulse on that question. If the answer is no, you have a sales job to do on yourself before you can take your wares to market.

CREATING SALEABLE THINGS

A writer wants to investigate the subject of incest. He might cover the material in a psychological novel or a mystery. He chooses to write the mystery. Why? Because he calculates that it has a better chance of selling.

A painter loves the smell and color of oil paints but has learned the many virtues of acrylics. He might paint with either, but chooses acrylics. Why? So that he can roll up the finished painting and take it right to a potential buyer.

A composer loves both the bass and tenor voice, and might make the central figure of his opera either. He chooses to write for the bass voice. Why? Because he has good connections to a well-known bass and none to a tenor.

It has never been easy and will never be easy to know how to value such considerations. Some will say, "Ignore the marketplace!" on the grounds that inviting marketplace concerns into the process deflects the artist and dilutes his art. Others will say, "You must be savvy about the marketplace!" on the grounds that work not informed from the start by a sense of what's wanted will, indeed, not be wanted.

I do believe that whether you manage to sell what you create is determined in largest measure by the shape of the market exactly as it is, not as one would like it to be or as one imagines one might influence it or transform it. Which screenplay, after all, has a better chance of selling, one called *Dumb and Dumber* or one called *Smart and Smarter*? Which book, after all, has a better chance of selling, a collection of bedtime stories about angels or a handbook for atheists? Is this a test that anyone but a hopeful artist could fail?

This is of course not to say that you should choose to do that which is likeliest to sell. Adherence to such a principle is the opposite of fearless creating. But a creator who wishes to reach people, move them, and better the world *must find a way* into the marketplace. Ignorance of the marketplace is not bliss; it is suicide. This is a matter of lifelong concern and lifelong learning for artists. Your present conclusions about meeting the marketplace are already embedded in the work you have undertaken; the next

The contemporary composer is a gate-crasher trying to push his way into a company to which he has not been invited.
ARTHUR HONEGGER

time you create, you will make new calculations and reach new conclusions.

I invite you to bring those calculations more into conscious awareness, where you can wrestle with them and really choose the direction you want to take. Will it be more toward commercial viability? More toward truth-telling? Or maybe, through some stroke of genius and luck, toward both at once?

CREATIVITY IN THE BALANCE

To actually think, to actually love, to actually commit, to actually rebel are remarkable feats. But accomplishing these feats puts an artist at risk. Throughout human history the efforts of individuals to think for themselves and to create works of art have inevitably put them at risk. Hence the title of this book. I see creators on Camus's high ridge, precariously balanced there, with armies of enemies of the truth mustering to topple them over the edge.

What the artist does poses a threat to the ordinary person, and at the same time strikes him as terribly luxurious. The artist is hated for telling the truth and envied for living his life authentically. Thus subtle and flagrant stops are put on the artist's creativity by society at large. But in the individual, too, his own creativity hangs in the balance.

Creating is not easy, nor are the results more than sometimes pleasing. A person can orient to almost anything at all and experience less unpleasure than he experiences trying to capture the nature of things with pigments on canvas, struggling to transform a fleeting idea into a beautiful book, or sweating with a lyric that won't come. So all too often he doesn't try. He simply doesn't try. He knows he's failing himself and calls himself names, but neither that knowledge nor that name-calling turns the tide. The scales have tipped the wrong way and another person has lost his voice.

I was signing copies of my previous book *A Life in the Arts* at a career conference when two women, arriving from opposite ends of the hall, stopped where I was sitting. The first woman, glancing at the title of the book, said, "What artists do is irrelevant," and walked on. The second woman shook her head and said, "And

Do lifelong artists pay a price for having chosen to make art? Of course. Everyone pays the price for his or her choices.

SALLY WARNER

when they look in the cells of political prisoners, they find poetry written on the walls in the prisoners' own blood."

Will you create? The question is an open one and can be answered only through action. If you have taken that action, congratulations! You know as well as I do that not creating is a dead loss; and that creating is one of the few genuine answers to the question "How can a life be meaningfully spent?"

There is not a single true work of art that has not in the end added to the inner freedom of each person who has known and loved it.

ALBERT CAMUS

AFTERWORD

I would love to hear from those of you interested in sharing your thoughts and feelings about the creative process or life in the arts. If by chance this book has helped you steward a creative project from wish to completion, it would give me great pleasure to hear about that too.

Please write me at the following address:

Dr. Eric Maisel
PO Box 613
Concord, CA 94522-0613

Or if you prefer, you can call me or fax me at (510) 689-0210. Thank you.

APPENDIX

Anxiety Management Strategies

The following anxiety-reduction techniques will help you deal with the various anxieties associated with the creative process. These techniques constellate into the following twelve categories.

TWELVE CATEGORIES OF ANXIETY-REDUCTION TECHNIQUES

1. Breathing techniques
2. Relaxation techniques
3. Meditative techniques

4. Guided visualizations

5. Affirmations

6. Reorienting techniques

7. Disidentification techniques

8. Symptom confrontation techniques

9. Emotional discharge techniques

10. Ceremonies and rituals

11. Rehearsal techniques

12. Cognitive techniques

You have freedom when you're easy in your harness.

ROBERT FROST

One of panic's greatest weapons is its surprise attacks. The best way to combat this weapon is to plan ahead for specific times when you are susceptible to panic.

R. REID WILSON

Using a single technique from a single category could save your artistic life. It is more often an inability to deal with anxiety than a lack of talent or imagination that derails artists and would-be artists. Consequently it's in the area of anxiety management that you can most profitably learn a new thing. Do you need a new glassblowing technique or another poetry workshop? Not as much as you need ways to manage ruinous anxiety.

Take a minute to reflect on the kinds of anxieties you encounter as you create, anxieties of the sort I've been describing throughout this book.

Stage	Anxiety	Solution
1. Wishing	hungry mind	appropriate feeding
2. Choosing	confused mind	appropriate clarity
3. Starting	weakened mind	appropriate strength
4. Working	chaotic mind	appropriate order
5. Completing	critical mind	appropriate appraising
6. Showing	shy mind	appropriate performing
	attached mind	appropriate detaching

If you've thought about these anxieties, you realize that each feels different. Hungry-mind anxiety does not feel like critical-mind anxiety or shy-mind anxiety, any more than hunger feels like self-criticism or shyness. Each is its own problem; each has its own edge to it. Therefore it's necessary to match the right anxiety-reduction technique with the right anxiety.

An emotional-discharge technique like "silent screaming" might be just the weapon to employ to combat weakened-mind anxiety, but critical-mind anxiety might be better fought with a cognitive technique like thought blocking or thought substitution. A rehearsal technique like unplugging your phone and role-playing a conversation might be the perfect tactic to help you deal with shy-mind anxiety, while chaotic-mind anxiety might be better met with a simple reorienting technique, like focusing for ten seconds on the swirls of your thumb.

It's very much a question of reinforcing choices as one makes them, of going further in and confirming them.

MURIEL RUKEYSER

This is a puzzle you must solve. You have anxieties; the following strategies and techniques are available to you. You need to choose among them and determine which ones work in which situations. This trial-and-error process is facilitated by the following steps.

Step 1. Read Through All the Techniques

- What's the central idea of each?
- Which feel congenial?
- Which seem best suited to managing your symptoms?
- Which seem best suited to your current stage in the creative process (that is, have you not yet started, are you in the middle of working, are you trying to complete, etc.)?
- Which seem like a "stretch" but potentially useful?

Step 2. Select a Few and Try Them Out

Practice them. See if you understand them. See if you can make them work. *To begin with, they may raise your anxiety level.* This is natural. Do not discard a technique merely because you find it

hard, unnatural, or anxiety provoking. Give it a chance. Try to be patient.

Step 3. Imagine a Work Situation

There exists no more difficult art than living.

SENECA

Our mind always follows our breathing.

D. T. SUZUKI

Visualize yourself wishing to paint, starting to compose, embroiled in the chaos of writing. Use your mental imagery skills. See if you can make use of your new anxiety-reduction strategy *in the visualization.* Do you see how it might work to breath a certain way or think a certain way? Is it reducing your anxiety? Tinker with the words of your affirmation or try a different breathing exercise if the first doesn't seem quite right.

Step 4. Try Out the Techniques You've Chosen in Vivo

See if and how they work. See if you're practiced enough to actually use them or if you revert to white-knuckling it. Practice your techniques between work periods and try out new ones. Don't expect complete and final success, but do expect your anxiety-management skills to improve greatly.

Note: The following are only brief descriptions. Fuller descriptions may be found in books on the recommended reading list following this appendix.

BREATHING TECHNIQUES

The simplest breathing exercise is the one described by Stephanie Judy in her book *Making Music for the Joy of It.* Judy explains:

> Anxiety disrupts normal breathing patterns, producing either shallow breathing or air gulping in an attempt to conserve the body's supply of oxygen. The simplest immediate control measure is to *exhale,* blowing slowly and steadily through your lips until your lungs feel completely empty. Don't "breathe deeply." It's too easy to hyperventilate and make yourself dizzy. As long as you make a slow, full exhale, the inhaling will look after itself.

Dr. Christopher McCullough described several breathing exercises in his book *Managing Your Anxiety.* The exercises have

names like "slow, complete breathing," "slow, deep breathing with shoulder relaxation," "counting breaths," "following your breathing," "circling your breaths," and the like. "Circling your breaths," for instance, works as follows:

> As you start to inhale, you slowly bring your attention up the ventral centerline of your body from the groin to the navel, chest, throat, and face, until you reach the crown of your head. As you exhale, slowly move your attention down the back of the head, down the neck, and all the way down the spine.

In this Twentieth Century, to stop rushing around, to sit quietly on the grass, to switch off the world and come back to the earth, to allow the eye to see a willow, a bush, a cloud, a leaf, is "an unforgettable experience."

FREDERICK FRANCK

Try out this simple exercise. It may seem odd to emphasize something as automatic and everyday as breathing, just as it may seem odd to argue that entering into a mindful relationship with your breathing is one of the more important anxiety-management techniques available to you. But centuries of meditation practice as well as the experiences of our contemporaries who heed their breathing confirm that breath attention is an anxiety-reduction tool of extraordinary value.

Learn one breathing technique. Even if that only means learning to consciously exhale at times of stress, begin that self-teaching today.

RELAXATION TECHNIQUES

Few of us relax very often or very well. Nor are those activities that manage to relax us—gardening, bathing, reading, listening to music—available to us as we create. You therefore have an entirely new thing to learn: how to relax *at will,* even as you paint, write, or compose.

Progressive relaxation training, self-massage, self-hypnosis, the Sarnoff Squeeze, the Quieting Reflex, and other relaxation methods available to you are unavailable until you learn them and practice them. Relaxation methods are not abstract ideas but procedures that need to be mastered.

Progressive relaxation exercises are designed to work by relaxing different muscle groups in sequence. Renee Harmon presents

a short progressive relaxation exercise in *How to Audition for Movies and TV*:

With writing songs, it's always a battle with my conscious mind, and yet when it comes down to it, it doesn't have much to do with my conscious mind. I wear myself out, and then I surrender to what's going to come.

MICHAEL MCDONALD

The following exercise should not take more than thirty seconds:

Relax your forehead.

Relax the area around your eyes.

Relax the corners of your mouth.

Listen to the sounds surrounding you but do not concentrate on them.

Feel your arms and legs become heavy.

At the point of the most intense heaviness, imagine that all your tension flows out of your body. Your fingertips are the exit points.

Feel sunshine warm your stomach.

Lift your chin and smile.

Mental relaxation exercises can be supplemented by physical relaxation exercises like self-massage. Take the time to massage your forearms, upper arms, shoulders, neck. Take real time and give yourself real pleasure. Make little sounds of satisfaction. Exhale and sigh. Find the knot in your shoulder and work it hard. Groan a little. Lose yourself in the process.

Part of the work of relaxing before and during the act of creation is gaining permission from yourself *to* relax. You may presently suppose that you must be tense at such times, that that is either natural or even desirable. But such thoughts are worth blocking and replacing with a new one: that *you can be as relaxed as you like.*

Learn one relaxation technique. Practice it today.

MEDITATIVE TECHNIQUES

Meditation is a discipline that includes breath, body, and mind awareness. Different meditation exercises have different goals. Some help you exercise thought control while others are designed

to allow thought free rein. Both are valuable skills for the artist to acquire.

An example of a simple meditative technique is the use of a mantra. Stephanie Judy writes,

> A mantra is one kind of thought pattern you can use to block negative thoughts. Often taught in conjunction with meditative techniques, a mantra is a word or short phrase that is simply repeated quietly, over and over again, aloud or in thought. *Peace* can be a mantra, as well as *one* or *love*. *Om* and *shanti* are Sanskrit mantras. The former is a universal word of affirmation or assent; the latter might be translated as "The peace that passeth understanding."

In *Don't Panic,* R. Reid Wilson explains:

> Meditation is a form of relaxation training. You learn to sit in a comfortable position and breathe in a calm, effortless way. You learn to quiet your mind, to slow down the racing thoughts, and to tune in to more subtle internal cues. You acquire the ability to self-observe. You practice the skill of focusing your attention on one thing at a time and doing so in a relaxed, deliberate fashion. By reducing the number of thoughts and images that enter your mind during a brief period, you are able to think with greater clarity and simplicity about whatever task you wish to accomplish.

By spending as little as twenty or thirty seconds meditating, you can interrupt your negative thoughts and create a transitional bridge between a mind-set in which stress predominates to one in which calmness predominates. In the blink of an eye you can alter your sense of the situation and dramatically reduce your experience of anxiety. In short, you can learn to do what I represented to be the most important thing an artist can do: *hush his or her mind.*

Visit your local Zen center. Consult a book or tape. Learn to meditate.

The trouble with our conscious mind is that it tries too hard.
R. REID WILSON

Abstraction is real, probably more real than nature. I prefer to see with closed eyes.
JOSEF ALBERS

GUIDED VISUALIZATIONS

Guided visualizations are mental pictures you create for yourself. You can imagine yourself in a tranquil spot—on a beach, in a garden, beside a secluded lake—and spend time there, in your mind's eye, relaxing and letting your worries slip away. Guided imagery provides you with a powerful means of "leaving" the scene of your stress without physically leaving.

A guided visualization proceeds as follows. You seat yourself comfortably, shut your eyes, and use progressive relaxation cues to drift into the sort of receptive state where images flow. Then you slowly and calmly speak the cues that produce the desired imagery. Instead of speaking the cues, you might tape-record them and then listen to the tape.

As practice, construct for yourself one of the following visualizations:

The writer by the nature of his profession is a dreamer and a conscious dreamer.

CARSON MCCULLERS

- Picture yourself in a bubble in which you and your work are together. Nothing distracts you or interferes with your process in this bubble. Entering your bubble is the equivalent of entering the trance of working.

- Picture yourself in a window seat on a train riding through the Swiss countryside. Sights pass. The train rocks. Ideas come.

- Picture a person crying. She is touched by your work.

- Picture a childhood spot. It is where you used to draw. See the sunshine, the furniture, the paper, the pencils. Relax there, drawing a zebra, cat's paws, people with long necks. Feel the tension leave your body.

- Picture your work completed. The final sentence of the draft is done. The painting has a certain shine to it. The symphony needs polishing but is essentially whole. That which now seems so far away is right at hand. Picture yourself getting up from the work and, spent and satisfied, going out to celebrate.

Try your hand at creating a guided visualization. Wouldn't it be nice to celebrate the completion of your work or escape to a beautiful place whenever you liked?

Create a guided visualization and practice it.

AFFIRMATIONS

An affirmation is a positive statement you create and repeat as needed, in which you assert that you are capable and confident. To be most effective, affirmations should be short, simple, and framed in the present tense. Examples of affirmations are "I'm perfectly able to write today" or "I know how to use color." Your affirmation can be as simple as the word "Yes," repeated with conviction.

The essential feature of the cognitive technique known as thought substitution is the replacement of negative self-talk with positive self-talk framed in the present moment. Affirmations do just that. You affirm that *right now* you have no need to worry. You acknowledge your strengths, not your weaknesses. You affirm rather than disaffirm yourself. You assert that the process is working, not that the process is derailing. You make use of the power of positive suggestion to block negative thoughts, encourage yourself, and remind yourself of the possibility that creating may sometimes be a joyful experience.

All of the following are simple, useful affirmations:

"I can write today."

"I can paint today."

"I'm equal to this."

"No problem."

"I'm starting."

"I'm staying with the work."

"I'm working passionately."

"I have no doubt."

"I'm fine."

"I am an artist."

"Yes."

Music is perpetual, but hearing is only intermittent.

HENRY DAVID THOREAU

Just looking at a blank sheet of paper is an absolute guarantee of failure.

ANNA HELD AUDETTE

There are so many stimuli around that sometimes I have to put myself in a dark room to calm down.

MEGAN TERRY

Affirmations serve a dual purpose. First, they positively reframe the moment, calming and encouraging you by helping you focus on your strengths and not your weaknesses. Second, they serve to alter your self-image over time by providing you with new, positive self-talk that begins to take root. One day, because you've changed, you'll say, "I feel fine," or, "I can do this," and discover that you're speaking the literal truth and not uttering a wish or a prayer.

Create an affirmation. Say it. Say it again.

REORIENTING TECHNIQUES

What we focus on determines how we'll feel. If you focus for a few minutes on the picture of a new, deadly virus leaping from a monkey to a man, crossing the ocean, slipping under your door, and climbing into bed with you, you can work yourself into a fine panic attack in no time at all. All that can save you is to *interrupt your thoughts* and *focus on something else.*

Cognitive therapists argue that much of the anxiety we experience is a product of *focusing* or *orienting toward* our own negative self-talk. It isn't simply that we possess that self-talk, but that we stop to listen to it. We allow it to move from the background to the foreground. Then we notice it and begin to obsess about it. Or we allow something in the environment to move from the background to the foreground: we glance out the window and suddenly see that the lawn is dying or that clouds have blotted out the sun.

Reorienting is an invaluable technique to learn. You learn to take your mind *off* the piece of negative self-talk, the doubt, the worry, the stressor in the environment, and focus your mind elsewhere—away from the work, back to the work, *wherever you choose.* Dr. Manuel Smith, in his book *Kicking the Fear Habit,* argues that each of us has a powerful "reorienting reflex" that we can effectively employ to manage our anxiety and that we naturally orient to five kinds of stimuli:

1. Stimuli with *novelty:* anything that is unexpected or new

2. Stimuli with *biological significance:* anything that satisfies our biological hungers

3. Stimuli with *innate signal value:* anything that we instinctually orient to, such as bodily sensations

4. Stimuli with *learned or acquired signal value:* anything that we have learned to pay attention to by any means

5. Stimuli with *instructed signal value:* anything that we have been told or instructed to pay attention to, either by others or ourselves

We are dominated by everything with which our self becomes identified. We can dominate and control everything from which we disidentify ourselves.

ROBERTO ASSAGIOLI

You're working on your novel and suddenly you're struck by a bout of chaotic-mind anxiety. What will you do? You might reorient to a different section of the book. The very act of orienting to something new can have a calming effect. You might introduce the sexy villain: introducing him or her may do you a world of good! Or you might orient to the "writing mantra" you've posted right next to the computer. The mantra will encourage you; and the very act of turning to it, of choosing to orient to it, breaks a negative thought's hold on you.

Where can your eyes turn when the tension mounts? The swirls of your thumb may not be able to engross you as negative thoughts assail you—or, in fact, they may. Focusing on an interesting crack in the wall next to your easel may not engross you— or, in fact, it may. Practice different reorienting tactics until you discover what has the power to capture your attention.

Learn how to reorient your focus, away from the work, back to the work, away from the work. Master the art of reorienting.

DISIDENTIFICATION TECHNIQUES

Disidentification is an idea elaborated by the Italian psychiatrist Roberto Assagioli as part of a therapeutic model he called "psychosynthesis." Assagioli argued that people too often become overinvested in and identified with transitory events and states of mind, and that the cure for that mistaken identification involved consciously *dis*-identifying.

Simply put, you are not your novel, as bad or even as good as it

There's something in one's nature that is unchangeable. It doesn't make any difference where you live. I would be the same person anywhere.

HANS HOFMANN

Inside myself is a place where I live all alone and that's where you renew your springs that never dry up.

PEARL BUCK

might be—you are more than your novel. You are not the mere equivalent of a certain song or movie associated with you, you are more than any song, movie, or painting could possibly be. You are not equivalent to one of your weaknesses or even to one of your strengths, to one of your potentialities or even to one of your actualities, you are different from any of your parts (or subpersonalities, as Assagioli called them)—different from them, and considerably more than them.

The process of disidentification involves using guided imagery of a certain sort, as explained by Assagioli in *Psychosynthesis*:

> The first step is to affirm with conviction and to become *aware* of the fact: "I *have* a body, but *I am not* my body." . . . For instance, we say, "I am tired," which is nothing less than a psychological heresy; the "I" cannot be tired; *the body* is tired.
>
> The second step is the realization: "I *have* an emotional life, but *I am not* my emotions or my feelings." To say "*I am* content" or "*I am* irritated" is to commit an error of psychological grammar. . . .
>
> The third step consists in realizing: "I *have* an intellect, but *I am not* that intellect." Ordinarily we identify ourselves with our thoughts, but when we observe ourselves while we think we notice that the intellect works like an *instrument*. . . .
>
> These facts give us evidence that the body, the feelings and the mind are *instruments* of experience, perception and action which can be deliberately used by the "I," while the nature of the "I" is something entirely different.

Making use of these ideas, we can create the following "disidentification affirmations":

> "I am not my poem."
>
> "The painting matters but it also doesn't matter."
>
> "I can laugh at all my absurd investments!"
>
> "I am not my situation."
>
> "I have negative thoughts but I am not my negative thoughts."

"I am more than the part of me that is afraid right now."

"I have fears but I am essentially unafraid."

"I am more than any mistakes I might make."

"My body is acting up but I am all right."

"My emotions are acting up but I am all right."

"My thoughts are acting up but I am all right."

"I am not my poem."

If the oyster had hands, there would be no pearl.
STEPHEN NACHMANOVITCH

Rather than wishing for your novel to spontaneously combust or for a terrific flood to arrive and wash away your studio, detach, disidentify, and accept the situation. Say to yourself, "All right, I'm here, I came here of my own free will, I meant to be here, I wanted to be here, I'm through squirming." Learn to step aside and detach. Learn to identify yourself as a *whole person* who also happens to write, compose, or make films.

Learn to disidentify. Learn that marvelous discipline today.

Symptom Confrontation Techniques

Symptom confrontation is a technique associated with existential psychotherapy and with the therapists Milton Erickson and Viktor Frankl in particular. In therapy of this sort a client is commanded, apparently paradoxically, to do *more* of the thing that he came into therapy wanting to do *less* of.

Eloise Ristad, who in her workshops championed symptom confrontation as a way to reduce performance anxiety, explains in her book *A Soprano on Her Head*:

> Take one of your own symptoms—clammy hands, shaky knees, or whatever—and apply the principle of pushing it to the point where it can go no further. Do *not* try to control it or make it go away; try only to increase the intensity and see how far you can carry this particular symptom. If you are like most people, you will find you can't push your symptom past a certain point, and that when you reach that point the symptom actually reverses. Your saliva begins to flow natu-

rally again, your knees stop shaking, your hands get respectably dry. You may find that almost as soon as you *try* to intensify a symptom, it begins to disappear. The significance of this information impresses me each time I experience it again.

The meaning of life must be conceived in terms of the specific meaning of a personal life in a given situation.

VIKTOR FRANKL

Not only can you confront the symptoms you have, you can create symptoms you don't have. Are you only suffering from butterflies in the stomach? Why not have your palms sweat too? Are you only worried about chapter two? Why not worry about chapter one, chapter three, and every other chapter in the book? This is known as "constructive catastrophizing." Indeed, why not just worry about worrying, an exercise known as "the transcendental metaworry exercise."

As Viktor Frankl put it, "A sense of humor is inherent in this technique. Humor helps man rise above his own predicament by allowing him to look at himself in a more detached way." But Frankl was quick to point out that paradoxical intention is not a superficial technique, even if it employs humor. He added, "I am convinced that paradoxical intention is in no way a procedure which simply moves on the surface of a neurosis; rather it enables the patient to perform on a deeper level a radical change of attitude, and a wholesome one at that."

Trying to confront and increase your symptoms in order to make them disappear is a technique that may or may not appeal to you. More queasiness! More woolly-headedness! More palpitations! What an idea. But if the idea intrigues you, investigate it. Astounding results are possible for artists able to add this technique to their repertoire.

Is symptom confrontation for you? *Find out the next time you begin to sweat.*

EMOTIONAL DISCHARGE TECHNIQUES

Artists can discharge the tension building up in them by doing something active, dramatic, and rebellious. They can utter an ear-splitting battle cry as they cross the studio, shake a fist at and curse the painting at its most recalcitrant, scream (or silently

scream) at their absent muse, or employ a Buddhist mudra to stop anxiety in its tracks.

In *Raise Your Right Hand Against Fear,* Sheldon Kopp described the original mudra:

> Determined to destroy the Buddha, a dark and treacherous demon unleashed an elephant charging drunkenly. Just as the raging beast was about to trample him, the Buddha raised his right hand with fingers close together and open palm facing the oncoming animal. The fearless gesture stopped the elephant in its tracks and completely subdued the recklessly dangerous creature. Once having faced the terrible threat of annihilation, the compassionate Buddha extended his other hand with its palm up, as if cupping the offering of an open heart. This selflessly charitable gesture of forgiveness restored the elephant's natural tranquility. The Sanskrit word for such ritually symbolic gestures is *mudra.* The Buddha's first mudra allowed him to face the fears in his own momentarily uncontrolled imagination.

When I scream with my horn, it's because the music needs screaming.

GATO BARBIERI

Every time you strike a dissonant chord fortissimo, that's an expression.

AARON COPLAND

Raise your hand to the anxiety. Or primally scream. Or if a real earth-shaking scream will bring the police, scream silently. A silent scream can feel almost as therapeutic as a real one. Practice obtaining the tension-discharging effects of a real scream without uttering a sound. Or discharge tension by uttering a silent, fiery battle cry. Create your personal cry and treat the moment of crossing to your work as if you were a knight or hero. Set off on a great, foolish adventure. Shout "Charge!" as wildly as you dare.

Any sort of moving about can help. Pace, jog in place, stretch, do a little walking meditation. Walk around the block. Just stepping outside can work wonders in reducing anxiety by counteracting in a split second the sense of "inhibited flight" that builds up as you work. Or make zany faces. Or laugh out loud. Even if you can't smile a lot, try at least to smile a little. Dream up some gesture or action—a wild dance, a left jab followed by a right cross—that really works to release tension from your body and your mind.

Consider the idea of discharging tension through gestures as powerful as a scream or a belly laugh. What might work for you?

CEREMONIES AND RITUALS

The simplest sort of calming ritual involves the use of a good-luck charm. Dr. Douglas Hunt wrote in *No More Fears*: "The simple faith that a good-luck charm will carry one through is a time-honored way to handle anxiety. Often faith in an object actually lowers the anxiety and fear levels, and things consequently go better. Superstitions may seem out of place in modern society, but if not carried to extremes, they can be viable techniques for self-control."

Art class was like a religious ceremony for me. I would wash my hands carefully before touching paper or pencils. The instruments of work were sacred objects to me.

JOAN MIRÓ

Rituals, too, are ancient calming techniques. The preparing of your palette, the arranging of your papers, playing certain warm-up exercises at the piano, if enacted with the seriousness of ritual, can both calm you and provide you with momentum and direction as you start to work. One of my clients, wanting to find a way to consciously say "yes" each day to the symphony he was composing, added a simple prayer to the end of his morning meditation. He prayed that this would be a day that he went directly to work; and more often than not, it was.

Is there a calming ritual you might create? Isn't it time to dream one up?

REHEARSAL TECHNIQUES

Performers often rehearse not only their material but all aspects of their performance: how they will enter, how they will bow, how they will exit. Stephanie Judy advised performers to rehearse the following five-step entrance ritual:

1. Acknowledge your audience.
2. Make contact with your instrument.
3. Make contact with the other musicians.
4. Think of a calming image.
5. Think about the music.

She described the experience of the pianist Andrea Bodo to illustrate these five steps. Bodo explained:

When I walk out, I acknowledge the audience in some way. I look around a little bit and notice who's there. I want to thank people with my expression. Then I focus on the piano. I look at the eighty-eight keys like smiling teeth. The piano is my friend. It's my ally. I always touch the piano as I sit down. Then I look at the other players so we all relax together and have eye contact. Then I just let everything float away. I have an image that I'm on a pool with water lilies. I think of myself in a Monet painting. I do it very quickly, but I do it. Then I start to think of the tune, and I try to think of it a little bit slower, because the adrenaline is always going. I just allow myself that extra minute to pull everything together, to look relaxed, to savor the moment.

To create presupposes love for that which one creates.

ERICH FROMM

Creators, too, can significantly benefit from rehearsing their "performance." Connect up the ideas of "waking up working," "the most important split second of the day" (when you say yes to the work), and "your most important short walk" (as you actively approach the work) by holding that whole period as rehearsal time. You bestow your best thoughts on the work beforehand while encouraging yourself and assuring yourself that you will in fact work. This sort of rehearsal is nothing less than an act of love.

Rehearsing can also go a long way toward quelling the shy-mind anxiety that accompanies showing, exchanging, and selling. How much easier it is to operate in the world if you've prepared answers for at least some of the questions bound to come your way. "Now, dear, what was that new music *about?*" "Why, Aunt, it was about love, death, infinity, and so much more!" "Now, Bob, if we were to want the manuscript, how long would it take you to complete it?" "Six months." Radio and TV interviews, poetry readings, and meetings with agents, producers, gallery owners, artistic directors, and editors feel that much less frightening the better prepared you become.

Learn to rehearse. Rehearsal is a skill not to be scorned.

COGNITIVE TECHNIQUES

People tend to talk to themselves in ways that are anything but encouraging. They predict that catastrophes will befall them,

magnify and exaggerate their problems, incorrectly assess the amount of danger they are in, and in a hundred other ways play "mind tricks" on themselves that cause them pain and anxiety.

One way to alter these self-sabotaging patterns is by practicing thought substitution, by identifying a negative thought and substituting a new positive one for the old. The following are some examples of thought substitutes.

If you want to have clean ideas, change them as often as you change your shirts.

FRANCIS PICABIA

I sit and pass judgment on myself: this is dull, this is unclear, this is insignificant: ergo I am dull, I am unclear, I am insignificant.

JANET BURROWAY

THOUGHT SUBSTITUTION

1. I'm too crazy to write.

 a. I'm crazy, but not *too* crazy.

 b. I'm excited, not crazy.

 c. I'm anxious, not crazy. I know what to do to calm down.

2. I know the work stinks.

 a. I'll work another hour before judging it.

 b. I'll just work and look at it in the morning.

 c. Maybe this part stinks, but the central idea is still excellent.

3. I know the work is boring.

 a. I'm tired. Let me splash water in my face.

 b. Who hasn't thought her work boring?

 c. I don't know anything of the kind. I'm just worried.

4. What if I die struggling to make this movie?

 a. If I die, I die.

 b. After I finish working, I'll die. Not before.

 c. Hush up, brain.

5. What if I disappoint myself?

 a. Why should I disappoint myself? I'm a capable person and I'm getting better at this all the time.

 b. Who doesn't get disappointed sometimes?

c. I'm not interested in the question. On to work.

6. What if I paint like a fool?

a. Hush. I'm prepared and everything will be fine.

b. I can live with embarrassment.

c. I can live with whatever happens.

7. The house smells awful!

a. I'll look for the smell later.

b. I won't be distracted by a smell. I know that mind trick!

c. Was there a smell?

8. Things aren't going as well today as they did yesterday.

a. So?

b. Do I really remember yesterday? No, it's just my nerves speaking.

c. Brain, comparisons are odious. Hush up.

9. What if I mess up all this expensive canvas?

a. I'm prepared to paint well. Why predict disaster?

b. My only job is to relax and to work with passion.

c. Such things happen. I'll get over it.

10. What if everything I do is bad?

a. Oh, mind, stop it! You have work to do.

b. Then do better, boy. It's your life.

c. I have great work ahead of me.

In silencing the voice of relentless self-hatred, the writer gains in fulfilled humanity as well as art.

VICTORIA NELSON

Many other cognitive techniques are available to you. The violinist and aikido expert Paul Hirata, for instance, taught a technique he called "Half-Half-Half." The idea is to suggest to yourself that you release just half your anxiety, using the word "Half" as a kind of mantra. You exhale, relax, and quietly say "Half." You inhale again, continuing to relax, and upon the exhale say "Half" again, continuing the process as necessary. With this "mind trick" you never have to get rid of all your anxiety at once.

Another cognitive technique is "reframing." Rather than believing one thing about a situation, you determine to believe something else instead. The objective facts haven't changed, but your view of them has. For example, rather than feeling trapped at the computer screen, remind yourself that you are free to leave *at any time.* Reframe the moment as one of freedom rather than entrapment. Indeed, you *are* free to leave. You may find it wonderfully calming just picturing yourself striding out of the room without a care or a backward glance.

Even when people learn about the physical and psychological manifestations of anxiety, they are still vulnerable to ignoring or misreading signals at critical times.

MICHAEL KERR

CREATING A PLAN

Describe what anxiety-reduction techniques you'll employ when you're confronted by:

1. Hungry-mind anxiety

2. Confused-mind anxiety

3. Weakened-mind anxiety

4. Chaotic-mind anxiety

5. Critical-mind anxiety

6. Attached-mind anxiety

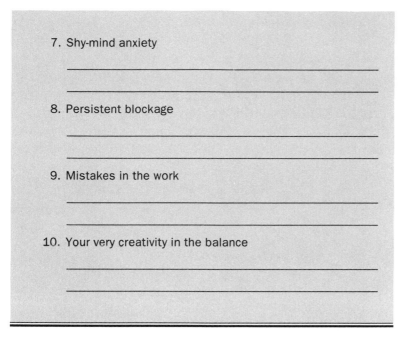

7. Shy-mind anxiety

8. Persistent blockage

9. Mistakes in the work

10. Your very creativity in the balance

Keep on starting, and finishing will take care of itself.

NEIL FIORE

No artist should expect to become a paragon of calmness. That is not real; that is not her goal. An artist accepts anxiety as a condition of life, one that she can only rid herself of through one inauthentic belief or another. But while she accepts anxiety as a condition of life, she does not accept that her anxieties will prevent her from creating. No!—and because she refuses to grant them that sway, she learns through honest practice those strategies and techniques that help her to quiet her nerves and to live authentically.

RECOMMENDED READING

GENERAL

Arasteh, A. Reza, and Josephine D. Arasteh. *Creativity in Human Development: An Interpretive and Annotated Bibliography.* New York: John Wiley & Sons, 1976.

Ashton, Dore. *Twentieth Century Artists on Art.* New York: Pantheon Books, 1985.

Audette, Anna Held. *The Blank Canvas.* Boston: Shambhala, 1993.

Bayles, David, and Ted Orland. *Art and Fear.* Santa Barbara, CA: Capra Press, 1993.

Betso, Kathleen, and Rachel Koenig. *Interviews with Contemporary Women Playwrights.* New York: Beech Tree Books, 1987.

Boyd, Jenny. *Musicians in Tune: Seventy-Five Contemporary Musicians Discuss the Creative Process.* New York: Simon & Schuster, 1992.

Cameron, Julia. *The Artist's Way.* Los Angeles: Jeremy P. Tarcher, 1992.

Camus, Albert. *The Myth of Sisyphus and Other Essays.* New York: Vintage Books, 1955.

———. *Resistance, Rebellion, and Death.* New York: Vintage Books, 1974.

Chadwick, Whitney, and Isabelle de Courtivron. *Significant Others: Creativity and Intimate Partnership.* London: Thames & Hudson, 1993.

Chamberlain, Mary. *Writing Lives.* London: Virago Press, 1988.

Cummings, Paul. *Artists in Their Own Words.* New York: St. Martin's Press, 1979.

Dardis, Tom. *The Thirsty Muse: Alcohol and the American Writer.* New York: Ticknor & Fields, 1989.

Field, Joanna. *On Not Being Able to Paint.* Los Angeles: Jeremy P. Tarcher, 1983.

Franck, Frederick. *The Zen of Seeing.* New York: Random House, 1973.

Friedman, Bonnie. *Writing Past Dark.* New York: HarperCollins, 1993.

Goldberg, Natalie. *Writing Down the Bones.* Boston: Shambhala, 1986.

Innis, W. Joc. *How To Become a Famous Artist.* Austin, TX: Eakin Press, 1994.

Ionesco, Eugene. *Fragments of a Journal.* New York: Grove Press, 1968.

Jamison, Kay Redfield. *Touched with Fire: Manic-Depressive Illness and the Artistic Temperament.* New York: The Free Press, 1993.

Jordan, Barbara. *Songwriters Playground.* Los Angeles: Creative Music Marketing, 1994.

Leonard, Linda Schierse. *Witness to the Fire: Creativity and the Veil of Addiction.* Boston: Shambhala, 1990.

London, Peter. *No More Secondhand Art.* Boston: Shambhala, 1989.

May, Rollo. *The Courage to Create.* New York: W. W. Norton, 1974.

McMullan, Jim, and Dick Gautier. *Actors as Artists.* Boston: Charles E. Tuttle, 1992.

Miller, Alice. *The Untouched Key: Tracing Childhood Trauma in Creativity and Destructiveness.* New York: Doubleday, 1990.

Munro, Eleanor. *Originals: American Women Artists.* New York: Simon & Schuster, 1982.

Nachmanovitch, Stephen. *Free Play.* Los Angeles: Jeremy P. Tarcher, 1991.

Nelson, Victoria. *On Writer's Block.* Boston: Houghton Mifflin, 1993.

Robbins, Lois. *Waking Up in the Age of Creativity.* Santa Fe, NM: Bear & Company, 1985.

Savran, David. *In Their Own Words: Contemporary American Playwrights.* New York: Theatre Communications Group, 1988.

Sternburg, Janet. *The Writer on Her Work.* New York: W. W. Norton, 1980.

Ueland, Brenda. *If You Want to Write.* St. Paul, MN: Graywolf Press, 1987.

Vernon, P. E. *Creativity.* Baltimore: Penguin Books, 1970.

Warner, Sally. *Making Room for Making Art.* Chicago: Chicago Review Press, 1994.

Zollo, Paul. *Songwriters on Song Writing.* Cincinnati: Writer's Digest Books, 1991.

ANXIETY MANAGEMENT

Agras, Stewart. *Panic: Facing Fears, Phobias, and Anxiety.* New York: W. H. Freeman, 1985.

Assagioli, Roberto. *Psychosynthesis.* New York: Penguin Books, 1982.

Borne, Robert. *The Anxiety and Phobia Workbook.* Berkeley, CA: New Harbinger Press, 1990.

De Rosis, Helen. *Women and Anxiety.* New York: Delacorte Press, 1979.

Gellis, Marilyn, and Rosemary Muat. *The Twelve Steps of Phobics Anonymous.* Palm Springs, CA: The Institute for Phobic Awareness, 1989.

Green, Barry, and W. Timothy Gallwey. *The Inner Game of Music.* Garden City, NY: Doubleday, 1986.

Hanh, Thich Nhat. *The Miracle of Mindfulness: A Manual on Meditation.* Boston: Beacon Press, 1987.

Harmon, Renee. *How to Audition for Movies and TV.* New York: Walker, 1992.

Hewitt, James. *Teach Yourself Relaxation.* New York: Random House, 1985.

———. *Teach Yourself Meditation.* New York: Random House, 1988.

Hooks, Ed. *The Audition Book.* New York: Back Stage Books, 1989.

Hunt, Douglas. *No More Fears.* New York: Warner Books, 1988.

Judy, Stephanie. *Making Music for the Joy of It.* Los Angeles: Jeremy P. Tarcher, 1990.

LeShan, Lawrence. *How to Meditate.* New York: Bantam Books, 1988.

McCullough, Christopher, and Robert Mann. *Managing Your Anxiety.* Los Angeles: Jeremy P. Tarcher, 1985.

Ram Dass. *Journey to Awakening: A Meditator's Guidebook.* New York: Bantam Books, 1990.

Ristad, Eloise. *A Soprano on Her Head.* Moab, UT: Real People Press, 1982.

Rosellini, Gayle, and Mark Worden. *Of Course You're Anxious.* San Francisco: Harper San Francisco, 1991.

Rossman, Martin L. *Healing Yourself: Better Health Through Imagery.* New York: Walker, 1987.

Sarnoff, Dorothy. *Never Be Anxious Again.* New York: Crown, 1987.

Seagrave, Ann, and Faison Covington. *Free From Fears.* New York: Poseidon Press, 1987.

Smith, Manuel J. *Kicking the Fear Habit.* New York: Dial Press, 1977.

Wilson, R. Reid. *Don't Panic: Taking Control of Anxiety Attacks.* New York: Harper & Row, 1986.

Wolpe, Joseph. *Our Useless Fears.* Boston: Houghton Mifflin, 1981.

INDEX

Discover more of yourself with Inner Work Books.

The following Inner Work Books are part of a series that explores psyche and spirit through writing, visualization, ritual and imagination.

To order call 1-800-788-6262 or send your order to:

Jeremy P. Tarcher, Inc.
Mail Order Department
The Putnam Berkley Group, Inc.
390 Murray Hill Parkway
East Rutherford, NJ 07073-2185

_____ The Artist's Way	0-87477-694-5	$13.95
_____ At a Journal Workshop	0-87477-638-4	$15.95
_____ Ending the Struggle Against Yourself	0-87477-763-1	$14.95
_____ The Family Patterns Workbook	0-87477-711-9	$13.95
_____ Following Your Path	0-87477-687-2	$14.95
_____ The Inner Child Workbook	0-87477-635-X	$12.95
_____ A Journey Through Your Childhood	0-87477-499-3	$12.95
_____ A Life in the Arts	0-87477-766-6	$15.95
_____ Pain and Possibility	0-87477-571-X	$13.95
_____ The Path of the Everyday Hero	0-87477-630-9	$12.95
_____ Personal Mythology	0-87477-484-5	$10.95
_____ The Possible Human	0-87477-218-4	$13.95
_____ The Search for the Beloved	0-87477-476-4	$13.95
_____ Smart Love	0-87477-472-1	$ 9.95
_____ A Time to Heal Workbook	0-87477-745-3	$14.95
_____ True Partners	0-87477-727-5	$13.95
_____ Your Mythic Journey	0-87477-543-4	$ 9.95

Subtotal $_____
Shipping and handling* $_____
Sales tax (CA, NJ, NY, PA, VA) $_____
Total amount due $_____

Payable in U.S. funds (no cash orders accepted). $15.00 minimum for credit card holders.
*Shipping and handling: $2.50 for one book, $0.75 for each additional book, not to exceed $6.25.

Enclosed is my □ check □ money order
Please charge my □ Visa □ MasterCard □ American Express

Card # _____ Expiration date _____

Signature as on credit card _____

Daytime phone number _____

Name _____

Address _____

City _____ State _____ Zip _____

Please allow six weeks for delivery. Prices subject to change without notice.
Source key IWB